THE MASTERWORKS
OF THE IMPRESSIONISTS

The Masterworks of the

IMPRESSIONISTS

Douglas Mannering

SMITHMARK

This edition published in 1996
by SMITHMARK Publishers,
a division of U.S. Media Holdings, Inc.,
16 East 32nd Street, New York, NY 10016

SMITHMARK books are available for bulk purchase
for sales promotion and premium use.
For details write or call the manager of special sales,
SMITHMARK Publishers,
16 East 32nd Street, New York, NY 100016; (212) 532-6600

This edition first published in Great Britain in 1996
by Parragon Book Service Limited
Copyright © Parragon Book Service Limited 1996

ISBN 0-7651-9693-X

Editor: Linda Doeser
Design Direction: Robert Mathias, Publishing Workshop
Designer: Helen Mathias
Special thanks go to Joanna Hartley of the Bridgeman Art Library,London
for her invaluable help

Contents

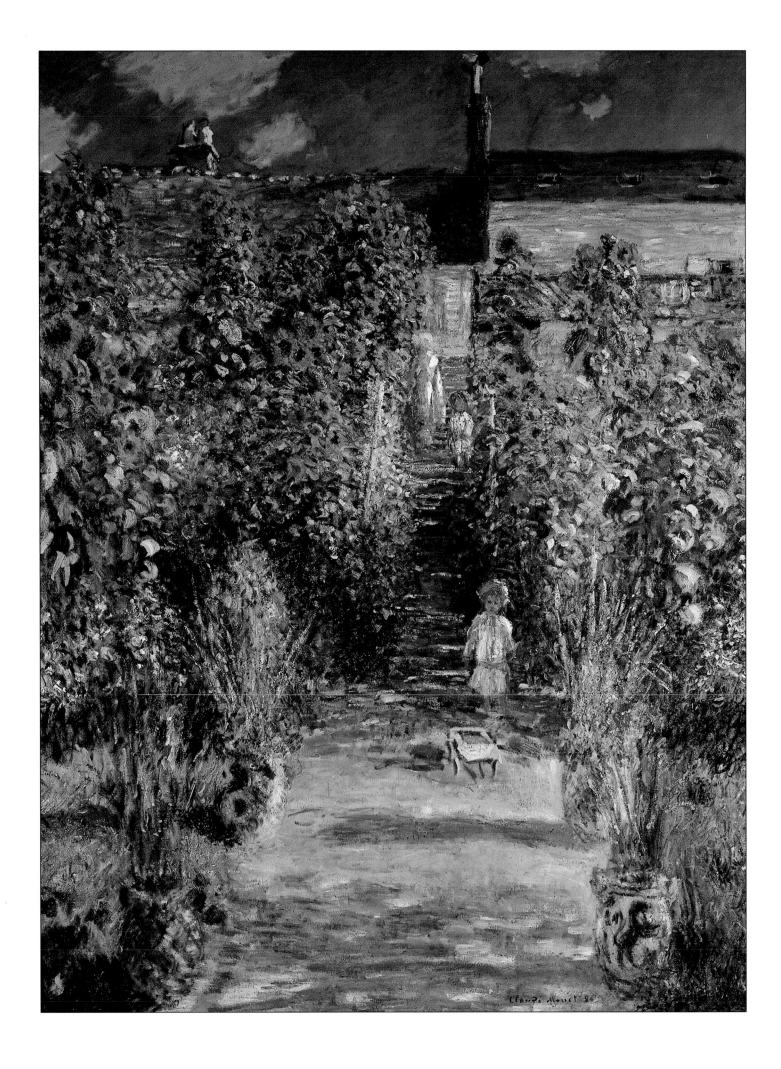

Introduction

Nowadays almost everybody knows that Impressionist paintings are brilliantly colourful and filled with life and atmosphere. The fact is so obvious that it hardly seems worth writing it down. Yet many of the people who first saw these paintings in the 1860s and 1870s were either outraged by them or moved to extravagant mirth. To a leading critic an Impressionist exhibition was 'a museum of horrors', while one of his colleagues dismissed a delicious sunlit nude by Renoir as a monstrosity resembling nothing so much as a decomposing mass of flesh. The cartoonists made merry and the general public followed suit. Nor was this response a mere whim of fashion. On the contrary, it represented a fixed attitude that took years to wear down. In effect, Impressionism was the first of the great modern movements in art, and because it was the first its struggle was the most protracted and severe. Ironically, the much less accessible styles that appeared in the twentieth century, such as Cubism and Abstraction, benefited from a more receptive attitude towards innovation (pioneered by the Impressionists)

and were accepted into the mainstream within a relatively short space of time.

The Nineteenth-century Scene

The trials and triumphs of Impressionism took place in nineteenth-century France, under the Second Empire of Napoleon III (1852–70) and the Third Republic (1870–1940). Only a handful of Impressionist paintings had any direct bearing on politics (they are described later), and generally speaking the artists were more concerned with their work than with the events of the day.

However, two major events did touch their lives. One was a catastrophic miscalculation by the Emperor Napoleon III, who had played an imposing, if erratic part in European affairs during his 18 years of power. Relying on an army that had dominated Europe for over 200 years, he declared war on upstart Prussia in 1870; but over time the balance of force and skill had shifted and it was the French who were crushed by the Prussian military machine. Defeated and captured, Napoleon abdicated and France became a republic again. Paris was besieged by the Prussians, holding out until food was so short that the creatures in the zoo were slaughtered for their meat and domestic animals mysteriously disappeared.

France was beaten, but worse was to come. While the national government at Versailles, outside Paris, negotiated with the Prussians, resentful Parisians set up their own radical organization, the Commune, in effect inviting other towns to join them in a revolutionary confederation (some did, briefly). With atrocities committed on both sides, civil war ensued. The Communards stood no real chance against the Versailles troops and during 'Bloody Week' in May 1871 tens of thousands were killed or executed as Paris was stormed. As later pages will show, all the Impressionists were affected by these events, whether they served against the Prussians or took refuge in Britain; and one of them, Frédéric Bazille, was actually killed.

Born in defeat and civil war, the republic barely survived the first few years of its existence. Although it eventually established itself, there were a number of alarms, of which the most serious was the Dreyfus Case. In 1894 Alfred Dreyfus, an army officer, was convicted of spying for Germany. Over the next few years evidence accumulated that justice had not been done, papers had been falsified and Dreyfus' Jewishness had fuelled prejudice against him.

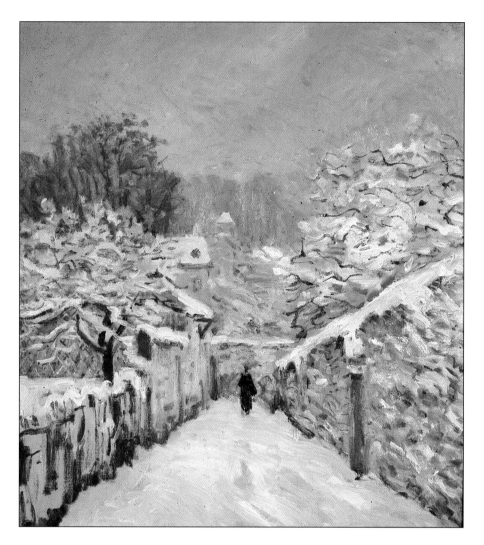

This was all the more apparent in the fierce resistance that manifested itself in attempts to revise the verdict. 'The Affair' divided the nation and became a party issue, as the army, the Church, monarchists and other anti-republican elements lined up against liberals, radicals and the left. In 1899 a solution of sorts was reached when Dreyfus was pardoned by the president; full recognition of his innocence was deferred until 1906. In the meantime, families quarrelled and friendships snapped, among the Impressionists as well as other French people.

At least as important as politics was the social and economic transformation of France during this period. As the country became industrialized, the middle class, or bourgeoisie, grew in size, wealth and influence. One effect of this was to enlarge the market for works of art, and although middle-class taste was generally conservative, the exceptions were numerous enough to make it possible for the Impressionists to survive their rejection by the art 'establishment'.

Understanding this establishment makes it much easier to appreciate what the Impressionists were up against and what made their works so unconventional. The arts were much more rigorously organized in France than in most other countries – more rigorously organized but also more generously patronized. Painting and sculpture were the concern of the Academy of Fine Arts, which functioned mainly through France's most prestigious teaching school, the Ecole des Beaux-Arts in Paris, and the Salon, a great exhibition of approved work held annually during the later nineteenth century.

Neither of these was technically a monopoly, but in promoting art and rewarding artists they had all the advantages. At the Beaux-Arts a talented pupil could win distinctions and prizes, including the Prix de Rome, whose holder enjoyed four years of pleasurable, subsidized study in the Eternal City. Medals awarded by the Salon were further proofs of merit, leading on to a distinguished career that would be punctuated by state commissions and official honours. Even those who had less elevated ambitions tried to make their mark at the Salon, if only because there was no real alternative. When the Impressionists first came on the scene in the 1860s, there were no exhibitions in Paris apart from the Salon, museums were in effect shrines to the glorious dead, and most dealers were little more than shopkeepers who were prepared to display a few canvases in their windows. Provincial towns had their own shows, but to be known in Paris an artist needed to be seen at the Salon; and that meant sending in works to the Salon jury for approval or rejection. Even when that obstacle had been overcome, an exhibitor's canvases needed to be well hung if they were not to be swamped by the pictures crowded onto the walls of the Salon; being put up in the 'sky' – high on the wall – meant being condemned to obscurity.

In normal circumstances there was no appeal against the verdict of the jury, which was composed of academicians who inevitably favoured the kinds of paintings and sculptures promoted by the Academy and the Beaux-Arts. By the mid-nineteenth century this kind of art had acquired a fixed set of characteristics. This was true in other countries besides France: 'academic art' has become a received term, describing the prevailing orthodoxy in much of Europe and America. Academic art was firmly outlined and meticulously detailed, with a smooth finish and a covering of

varnish to remove all traces of brushwork. At first sight academic paintings often look like photographs, except for their dignified darkness of tone and an almost universal tendency towards emotional overstatement, apparent in their treatment of qualities such as nobility and sweetness. Academic painters idealized their subjects, avoiding the commonplace and sordid (or rather believing that the commonplace *was* sordid); and they did so quite consciously. When the young Impressionist Auguste Renoir was working in the studio of the academic master Charles Gleyre, he was told that it would be wrong to paint the big toe of Germanicus (a Roman hero) in the same banal fashion as he would paint the big toe of a mere coalman!

As this implies, not all kinds of painting were valued equally. The most highly regarded pictures were histories or mythologies, in which work on a large scale ('the Grand Style') and evidence that the artist had researched his subject long and laboriously were strong recommendations. One amusing result was that, as time went on, history painters exhausted one period after another and researched ever more obscure subjects, even venturing into the Old Stone Age. The 'story' element was strong in these and many other academic works, and a reaction against 'literary' painting was to be one of the features of Impressionism. So was a rejection of the academic pecking order, which placed genre ('ordinary life') scenes and landscapes below history paintings and relegated the still life to the very last place.

Stirrings of Discontent

Of course nothing was quite so cut and dried as this. In practice, some Beaux-Arts teachers were surprisingly broad-minded, some quite unusual talents won acceptance, fashions came and went and the Salon jury's mood was known to swing about from one year to the next. Earlier in the nineteenth century the art world had been divided between the Classicism of Jean-Auguste-Dominique Ingres and the colourful Romanticism of Eugène Delacroix. By mid-century a number of landscapists, such as Camille Corot and Charles-François Daubigny, had established substantial reputations. And when the first outright rebel of stature, Gustave Courbet (1819–77), showed his *Burial at Ornans* (page 12), it was at the Salon of 1850. Courbet's self-proclaimed Realism was to influence most of the Impressionists, although his peasant subjects and relatively academic style differentiate

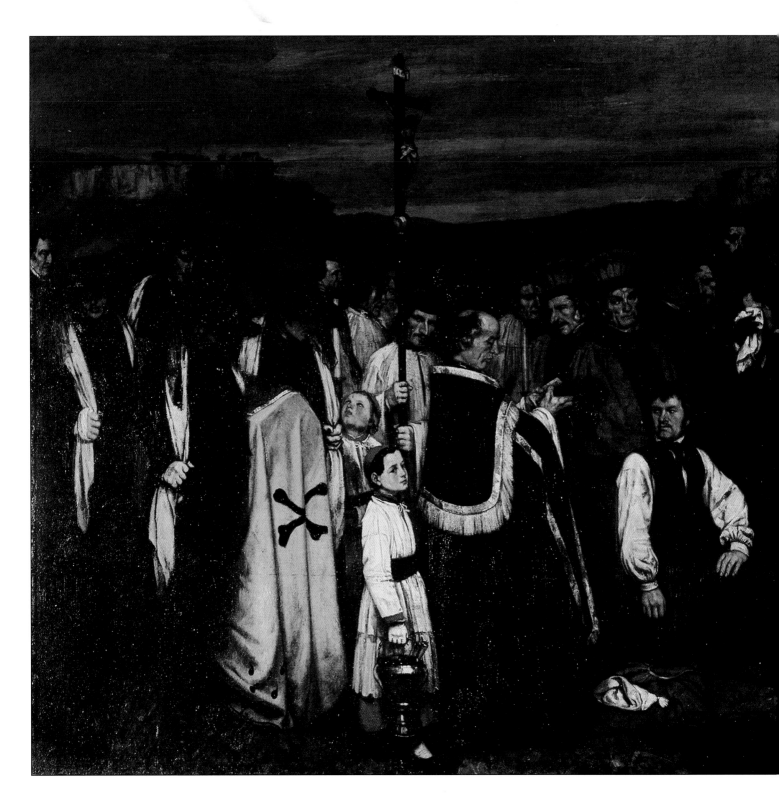

his pictures quite sharply from the works they produced as
mature artists.

When the Impressionists became active in the early 1860s,
they too hoped to make their names at the Salon. In fact Edouard
Manet (1832–83) never gave up hope, and it was in spite of him-
self that he replaced Courbet as the leader of the rebellious
younger generation. Manet broke new ground as a 'painter of
modern life' – mainly Parisian manners and personalities –

12

rather than of statuesque scenes from history. His style was also non-academic, involving the use of a free brushwork that eliminated detail and was often visible to the naked eye. Manet's near-contemporary Edgar Degas (1834–1917) also painted contemporary subjects, from racecourse subjects to ballet dancers and laundresses, employing some original techniques to capture movement and gesture with startling immediacy.

Impressionism was never a movement in the sense of possessing

an organization or a programme. But Manet's table in one or other of his favourite cafés did become an evening rendezvous for like-minded artists and their literary friends, including the painters who would later be identified as Impressionists. Among the most important of these were younger men such as Claude Monet (1840–1926) and Auguste Renoir (1841–1919), who spent most of the 1860s alternating between pleasing themselves and making various compromises in an effort to please the Salon. As they increasingly followed their own impulses, they painted with more and more freedom and brighter colours, eventually developing techniques that were particularly effective for landscape painting.

The Impressionist Landscape

The result was a wonderful collection of light-filled, atmospheric pictures which are often regarded as the greatest legacies of the Impressionists. From the first, the Impressionist landscapists painted in the open air (the French term *en plein air* is often used), believing that this would make their work fresher than studio-bound productions. It also made it thinkable for the artist to capture fleeting effects, produced by changes in the light or the weather, as they actually happened – that is, as they actually appeared to the eye. This was more unusual than it sounds, since catching the moment on the wing was alien to the portentous ideals of the academic tradition, and even less hidebound painters, such as Corot and Daubigny, strove to give their landscapes a generalized, 'eternal' appearance.

Moreover the Impressionist approach led to a number of other developments that shocked and bewildered many of their contemporaries. What 'actually appeared to the eye' turned out to be different from what everyone had supposed. Colours were greatly modified by the interplay of light, reflections and the placing of objects in relation to one another. Shadows, for example, normally perceived and represented as black or grey, were in reality sprinkled with reflected colours. Similarly, the 'decomposing flesh' in Renoir's picture was simply tinted by reflections from the greenery which surrounded the nude model; but the critic, brainwashed by convention, could not see it.

The painting technique developed by Impressionist landscapists added to the critics' puzzlement. Instead of carefully blended and smoothed-in tones, the canvas was covered with small

touches or strokes of pure colour. Two colours that would have been mixed on the palette of a conventional artist were kept separate but put on in close proximity to each other. The viewer's eye did the mixing without any conscious effort, so that the painting was perfectly comprehensible, but the separate colours also retained their potency, making for a brightness and vibrancy that could not be achieved by normal means. In fact, it is just this vibrancy that is responsible for the famous sense of atmosphere that suffuses Impressionist landscapes.

It should be added that Impressionist landscape technique conformed to colour theories that were being developed by contemporary scientists and that some or all of the artists may have been aware of them. In any case, the technique adopted by the Impressionists was obviously ideal for painters who needed to work rapidly in the open air. By the 1860s, *plein-air* painting was no longer unusual in itself, although it was still regarded in some quarters as suspiciously bohemian. Paradoxically, it was most acceptable when done by young ladies, if they were properly chaperoned, as they were expected to produce 'charming sketches' rather than works of art. However, 'proper' artists, if they ventured outdoors, tended to confine themselves to drawings and, at most, studies in oils, before retiring to their studios to produce highly finished canvases of the kind that could be done only with great care, considerable labour and an absence of bad weather, flying sand and intrusive insects. In practice, even the most dedicated of *plein-air* painters, Claude Monet, touched up his canvases – and sometimes did more than touch them up – in the studio, although he was loath to admit the fact; but the touching up did not involve the conventional smoothing and varnishing. However it was executed, the Impressionist landscape *appeared* to be the spontaneous record of a fleeting moment.

It was the difference in the end product rather than the method of working that made Impressionist landscapes so offensive to the academically trained eye. By Beaux-Arts standards the blobs of colour, the cursory passages, the 'rough' surfaces that now seem so lively were merely symptoms of slovenliness. Their creators, who could not be bothered to finish their work properly, produced daubs or, at best, rough drafts for real paintings. Viewed from a distance, an Impressionist scene made perfect visual sense, but critics and public alike expected to be able to go right up to a painting and, if the workmanship was first class, still see all the pictured details and none of the brushwork.

This makes it possible to understand why Impressionist paintings were so vehemently denounced and ridiculed. People looked for certain familiar qualities, for adherence to unbreakable rules and, failing to find the qualities present or the rules respected, concluded that there was nothing worthy of scrutiny in front of them. Their responses were not governed by what they saw but by what they expected to see. By doggedly showing their work, the Impressionists very gradually made it familiar and acceptable. Like other innovators, they had to create their own public.

What was Impressionism?

Discussion of Impressionism inevitably tends to focus on landscape painting because of its striking novelty, both technically and in terms of immediate impact; but landscape is far from being the whole of Impressionism. However, not all critics agree with this statement. Some argue that the *plein-air* painters form the only coherent 'movement' in the 1860s and 1870s and that they alone should be called Impressionists. They point out the wide differences between these artists, with their overriding concern with capturing momentary effects, and several of the other masters traditionally regarded as Impressionists. Manet, for example, was a man of the city and not a *plein-air* painter except for a few years in the early 1870s, when he was influenced by his younger contemporaries. Unlike Monet and Pissarro, who boasted of having eliminated the 'unnatural' black from their palettes, he often employed this colour (or non-colour) to startling effect, as in *The Fifer* (page 17). Degas, one of the leading figures in the Impressionist exhibitions, always scorned the idea of working out of doors. He planned every effect down to the last detail and composed with firmly drawn outlines that represent the opposite tradition to the 'painterly' style of the *plein-air* artists, who employed colour rather than line to indicate forms. Consequently, the argument runs, there was either no such thing as Impressionism, or the term should be restricted to a very limited body of work.

This is unsatisfactory because it flies in the face of history. The artists we normally label Impressionists were closely associated during their lives, meeting frequently, encouraging one another and exhibiting together at the shows where they were all jeered at as 'Impressionists'. (The only non-exhibitors were Manet, who remained aloof despite the popular conviction that he was the chief of the entire school, and Bazille, who died before the exhibitions

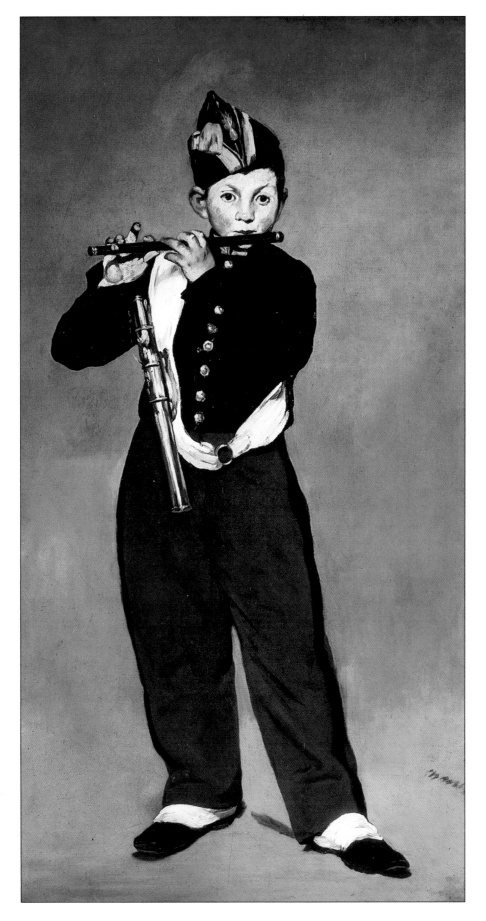

LEFT: **The Fifer**
1866
Edouard Manet
MUSÉE D'ORSAY,
PARIS

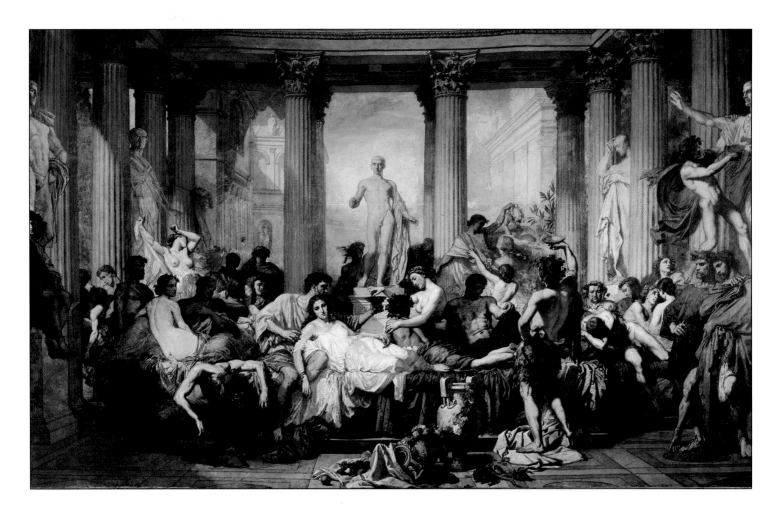

came into being.) It is difficult to believe that the artists themselves, and a hostile public, could be mistaken about their belonging together.

In fact, the common elements in Impressionist canvases become clearer when they are directly contrasted with paintings in the academic tradition. For the sake of simplicity we can confine ourselves to two works whose subject – having a good time – gives them an amusing affinity: Thomas Couture's *Romans of the Decadence* (above) and Auguste Renoir's *Luncheon of the Boating Party* (right). To begin with, their dimensions: although they are shown here at about the same size and Renoir's painting is large by Impressionist standards (129.5 x 172.5 cm), it is dwarfed by Couture's (473 x 789 cm). Its size is only one symptom of the inflated ambition of the academic painting. It is also dark-toned, formal (statuesque even in mid-orgy) and set in a larger-than-life past. By contrast, the Impressionist painting is brighter, informal or even casual, and set in the present. Only a minority of Impressionist works were consciously painted with any notion of reflecting 'modern life' (this is most obviously true of Manet,

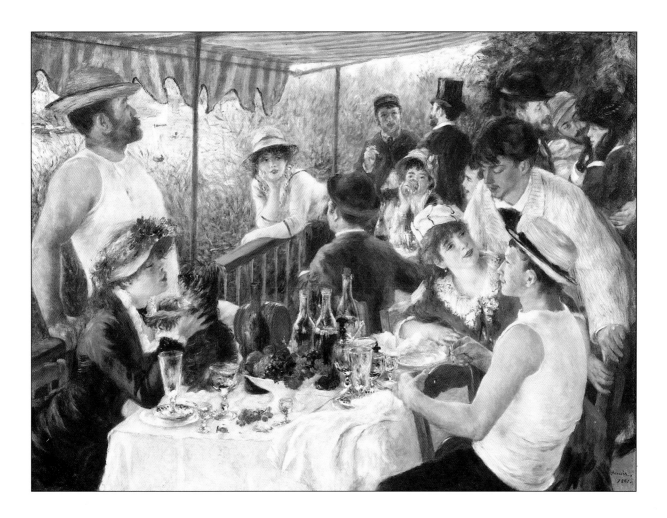

Degas and Caillebotte), but virtually all of them represented everyday realities without dressing them in mythological or historical trappings.

As a corollary to all this, the academic painting was apt to tell a story and point a moral. *The Romans of the Decadence* is relatively restrained in this respect, as Couture does not actually show the barbarians at the gates taking advantage of the partygoers' moral degeneracy. By contrast with history painting and with the lighter anecdotes that were popular in other, more overtly sentimental types of nineteenth-century art, the Impressionists generally avoided 'literary painting'. Many of their works are implicitly celebrations of natural beauty or people enjoying themselves, but that is all; even a canvas such as Degas' *Women Ironing* (page 190) is a study of physical movement rather than a protest against overwork in a sweated trade.

A related difference exists between the theatrical nature of academic art, in which the subject is framed and shown in deep perspective, and the Impressionist painting, in which various devices are used to draw the spectator in or, at any rate, to give the

ABOVE:
Luncheon of the Boating Party
1881
Auguste Renoir
PHILLIPS
COLLECTION,
WASHINGTON, DC

19

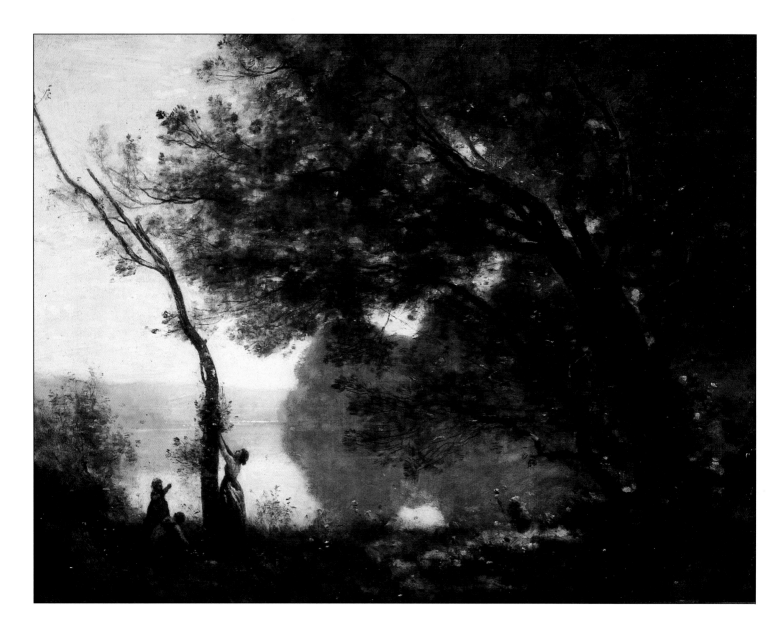

illusion that the framing is arbitrary, restricting how much we can see of a real event which is felt to go on outside its limits.

A similar series of points might be made about the landscape tradition; for example, by contrasting a masterpiece by Corot, *Recollection of Mortefontaine* (above) with a work by his Impressionist pupil Camille Pissarro (1830–1903), *Chestnut Trees at Louveciennes* (page 21). The fact that the Corot is a masterpiece should serve to remind us that the Impressionist revolution did not invalidate the whole of earlier nineteenth-century art, although it ultimately exposed the emptiness of history painting. Only eight years separate the two canvases. Pissarro's work is by no means the brightest of Impressionist paintings, Corot has imbued the shining water and breeze-blown tree with sublime poetry (and has refrained, on this occasion, from putting nymphs in the landscape) – and yet the finished 'classical' appearance of the Corot is quite different from Pissarro's visible brushwork and higher-key

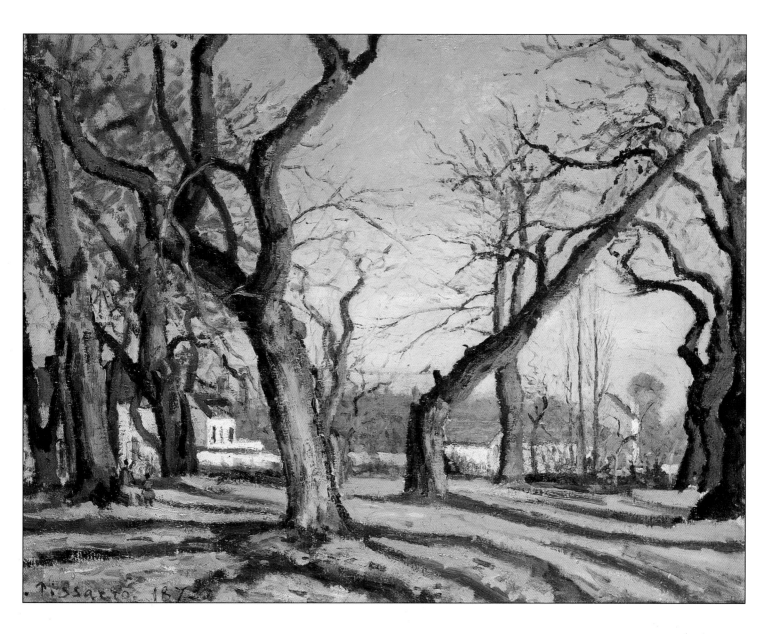

colours, and the rugged strength with which he has rendered a humdrum, apparently de-poeticized scene.

Finally, Impressionism was a coherent and revolutionary movement in its challenge to the priorities of established art. The entire group scorned history and myth, preferring supposedly lesser genres, such as scenes of everyday life, landscapes and, to a lesser extent, the humble still life (whose day would dawn a little later).

This book consists of three parts, which effectively show the Impressionists coming together, making their assault on the public and then moving apart in later life. Consequently, the first part follows the individual lives of the artists, the middle section, 'Exhibition Years', chronicles the eight Impressionist shows that scandalized Paris between 1874 and 1886, and the book finishes with the later careers of the Impressionists and sketches of some minor figures and latecomers.

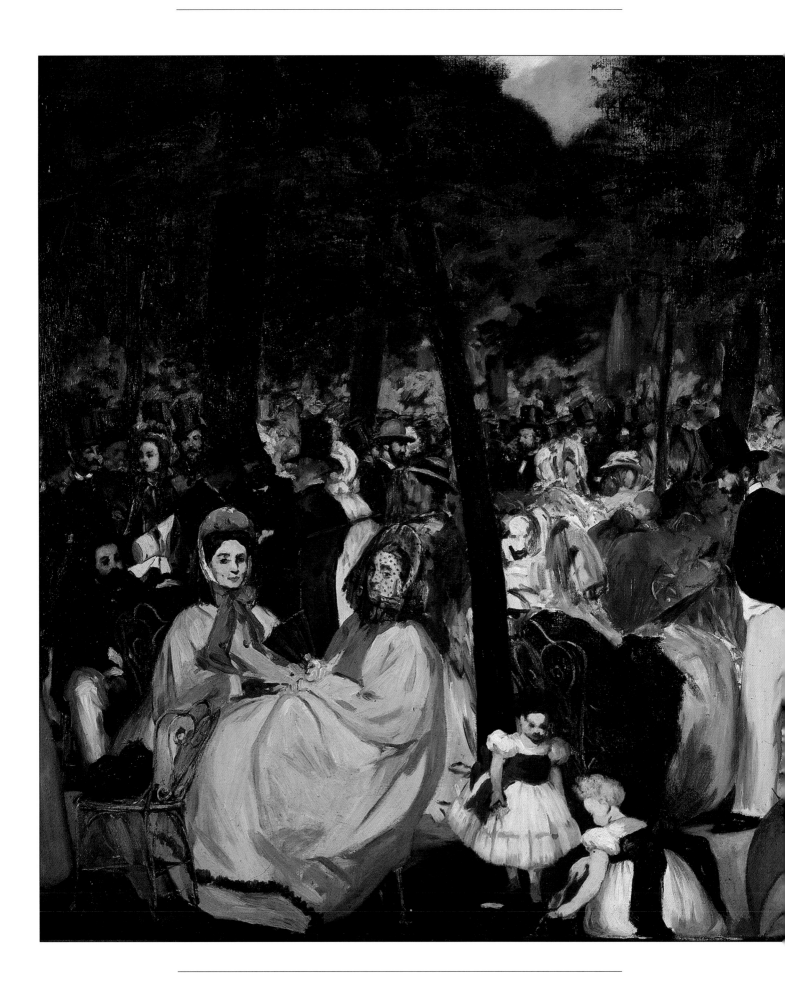

Towards a New Art

MANET
1832 – 1883

douard Manet was the great pioneer of an art based unmistakably in its own time – in the distinctively nineteenth-century, citified life of the boulevards and the boudoir. Because this was not the 'proper' subject of painting, his works caused the greatest scandals of the century, and few of his contemporaries doubted that he was the leader of the new school that subsequently developed, whether it was labelled 'Impressionist', 'Realist' or even 'Intransigent'. To hostile critics, the painters associated with him were 'Manet's gang', or could be lumped together as citizens of 'Manet's republic'. Ironically, Manet himself was too much of a gentleman to relish controversy, having 'no wish to protest about anything' and a craving for recognition and honours that was forced to yield only to the still more powerful impulse of his genius. His friend Degas described him as great in spite of himself, and as such the victim of his own genius: 'he is a galley slave tied to his oar'.

LEFT: **Music in the Tuileries**
1862
Edouard Manet
NATIONAL
GALLERY,
LONDON

Edouard Manet was born on 23 January, 1832, in Paris, where his father served as a highly-placed civil servant and magistrate. The future painter belonged to the upper-middle class, albeit to a

serious-minded section of it. In fact, Manet's later elegance and man-about-town airs may have been adopted as a reaction against the rather puritanical atmosphere in which he was brought up.

From the outset he seems to have been determined to disappoint his parents. His lamentable performance at school saved him from a legal-administrative career like his father's. At 16, intent on becoming a naval officer, he failed the college examination and had to go to sea for six months as a cadet in order to qualify for another try. The long voyage to Rio de Janeiro on the *Le Havre et Guadeloupe* was to be his only experience of the world beyond Europe.

On his return, Manet sat the naval college examination for a second time and failed a second time. With few options remaining,

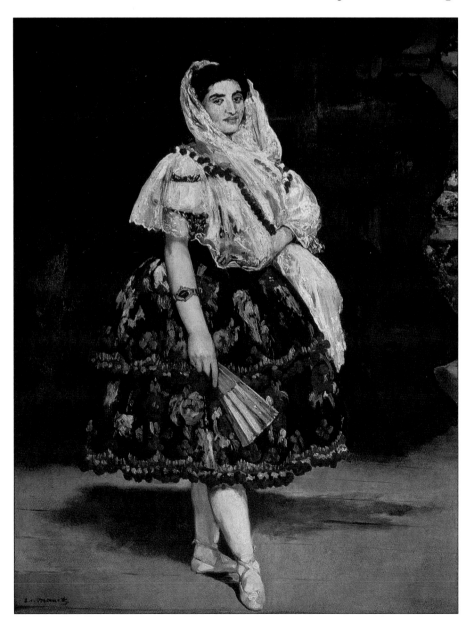

RIGHT: **Lola de Valence** 1862
Edouard Manet
MUSÉE D'ORSAY,
PARIS

Manet's father agreed that Edouard, who had at least shown 'artistic inclinations', should become a painter. Like other respectable parents of Impressionist sons, the Manets must have expected that Edouard would study under approved masters, exhibit laborious, tasteful works at the Salon and eventually enter the ranks of the prize-winning masters, highly-placed in the echelons of the Academy of Fine Arts.

Edouard Manet was not the kind of man to become involved with bohemian artists or noisy public controversies. A polished, even dandified gentleman, he was at home in the best society, observed the social niceties and carefully kept up appearances in his private life. Yet in spite of his background, he became the most scandalous painter of his generation and, in the eyes of the public, the leader of a rebellious band of artists who had 'declared war on beauty'. What makes this situation all the more curious is that Manet himself seems to have been only half-aware that there was anything offensive about his work. He was anxious for conventional success and became deeply hurt, but also mystified, when abuse rained down on him for paintings that contemporaries found improper as well as inartistic. And yet he was thoroughly familiar with the moral and artistic conventions of the age. Perhaps he was too absorbed in his work to think about consequences, or perhaps he was always taken by surprise because he found it hard to believe that people could fail to appreciate his achievements. Perhaps. Manet himself said little about his artistic intentions, and the truth is that no fully convincing explanation of the Manet mystery has yet been put forward.

Student Days

In 1850 Manet dutifully enrolled at the studio of Thomas Couture, a 35-year-old painter who had staked his claim to greatness three years earlier with the much-admired *Romans of the Decadence* (page 18). Exposing the degenerate party-goers who were responsible for the decline and fall of the Roman Empire, the picture was everything that a nineteenth-century masterpiece was supposed to be: a large historical set-piece, carefully researched, convincingly realistic and rendered in precise detail. If the decadent revellers looked rather lifeless, that could be put down to their post-orgiastic exhaustion and, in view of the subject, the decorous hints of sexual abandon could hardly be blamed on the artist. The entire enterprise was justified – and crowned – by the moral judgement implicit in the presence of virile-looking statues (representing the

undecadent past) and a pair of disapproving, high-minded intellectuals (philosopher and poet) in the wings. *The Romans of the Decadence* was, if nothing else, beautifully judged to appeal to its audience, who rewarded it appropriately.

Anecdotes about Manet's student days suggest that he was out of step from the beginning. He is said to have made life difficult for the professional models, who were used to taking up heroic poses, by complaining of their artificiality: 'You wouldn't buy radishes with a gesture like that!' And whereas it was normal to work from the nude in order to understand the musculature of the human body, Manet actually tried to persuade one of the studio's models to keep his clothes on and be drawn as he appeared in ordinary life. These stories are just what we might expect, but whether they are true is another matter. Most of them come from Manet's boyhood friend Antonin Proust and were only published after the painter's death. Although we cannot say with certainty that any one of Proust's anecdotes is false – or at any rate touched up – their very aptness makes them suspect.

Couture's cannot have been too unpleasant, since Manet stayed there for six years. And if he was at all dissatisfied he compensated for it by spending his evenings at the Académie Suisse, where the atmosphere was notably free and easy. Actually the Suisse was not an academy at all, but a place where, for a small fee, anyone could come and work from the model provided. The Académie was already well established when Manet patronized it, provided a haven a dozen years later for Monet, Pissarro and Cézanne, and lived on as a 'free school' into the twentieth century.

Manet also made regular visits to the great Parisian museum, the Louvre, where he studied and made copies of paintings in its famous collection. Copying was a way of learning Old Master techniques, but it also served another purpose: the copy itself was the counterpart of the modern colour reproduction, enabling the owner to possess a version of the original for purposes of enjoyment or reference.

For all his modernity, Manet had a strong sense of his relationship to the past, and he continued to study and make copies after leaving Couture's. He spent the years 1856–8 in leisurely travel in western Europe, and during a stay at Florence he made a copy of *The Venus of Urbino*, by the Venetian Renaissance master Titian, which was to inspire the most controversial of all his own paintings.

Finally settled in Paris again, Manet began his career as a professional artist in 1859, when he submitted *The Absinthe Drinker* for consideration by the Salon jury. Its subject, an alcoholic ragpicker named Collardet, was a well-known character who was often seen in the vicinity of the Louvre. Manet's painting might almost have passed as a piece of heavy moralizing, since absinthe was a drink of poisonous potency that was eventually banned, and the abandoned bottle, the bright, enticing glass and the blurred features of Collardet sent an unmistakable message to the spectator. Nevertheless the jury rejected *The Absinthe Drinker* as too sordid in its realism (although it now appears a little romanticized); and Manet's bold contrasts and very free brushwork probably added to their sense of discomfort.

Collardet appeared again in a more sentimental picture, *The Old Musician* (*c.*1862), but the painter's concern for the poor was at best intermittent and soon petered out. One of its replacements, much longer-lived, was a taste for the customs and costumes of Spain. The French tended to believe that their Spanish neighbours were primitive, passionate and colourful, so Manet's interest was typical and, from a career point of view, promising. His first Salon acceptance, in 1861, was for *The Spanish Singer*, a conventional, dark-toned picture of a guitarist on a bench, giving his all. It won Manet an honourable mention, and might have been – but was not – the beginning of a quietly successful career.

Over the next few years Manet returned to Spanish subjects from time to time. *Lola de Valence* (page 24), a much better painting than *The Spanish Singer*, unaccountably failed to repeat its success. Lola was a genuine Spanish dancer, but above all the subject gave Manet an excuse for painting colourful embroidery and delicately patterned lace – the kind of virtuoso display that the public could normally be expected to admire. The dancer is posed behind a piece of stage scenery; the audience can just be glimpsed on the right-hand side of the picture. A certain theatricality always appealed to Manet and other 'Spanish' paintings by him include two very 'staged' bullfight scenes, *Mlle Victorine in the Costume of an Espada* (1862) and *The Dead Toreador* (1864). He produced more convincing paintings of the *corrida* after visiting Spain for the first time in 1865. In Madrid he became acquainted with Théodore Duret, who became a major patron and interpreter of the Impressionists. Ironically, direct contact with Spain seems to have blunted its romantic appeal for Manet and it rapidly faded from his work.

Meanwhile Manet struck out in a very different direction as a painter of contemporary scenes. He was almost certainly influenced by a friend, the poet Charles Baudelaire, who had written of the need for an artist to appear who could convey the heroic qualities of men who sported neckties and wore polished boots. In his essay *The Painter of Modern Life*, Baudelaire could hold up only the clever but lightweight art of Constantin Guys (1805–92) as an example of what he sought, so Manet may have realized that there was a vacant throne waiting to be filled. At some point in 1862 he claimed it by painting a superb open-air scene, *Music in the Tuileries* (pages 22-3), which, without undue solemnity, treated a fashionable crowd of his contemporaries with the kind of seriousness normally reserved for historical groups. The people are wearing tall hats and crinolines, but Manet shows them in apparently casual poses and on an informal occasion, assembled among the trees to hear the band play in the Tuileries Gardens in Paris. The eye is drawn right across the picture, as restless as the crowd, which is its real subject. However, among the faces are a number of recognizable portraits: Manet himself, the most elegant figure present, stands at the extreme left and Baudelaire is not far from him, indistinct but unmistakable, outlined against a tree immediately above one of the two yellow-swathed ladies in the foreground. The other identifiable figures are also friends or supporters, making *Music in the Tuileries* a kind of artistic manifesto.

In the spring of 1863 Manet showed *Music in the Tuileries* and some other paintings at a small gallery on the Boulevard des Italiens whose owner, Louis Martinet, acted as his dealer. The one-man show – still an unusual event – may have been an early attempt by Manet to appeal to the general public or the critics, pre-empting the verdict of the Salon jury. If so, the strategy failed. Manet's paintings were criticized as lacking in finish (a stricture that the Impressionists would read again and again), while *Music in the Tuileries* was dismissed as 'trivial'.

Shortly afterwards, Manet submitted the maximum number of paintings – three – to the Salon. Two were Spanish subjects of relatively modest dimensions, but the third, *Déjeuner sur l'Herbe* (Luncheon on the Grass) (right), was of a size (208 x 206 cm) only submitted by artists bent on becoming famous at a single bold stroke. It was effectively Manet's bid for a medal and recognition as one of the leading painters of the day. Presumably it never

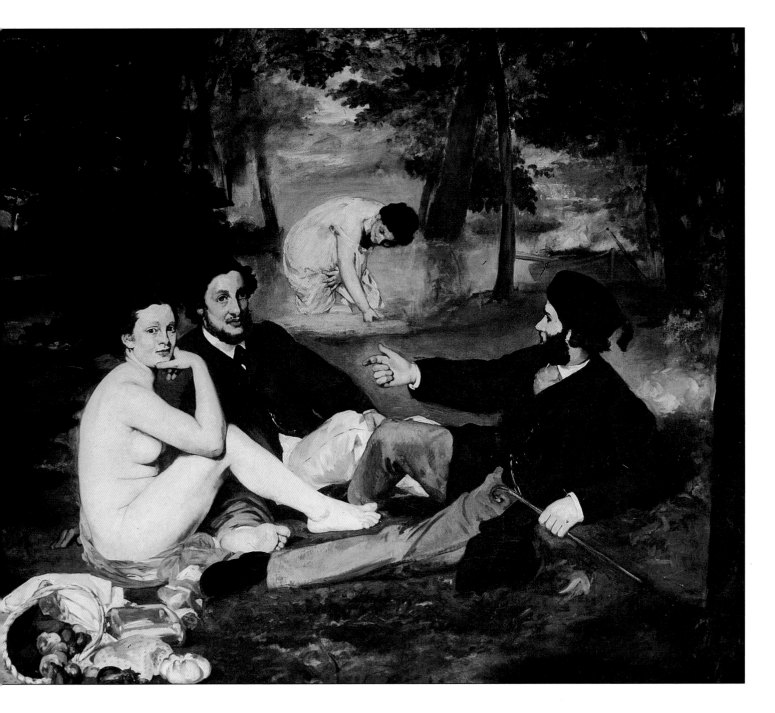

occurred to him that anybody would find the picture offensive.

The Salon jury rejected all three of Manet's submissions. But that was not the end of the matter since they also rejected several thousand other works, some of them by well-known artists. Their severity was so extreme that a storm of protests broke out and the commotion was protracted enough to attract the attention of the Emperor. Louis-Napoleon decided to let the public judge, allowing the rejected artists to hold their own Salon in the same building – the Palais d'Industrie – as the official show.

In the event, the Salon des Refusés drew bigger crowds than its rival, but most of the visitors had made up their minds before they passed through the turnstiles. They were determined to be

ABOVE: **Déjeuner sur l'Herbe** 1863 Edouard Manet MUSÉE D'ORSAY, PARIS

amused and exercised their wit freely on what must have been a curious jumble of conventional, 'modern', well-executed and merely incompetent works. Manet's *Déjeuner* quickly became the star attraction, surrounded by scoffers, while the reviewers were less amused and more savage. Most of them criticized the way in which Manet had rendered the figures, their ugliness and the incongruity of the pastoral setting, although occasional remarks about the naked girl 'lolling shamelessly between two fops' hinted at the moral outrage underlying their aesthetics.

The *Déjeuner* shows the girl sitting in a woodland glade with two unmistakably modern young men who are still fully dressed. In the background a second girl, clad in a shift, emerges from a stream. Manet deliberately emphasized the picture's place in the history of art, taking the clothed-unclothed theme from the *Concert Champêtre* by the Venetian painter Giorgione (or possibly his contemporary Titian), and basing the poses of the main group on a sixteenth-century engraving. However, his witty modern reworking of the scene was precisely what gave offence. There was nothing arcadian or nymph-like about a girl whose discarded clothes lay prosaically on the ground beside her and who looked the spectator in the eye. Moreover, the presence of the two male moderns, locating the scene in the 'sordid' present day, was the final insult. Although not erotic, Manet's picture was definitely improper.

Despite the furore, in 1863 Manet painted yet another modern masterpiece, *Olympia* (page33). It is tempting to relate the boldness of his work during this period to the death of his father in 1862. The history of Impressionism (Monet, Cézanne) bears witness to the awful authority of the Victorian parent, especially when he held the purse-strings, and Manet probably had to rein himself in until his father died and he inherited his share of the estate. After this, unlike most of the Impressionists, he was never seriously in need of money and could paint as he pleased – provided he could put up with public and critical hostility.

Newly independent, Manet was also free to marry. Discreet as ever, he slipped away to Holland and, in October 1863, married a Dutch woman named Suzanne Leenhoff. She had been his piano teacher in about 1850, when their connection began, and the secret was well kept. With Suzanne came 11-year-old Léon Koëlla, who was almost certainly Manet's son by Suzanne. It seems likely that Manet's family life was fairly happy, since Suzanne and Léon appear in a good many of his paintings.

In 1864 the Salon jury was more liberal (no doubt recalling the previous year's controversies), and both of Manet's submissions were accepted. However, neither was well received and Manet was so depressed that he cut up one of the canvases, *Episode from a Bullfight*, preserving only two fragments with which he was satisfied. This was not the only time he mutilated or scrapped one of his works in response to criticism. Manet, the affable man about town, seemed unflappable. Manet the artist was prone to self-doubt and, when everything was against him, sometimes thought that the critics must be right.

Later in the year, he painted one of his most dramatic canvases, *The Battle of the Kearsarge and the Alabama*. This represented an American Civil War engagement that had just then taken place outside Cherbourg, ending in the sinking of the Confederate cruiser *Alabama*. According to some accounts, Manet was present and had himself rowed out into the harbour to follow events more clearly, but it is more likely that he worked from photographs of the ships. His maritime experience is evident in the painting's high horizon and heaving sea, offering a sailor's-eye view of the battle.

The Great Olympia Scandal

When the Salon of 1865 opened, Manet was again represented by two canvases. As in the previous year, one of these was a religious work, *Jesus Mocked by the Soldiers*. Manet was not really at home in this genre and soon gave it up. It is hard to understand why he gave his efforts such prominence by sending them to the Salon, unless he was hoping to disarm criticism and live down the scandal of the *Déjeuner*. However, *Jesus Mocked* did nothing to offset the impression made by his other exhibit, *Olympia* (page 33). Naïve though he sometimes appeared to be, Manet evidently half-expected trouble, for he had put off submitting this painting of 1863. Surprisingly, the jury accepted it; unsurprisingly, the public and critics denounced it. A storm of disgust and abuse, far more intense than the row made over the *Déjeuner*, now broke out over Manet.

'Olympia' was a current term for a courtesan, and Manet's version is displaying her wares for the benefit of a lover. She is evidently one of the high-class 'horizontals' who enjoyed star status in Second Empire France, able to employ a maid and needing to be wooed with bouquets and presents before she was prepared to

grant her favours. Details such as her neck-ribbon and slippers, and her confident pose and hard gaze, identified her as a distinctively modern type. She was, in fact, Manet's favourite model, the red-haired Victorine Meurent, who had posed for the *Déjeuner* and appeared in a number of his other paintings.

As in the *Déjeuner*, Manet related his work to the past, in this instance the *Venus of Urbino* which he had copied in Florence. Despite the title of the Titian, Manet and his contemporaries assumed (possibly rightly) that the 'Venus' was actually a courtesan, so that the two pictures were directly comparable. The main contrast – between the smiling, accommodating Venus and a cool, self-possessed Olympia – is reinforced by other details, notably the replacement of Venus' lapdog by a fierce, black, high-tailed cat.

Of course *Olympia* can be appreciated without the spectator knowing the references to Titian's *Venus*. On the other hand, the critics should have noticed them, but were presumably too blinded by indignation to register anything but the ugliness of the 'female gorilla' with her 'yellow belly' and 'dirty flesh'. Olympia's ugliness was endlessly rehearsed, whereas moral objections were generally absent or muted (the lady's trade remained unmentioned). Visitors to the Salon were equally hostile and *Olympia* had to be moved higher up the wall to keep it out of reach of vandals. The reputed ugliness of Olympia remained a byword, and even in 1890, when the canvas passed to the state, a cartoonist happily showed a blowsy, unkempt Olympia incongruously entering the halls of the Louvre crowded with noble classical nudes. Olympia's imaginary ugliness highlights just how blandly smooth, pink, hairless and unshadowed the ideal of nineteenth-century beauty was supposed to be, and how far removed the artist was supposed to stay from everyday experience.

Up to this point, reactions to Manet's subject-matter had been so violent that little attention had been paid to his unconventional painting style, with its passages of cursory brushwork, strong contrasts and preference for powerful surface forms at the expense of conventional perspective. Nevertheless, these may have played a part when the 1866 Salon rejected both of his submissions, including *The Fifer* (page 17), a painting whose charm now seems self-evident. The jury may well have been influenced by the *Olympia* scandal of the previous year, but subsequent criticism castigated the painting's crude, unfinished character – or, to put the same facts another way, its masterful simplifications, which eliminate all but a few internal details, and the neutral background

which focuses the attention on the bright, brilliant figure of the little fifer. The picture owes a great deal to the bold outlines and strong, unmodified colours of Japanese prints, which introduced nineteenth-century Europeans to an original art founded on principles very different from those of the academies.

'Manet's Gang'

From the time of the *Olympia* scandal Manet was widely regarded as the chief of the rebellious moderns, admired by discerning literary men and some outstanding talents among the younger painters. At some point in the later 1860s they began to gather round him, joining him in the evenings at his regular table at the Café Guerbois, close to his home in the Batignolles Quarter. The 'Batignolles painters' were not an organized group and did not work in a common style, but they were united by common sympathies and aversions. They were, in fact, the artists later labelled the

BLEOW:
Olympia 1863
Edouard Manet
MUSÉE D'ORSAY,
PARIS

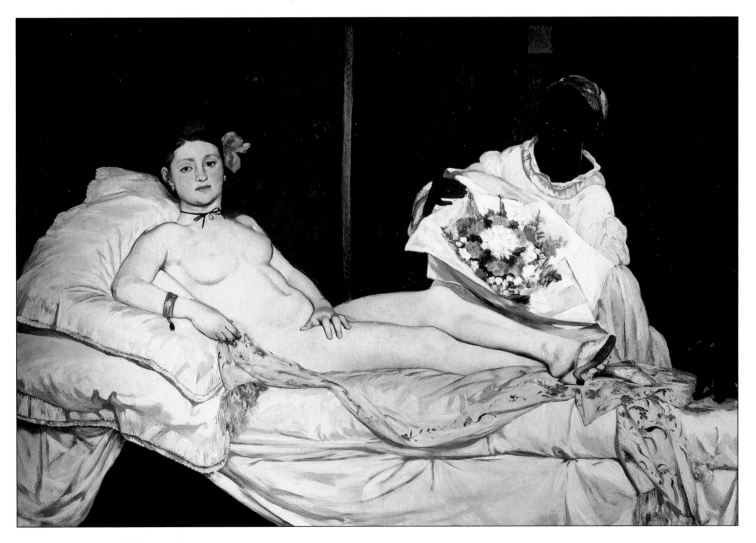

Impressionists: Manet himself, Degas, Monet, Renoir, Pissarro, Sisley, Bazille and Cézanne. To the critics and the public, Manet's friends were all disciples, members of *la bande à Manet*, 'Manet's gang'. The element of truth in this is confirmed by the painting *A Studio in the Batignolles Quarter* (1870; right), by Manet's friend Henri Fantin-Latour (1836–1904), a gifted if relatively conventional flower painter and portraitist. It shows Manet seated, painting the writer Zacharie Astruc, watched by a group of admirers including Monet, Renoir and Bazille. Only seven years earlier, Manet had been one of the admirers in a similar painting, *Homage to Delacroix*; by analogy, the Batignolles painting has often been called *Homage to Manet*.

In spite of these contacts, Manet himself never adopted the pose of a rebel. The nearest he ever came to a statement of principle occurred during the International Exhibition of 1867, held in Paris. Such exhibitions, frequent in the nineteenth century, extolled industrial and cultural progress, including achievements in painting and sculpture. Manet felt unable to accept the conditions imposed by the organizers of the French show and set up his own pavilion outside the exhibition, with 56 of his own works on view. In the catalogue he fastidiously denied any intention to protest or overthrow tradition. He merely sought to be himself and not to be prevented by the Salon from allowing his work to be judged by the public. In an amusing anticipation of the later label, he defended the artist's right 'to express his own impressions'. Manet's faith in the public proved to be misplaced on this occasion: his one-man show was a miserable failure.

In the same year, one of Napoleon III's less happy ventures came to a calamitous end. Anxious to extend French influence in Mexico, he had installed an Austrian archduke, Maximilian, as its emperor. Later, political considerations led Napoleon to withdraw his troops from Mexico, leaving Maximilian to his fate: the emperor was captured by Mexican republicans and, with two of his generals, executed by firing squad in June 1867. The episode, widely reported in France, was viewed as a national disgrace. Manet was fascinated by it and painted it three times over the following two years, as well as making it the subject of a lithograph. The authorities intimated that Manet would be wasting his time in submitting one of the paintings to the Salon, and publication of the lithograph – a print that could be replicated and reach thousands of people – was banned outright. Manet's political motivation was unmistakable and seemed to become stronger (perhaps in reaction to the

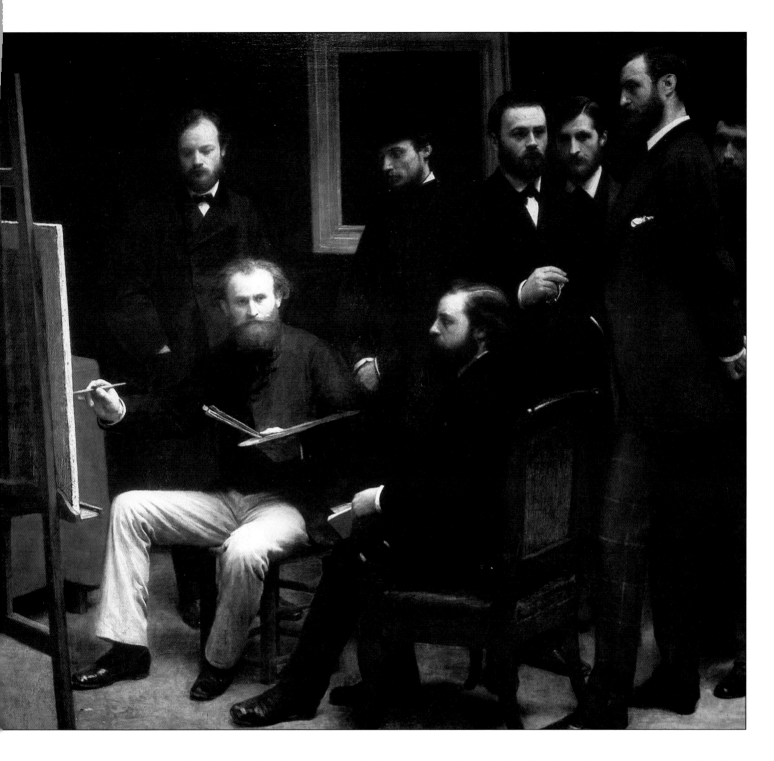

authorities' attitude) as he worked on the project. In the final version of *The Execution of the Emperor Maximilian* (page36-7) the firing squad wear French uniforms and Maximilian's straw hat serves as a kind of martyr's halo. Manet was certainly a republican, out of sympathy with the Napoleonic regime; but on the other hand he was not politically active (let alone a political activist) and it is possible to interpret the *Execution* as a 'modern-life' equivalent to the academic history painting, showing up the established genre by its relevance and immediacy.

In 1868 Manet showed two paintings at the Salon, his

ABOVE: **A Studio in the Batignolles Quarter** 1870 Henri Fantin-Latour MUSÉE D'ORSAY, PARIS

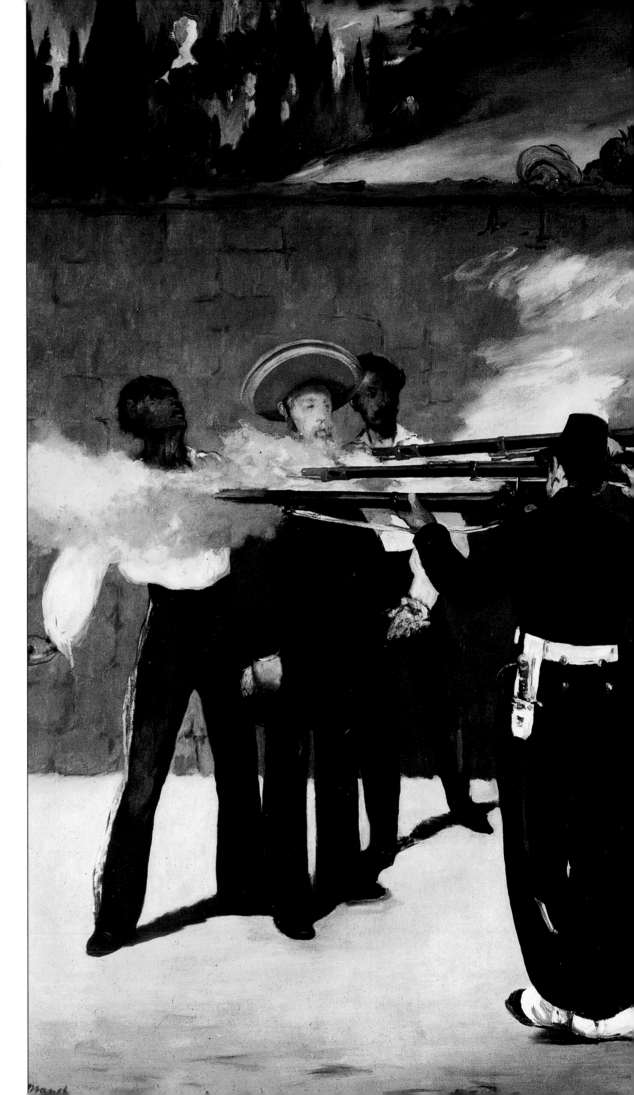

Portrait of Emile Zola (right) and *Young Woman with a Parrot.* The portrait of Zola was a flattering tribute to a staunch ally who in 1866, as the art critic of the radical paper *L'Evénement,* had praised Manet and other innovators in a series of provocative reviews. In 1867 Zola had returned to the attack in the pages of *L'Artiste,* and he and Manet had arranged to reprint the work and sell it as a pamphlet at Manet's one-man show during the International Exhibition. It was, in fact, the first extended critique of Manet's art. Zola was not yet the author of the great Rougon-Macquart cycle of novels, but Manet's painting invests him with all the dignity and glamour of the man of letters. However, the portrait is also an advertisement for Manet, since the pictures on the wall of the writer's study reflect Manet's tastes rather than Zola's: a Japanese screen and a Japanese print, a print by Goya representing the 'Spanish' element in Manet's work, and above all the scandalous *Olympia.* Behind the writer's quill pen, propped up on his desk, we can see Zola's pamphlet on Manet.

At about this time Manet was introduced to a young woman painter named Berthe Morisot. She and Manet were of the same social class and the Manet and Morisot families saw a good deal of each other. Manet obviously found Berthe a good model, since he painted her 11 times. She appears in *The Balcony* (page117), which was accepted for the 1869 Salon along with *Lunch in the Studio.* Both works have a curiously stagy look; *The Balcony,* in which Morisot is seated, holding a fan, is a modern-dress version of a Spanish scene by Goya. In a letter, Morisot described with affectionate amusement the roller-coaster of Manet's emotions before the opening, which made him feel at one moment that *The Balcony* was not good enough and at another that it was bound to be a great success!

The year 1870 began in unusually violent fashion for Manet, when the writer Edmond Duranty published wounding criticisms that led the two men to fight a duel. Duranty was slightly wounded, honour was satisfied and he and Manet repaired their friendship. When the Salon came round in April, Manet had paintings accepted for the third year running and must have felt that his star was rising.

Then, in July, violence erupted again, but on an international scale. France declared war on Prussia, but was thoroughly beaten. By September the Prussians were besieging Paris. Manet had sent his family to safety, but remained behind and joined the National Guard. His activities during the siege are known through his

RIGHT: **Portrait of Emile Zola**
1868
Edouard Manet
MUSÉE D'ORSAY, PARIS

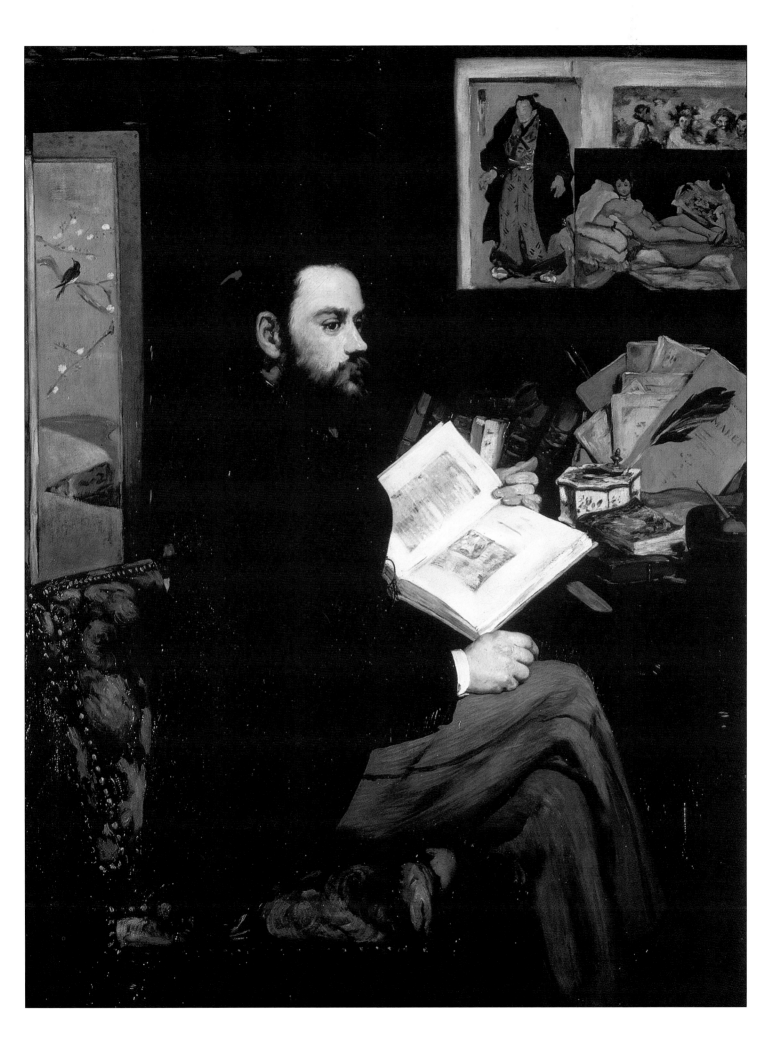

letters to Suzanne, carried out of Paris by balloon. They probably minimize the dangers of his situation, but give a vivid picture of a capital being starved out by a determined enemy. In January 1871, when Paris capitulated, Manet and his two brothers were thin but still alive. Manet joined his family at Oléron in the south-west and waited for the return of normality.

DEGAS
1834 – 1917

Brilliantly gifted, utterly dedicated and almost intolerably cantankerous, Edgar Degas detested the label 'Impressionist' and was in some important respects the odd man out among his fellow artists. Yet, surprisingly, it was not the genial Manet but the aloof, acid-tongued Degas who would play a leading role in the Impressionist revolt against the Salon.

Like Manet, Degas was born into the affluent, cultivated upper-middle class, but his background was more cosmopolitan. His grandfather had made his fortune in Italy and married an Italian girl, while the family of Degas' mother, the Mussons, had strong American connections; dutiful in the matter of family ties, Degas came to know both Italy and the United States. His father had founded the Banque de Naples, and on 19 July, 1834 Degas himself was born on the premises. His upbringing was conventional, and in due course he was schooled in the classics at the prestigious Lycée Louis le Grand in Paris. Subsequently he began to study law, but he soon announced his wish to be an artist and parental opposition – if any – was short-lived. One of the rooms in the Degas family home was turned into a studio for his use and at 18 he began to work under a minor master, Félix Joseph Barrias. Later he enrolled at France's premier teaching academy, the Ecole des Beaux-Arts, studying under Louis Lamothe.

Degas the Draughtsman

Lamothe had been a pupil of Jean-Auguste-Dominique Ingres (1780–1867), the great standard-bearer of the classical-academic tradition. Although that tradition had become sterile, Ingres himself was a great artist and Degas became his devoted admirer. In later years he loved to recall their one meeting in 1855, when Ingres told him 'Draw lines, young man, many lines, from memory

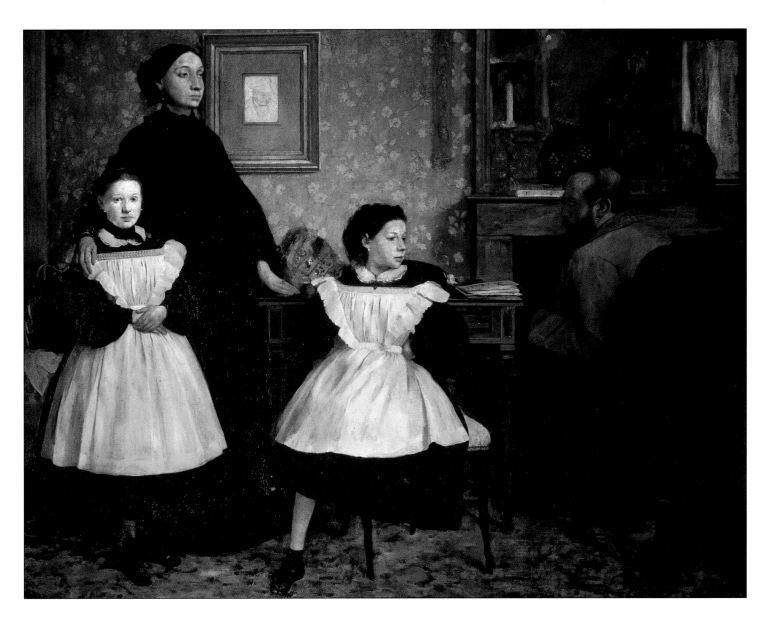

or from nature; it is in this way that you will become a good artist'. The advice sounds banal enough, but it confirmed Degas in his preference for draughtsmanship as the basis for painting. The quarrel between the 'drawing' masters and those who preferred a more 'painterly' technique (modelling forms with their colours) went back at least as far as the seventeenth century. Most of the Impressionists adopted the 'painterly' approach, and the difference in the results can be seen by comparing, for example, Degas' *On the Beach* (page 187) with Monet's *Beach at Trouville* or *Hôtel des Roches Noires* (page 73).

Degas soon lost his respect for the Ecole des Beaux-Arts and spent most of his time in private study, copying at the Louvre or travelling in Italy. Characteristically, he became bored with the Italian landscape, but he never tired of looking at Renaissance art

ABOVE: **The Bellelli Family** 1858-61 Edgar Degas MUSÉE D'ORSAY, PARIS

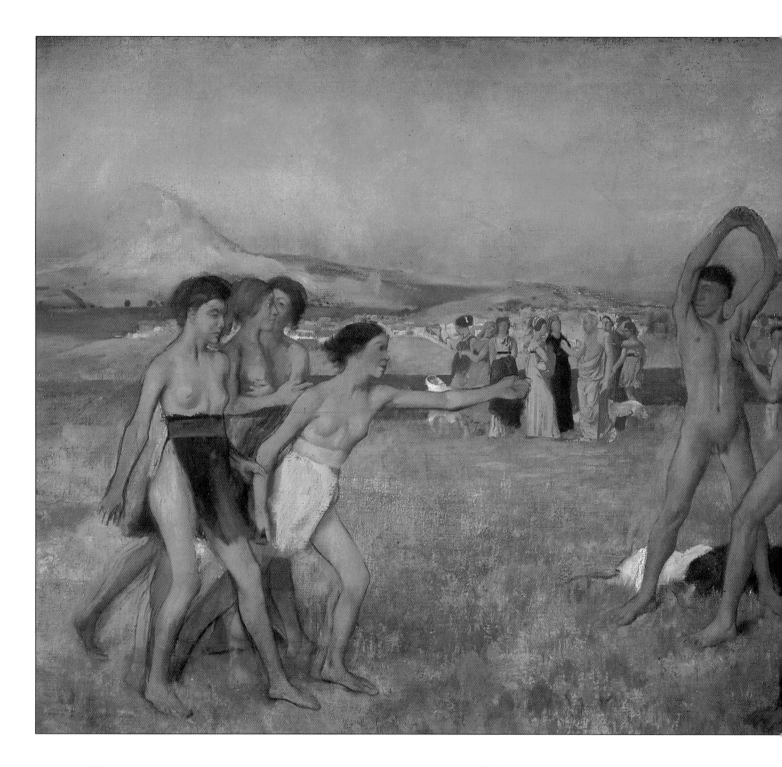

ABOVE: **The Young Spartans** *c.*1860 Edgar Degas NATIONAL GALLERY, LONDON

or observing the movements and gestures of the people in the streets. Visits to Italy gave him some of his earliest subjects and also his first major work, *The Bellelli Family* (page 41). The Baroness Bellelli was Degas' Aunt Laura, and in 1858–59 he spent nine months with the family in Florence. Returning with a portfolio of sketches and studies to his new Paris studio in the Rue Madame, Degas created a single, complex composition that was strikingly original. Instead of the neutral background of academic portraiture, the family are shown in one of their own rooms and if the baroness and one of her daughters are solemnly posed, the other girl sits in

the foreground with one leg tucked under her, while the baron appears to have turned obligingly in his seat, just far enough to present his profile. Such apparently casual touches became hallmarks of Degas' art, as did the lack of a single focus for the viewer's attention.

Degas kept *The Bellelli Family* by him throughout his life, making no attempt to sell or exhibit it. However, although the distinctive nature of his gifts was becoming apparent, his public ambitions were remarkably conventional during the early 1860s. *Semiramis Building a City, The Young Spartans* (left) and *Scenes of War in the Middle Ages* were conscious efforts to win recognition at the Salon by putting forward the kind of 'serious' historical subject that Degas' contemporaries admired so much. When *Scenes of War* was shown at the 1865 Salon – the occasion on which *Olympia* created such a scandal – no one could have imagined that Degas would soon be classed with Manet as a 'painter of modern life'. *Scenes of War* owes less to Ingres' classicism than to the Romantic tradition of sex-and-violence associated with Ingres' great rival, Eugène Delacroix (1798–1863). The naked dying women, with heads bent forward to allow their hair to fall over their faces, are such Delacroix trademarks that it is surprising to find Degas shamelessly employing them at this late date. As in so much nineteenth-century academic art, the eroticism of the painting is, to modern eyes, perfectly obvious. This, too, represents Degas courting popularity, since it virtually disappears in his mature work. There is a certain irony in the fact that Degas would later make a point of his unshakeable independence and scoff at artists such as Manet, who craved the approval of the Salon and the artistic establishment!

The Young Spartans has greater artistic interest, possibly because Degas reworked it at some point after its creation (*c.*1860). The Spartans were known in antiquity for their austere, military way of life, one peculiarity of which was that boys and girls were brought up together and were trained to acquire a comparable hardness and ability to withstand pain. So in tackling this subject Degas was adopting a typical academic approach, entailing scholarly research to re-create an historical episode. In this one, the girls are evidently challenging the boys to some kind of contest. X-rays of the painting show that it originally included a classical temple and that the faces of the young people were idealized, with 'classic' Grecian profiles. At some point Degas de-classicized the scene (except for the incongruous group in the background), making it

more like an exchange of taunts in the street between gangs of adolescents. The outlines that are visible here and there, especially among the girls' legs, represent earlier workings of the kind that sometimes show through as a painting ages; their technical name is pentimenti. Degas evidently had a fondness for *The Young Spartans*, which he intended to put on show as late as 1880 in the fifth Impressionist exhibition.

After 1865 Degas gave up history painting and concentrated on portraits and other 'modern' subjects. He had already begun to paint racecourse subjects and the professional musicians who regularly visited his father's house and performed there. Perhaps the scandal over *Olympia* was the final straw, making him feel that he must take sides in the battle between the academics and the moderns. His choice of modernity, once made, was never modified.

Degas and Manet

Degas' acquaintance with Manet, dating back to 1862, must also have influenced his outlook. In the years 1862–5 Manet emerged as the leader of the moderns, and the deference with which he was treated by the younger generation (although he was only in his thirties) certainly irritated Degas. The two men were friends after a fashion, but their relations were often uneasy. Degas particularly enjoyed sniping at Manet's thirst for official recognition, having presumably buried his history painting ambitions deep in his subconscious. When Manet congratulated a fellow artist who had been awarded the Legion of Honour, Degas exclaimed 'I've known for a long time what a bourgeois you are!' But when Degas claimed that Manet had copied him by taking the races at Longchamps as a subject, Manet hit back with cruel accuracy: 'I was painting modern life while you were painting Semiramis building a city!'

However, the worst insult was perpetrated by Manet. Degas painted a double portrait of the artist and his wife; Manet was on the sofa, listening while Suzanne played the piano. When Manet received the painting he was dissatisfied with the portrait of his wife and, in an astonishing act of vandalism, cut off a large section on the right-hand side so that Suzanne's face was no longer visible. When Degas found out, he marched off with the canvas. He may have intended to restore the missing section, but if so, he never got round to it and the painting survives in its mutilated condition,

with Manet lounging on a sofa behind a seated half-woman. Surprisingly, there was no duel and Manet and Degas remained on unfriendly-friendly terms, seeing each other frequently in the evenings at the Café Guerbois.

Degas may have benefited from the artistic discussion at the Guerbois, although he was often inclined to disrupt the proceedings by issuing provocative announcements, such as 'Art should be kept away from the working classes', which he defended with more irony than conviction. In any case, by about 1868, when the gatherings at the Guerbois were becoming lively, Degas had made most of the discoveries that formed his mature style.

The Subtle Technician

A masterpiece such as *At the Races, in Front of the Stands* (pages 46-7) is thoroughly characteristic. Degas avoids the drama associated with the actual race, picturing the scene at some point before the start. The moment seems to have been chosen at random, with the horses facing different directions and one jockey in real trouble as his mount bolts. Another artist might have taken this as the subject of his painting, but Degas places the endangered rider and mount in the distance, making the action incidental. In fact, the entire scene is meticulously organized to look as casual and natural as possible. As in *The Bellelli Family*, there is no central figure, patently more important than the rest, on which the eyes are compelled to focus, although the double line of horses and jockeys does form a kind of tunnel leading the viewer into the picture. The most striking technique is the cropping which cuts off the head of one of the horses. Degas used this device again and again to achieve an effect of apparent spontaneity. Among other things, it gives us the illusion that the scene extends beyond the edge of the picture, which just happens to have cut it off at a particular place. The scene might be a hastily taken photograph which has not been accurately framed, so that the horse's head has been 'lost'; indeed the new art of photography may have been one of Degas' inspirations. In his case, of course, the effect was carefully calculated and the composition is such that the inclusion of the cropped material would spoil it.

Achieving such effects was a laborious business, involving the use of many sketches and studies. It could never have been done by painting directly onto the canvas in front of the subject, a technique often believed to be the quintessence of Impressionism,

OVERLEAF PAGES 46-7: **At the Races, in Front of the Stands** 1868 Edgar Degas MUSÉE D'ORSAY, PARIS

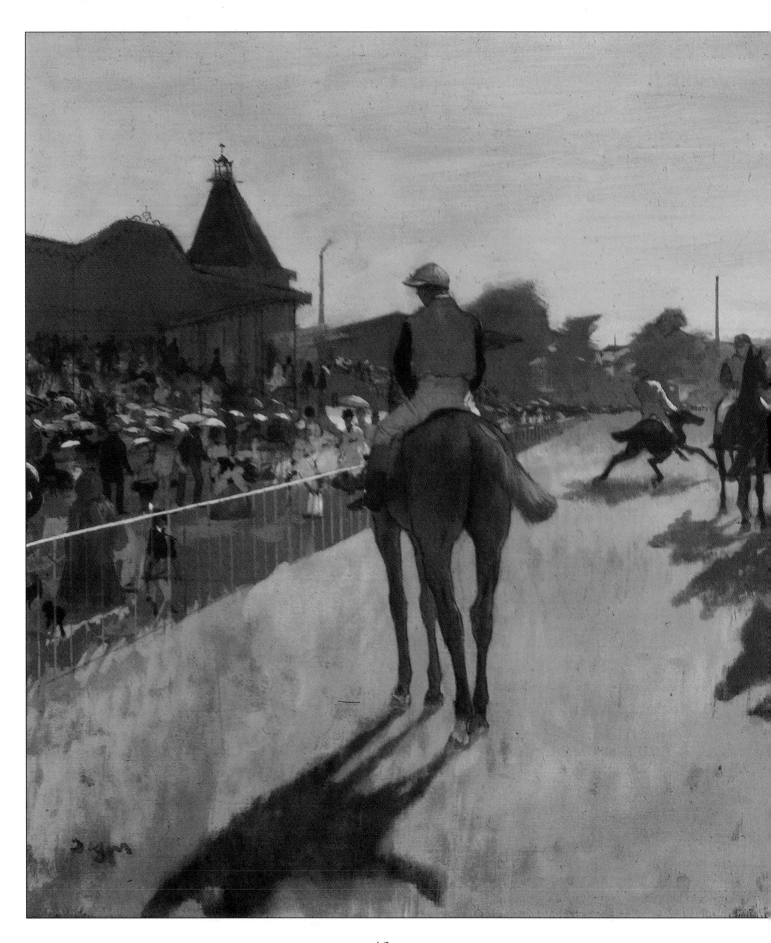

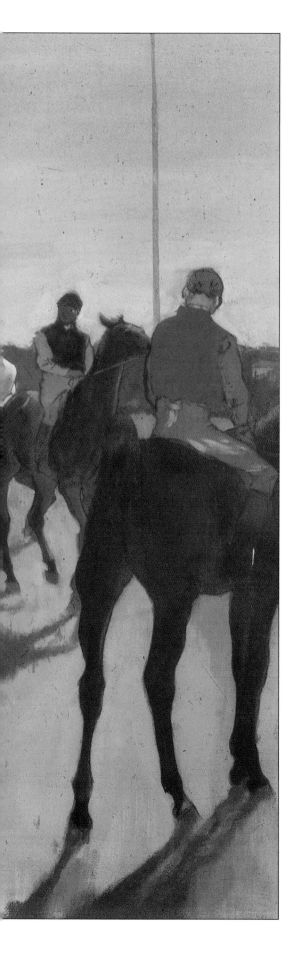

but one that Degas never practised and claimed to despise. He never tired of emphasizing that his work was completely premeditated: 'No art is less spontaneous than mine.'

Degas' friendship with musicians and his interest in the theatre came together in *The Musicians of the Orchestra* (page 49). The orchestra pit had never before been considered an appropriate subject for an artist, despite the opportunities for elegant patterning offered by the juxtaposition of instruments and spear-like bows. Degas' treatment was audacious, using the dancers' colourful skirts, harshly stage-lit, to create a bright band across the top of the picture; but the cropping that removes the girls' heads prevents them from competing for attention with the instrumentalists. The two areas are linked by the scrolled neck of the double bass; this quizzical, or perhaps phallic, intruder reappears, rearing up even more irresistibly, in the gamier atmosphere of the later *Café-Concert at Les Ambassadeurs* (page 189).

For all its artistic virtuosity, *The Musicians of the Orchestra* is also a group portrait, showing some of the friends who came to the Degas family's musical evenings. It was painted for the bassoonist Désiré Dihau, who looms large in the foreground. The flautist Altès is sitting right next to him; behind Dihau is the bespectacled cellist Pillet, while at the far right the double-bassist Gouffe looks out into the space beyond the edge of the picture. However, the group is far from being a transcript of reality, since Degas altered the seating plan of the orchestra for the sake of the composition and included the faces of a number of friends who were not among its members.

Despite this in-joke element, the painting is typical of Degas' work in one important respect: the people in it are not posed for the benefit of the viewer (or even looking out at him/her), but are preoccupied with their work. This unselfconscious quality links almost all the small group of subjects to which Degas returned again and again – jockeys and horses, musicians, dancers, laundresses, milliners and their customers, women washing themselves, and even financiers manipulating the Stock Exchange. Generally speaking, Degas is interested in people as professionals and shows them in characteristic poses, getting on with their jobs rather than behaving as individuals or relating to others. He was a wonderfully exact observer of the trained human performer, studying, for example, laundresses, and the art of wielding a hot iron, with the kind of scrupulous attention that an academic painter might devote to the furnishings of a house in ancient Pompeii. Degas

recorded the moments of boredom and fatigue experienced by his performers, but he was not much interested in their non-professional emotions. Indeed, emotion is generally absent from his work or so restrained that it can scarcely be pinned down. Such restraint is the hallmark of the classical tradition in art (the genuine classical tradition, not its academic imitator) to which Degas, for all the modernity of his subjects and his innovatory techniques, undoubtedly belonged.

In true classical fashion Degas neither represents intense emotions nor attempts to convey emotions of his own. He is the seemingly detached observer, registering the world about him and re-ordering it into art. Naturally, the source of this lay in his own temperament, which led him to keep a certain distance between himself and others. Even his self-portraits have a guarded look, suggesting that its subject was a young man determined not to give too much away; and it is probably significant that after the age of 30 he painted no more of them. His love affairs and sexual adventures were either concealed with superhuman skill or were non-existent, so that the romantic-minded have been forced to speculate wildly on the basis of an enigmatic scribbled memorandum or social and professional relationships which were, so far as the evidence goes, entirely proper. A radical alternative view, based on an interpretation of Degas' art as voyeurism, is that he was impotent. But when this kind of suggestion starts to be made, again from only the most general and arguable type of evidence, we know we are in a region where there is really nothing worth saying. The only thing that is clear is that Degas was a bachelor of a recognizable nineteenth-century type, formidable in his dealings with strangers and acquaintances, most at ease among old friends and capable of enjoying a pseudo-domesticity on visits to the homes and families of his married contemporaries. Degas himself described his life-situation in distinctly non-Freudian terms which tell at least part of the truth: 'There is love, and there is work; and we have only one heart.'

His art was certainly the centre of Degas' life, although, like Manet, he maintained the air of effortlessness that was held to characterize the gentleman. He would have been pleased by the comment made by his brother in a letter to an American relative: 'Edgar does an enormous amount of work without seeming to.' Aside from his activities as an artist, there were few obviously important events in his life until history intervened in the form of the Franco-Prussian war. Degas joined the National Guard and was

RIGHT:
**The Musicians
of the Orchestra**
1868-9
Edgar Degas
MUSÉE D'ORSAY,
PARIS

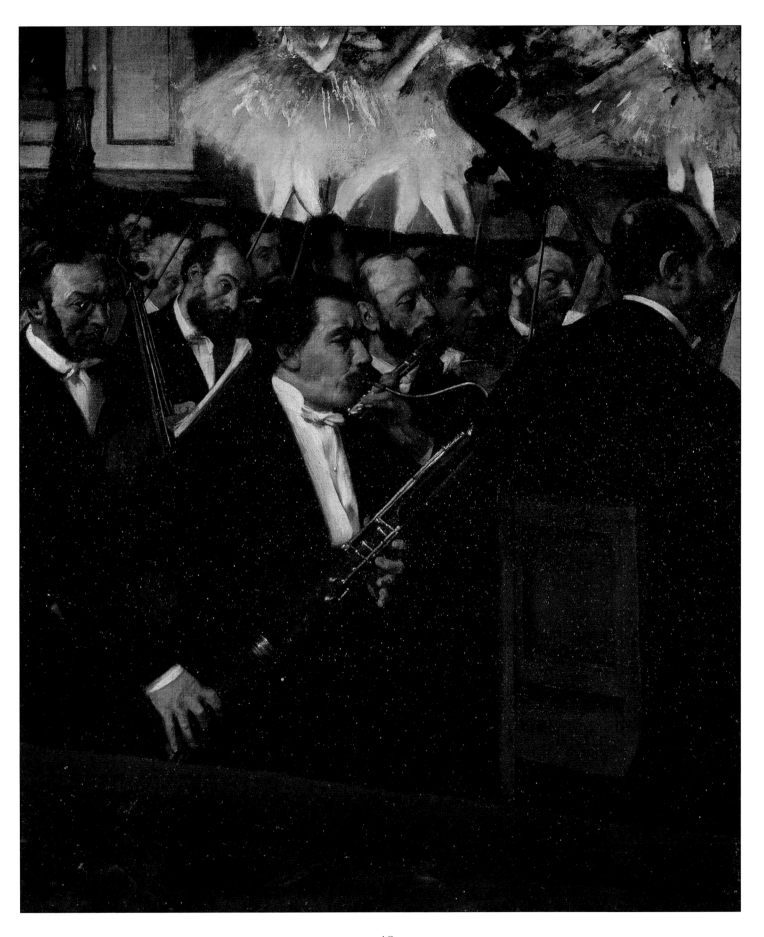

posted to the artillery section, where he met an old school friend, Henri Rouart, who was to become one of the social mainstays of his later life. If Degas saw action of any intensity during the siege of Paris, he was too much the gentleman-stoic to advertise the fact. What did become clear during this episode was that Degas' sight was severely defective. The trouble may have been caused or activated by exposure during a spell of duty; and the progressive deterioration of his sight was a fearful affliction that Degas had to live with for the rest of his life, until the worst happened and he was no longer able to work.

The Ballet

When the war and the Commune (which found Degas on holiday in Normandy) were over, life returned to normal. Gradually expanding his repertoire, Degas made his first studies of the ballet in 1872. The loveliest of his early efforts was the modest-sized *Dance Foyer at the Opéra* (right). The wonderful quality of the light and the sober grandeur of the interior give the occasion an air of noble, classical calm. We are looking at the practice rooms of the Paris Opéra, in the Rue Le Peletier. As usual, the scene looks like a randomly frozen moment in the flow of time, with dancers scattered through the rooms while one of their number takes up her position, ready to obey the master's commands, and a seated fiddler waits to strike up an accompaniment. However – as usual again – everything has been planned down to the last detail. To mention just a few of Degas' compositional devices: the vertical of the music stand rises to form a right-angled corner with the red line of the practice bar; the dancers seen through the archway make a neatly symmetrical pair; and the skirt and leg glimpsed through the left-hand doorway run in parallel with the back-thrust leg of the principal dancer. Here, meticulous design and poetic feeling are inseparable.

Most painters, having created a masterpiece such as *The Dance Foyer*, would have spent months or years mining this rich new vein of balletic poetry. Instead, Degas moved on almost at once, tackling the same subject in a very different spirit. For although his ballet pictures are so immensely popular that they are regularly reproduced on chocolate boxes and fancy stationery, in many instances their glamour hardly stands up to scrutiny. The lighting is intense and the dresses are pretty, but a carefully chosen viewpoint reveals the flat stage scenery, destroying the theatrical

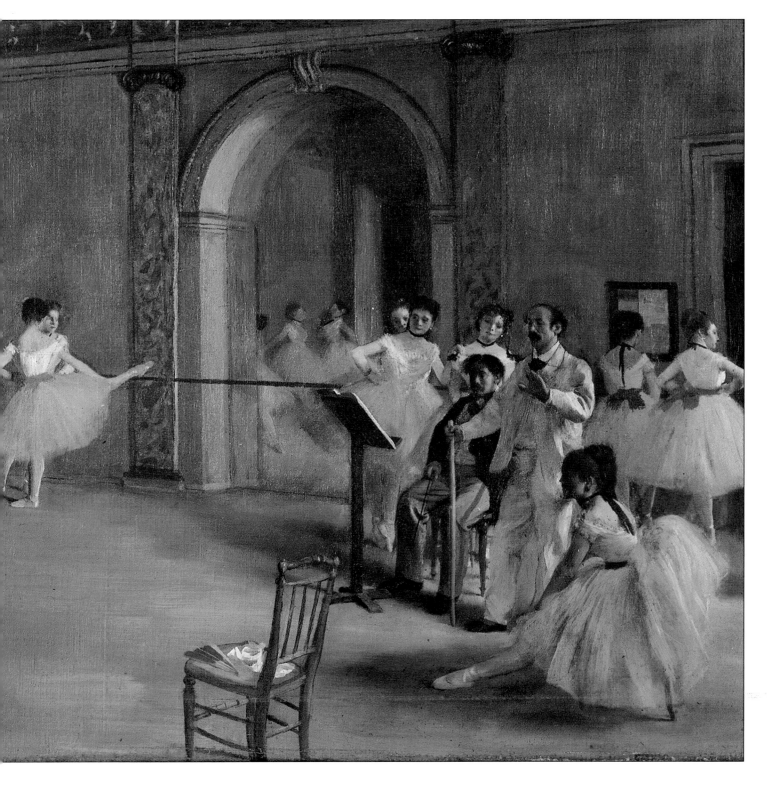

illusion, or there are glimpses of the dancers scratching themselves or trying to give their aching feet a moment's relief. As a man Degas loved the theatre, but as an artist he was more concerned with its human machinery than with its aesthetic power to create illusory worlds.

In the early 1870s he actually preferred to paint classes or rehearsals, where the dancers were obviously working, not dazzling the spectator with a finished performance. These are among Degas'

ABOVE: **Dance Foyer at the Opéra** 1872 Edgar Degas MUSÉE D'ORSAY, PARIS

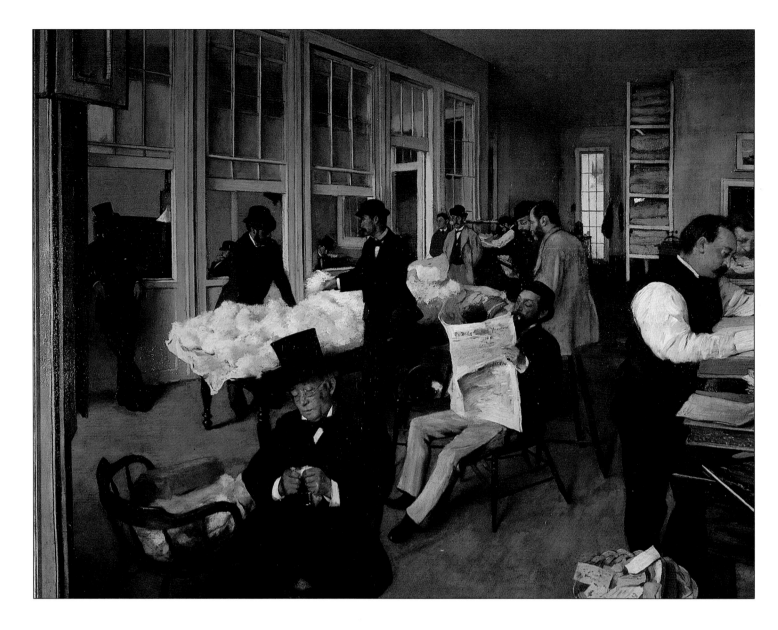

most effective ballet pictures (pages 51 and 54-5). The most unusual is *The Rehearsal on Stage* (pages 54-5), which verges on caricature and might easily be interpreted as a sardonic comment on the pearly vision of *The Dance Foyer*. The theatrical lighting makes the setting resemble the infernal regions, with the dance master as a frantic Mephistophleles. The two principal performers are graceful and charming – Degas made them the subject of a separate painting – but they are surrounded by banalities. The scratching, stretching girls in the wings and the men on the far side, probably managers or backers, have seen it all before and can hardly wait for it to be over. Once again the double bass rises up from the unseen orchestra pit, this time punctuating the proceedings like a back-to-front question mark. Degas evidently relished his own invention, for he made three versions of this picture, preserving the composition but varying some of the details. It is the details that tend to hold the attention, but when we pull back

and take in the entire scene, we realize that Degas has somehow managed to combine many busy parts into a brilliantly effective asymmetrical design.

New Orleans

Between *The Dance Foyer* and *The Rehearsal on Stage* Degas had experienced American life, although it cannot be said to have had any discernible influence on his art. In October 1872 he left Paris to visit his brothers, who had settled in New Orleans among their Musson relatives. Degas' letters to friends in France enthuse about the tropical environment and the fascinating spectacle of Louisiana's multi-racial society. (Characteristically, he was interested in its striking pictorial quality rather than the state of white-black relations in the aftermath of the recent Civil War.) But he was emphatic in believing that this kind of picturesque local colour had no value for him as an artist. There was an element of conservatism in this ('one Parisian laundress with bare arms is worth them all to an old man-about-Paris like me'), but underlying it was the profounder point that Degas' method involved a long, concentrated study of anything he chose to paint, returning to it again and again, creating variations and refinements and constantly making new experiments and discoveries. In this way he was able to work for a lifetime on a handful of subjects without exhausting their possibilities.

Consequently, most of the works painted by Degas in New Orleans were family portraits. He was particularly fascinated by his brother René's wife, Estelle, who was blind. Degas, doubtless aware that he might suffer a similar fate, admired the stoicism with which she bore her affliction. His most ambitious painting in New Orleans was the well-known *Cotton Market* (left), which is, among other things, one of his most original variations on the traditional group portrait. Michel Musson, René Degas' father-in-law, is seated in the foreground, pulling on a hank of cotton to test its strength. By contrast with the activity around them, Degas' brothers are pictures of idleness: René is reading New Orleans' *Times Picayune* newspaper, while Achille lounges nonchalantly against the open window of a partition. Cotton is given pride of place in the middle of the scene – appropriately so, as it was the staple of the entire Southern economy, but also for the prosaic pictorial reason that it balances and contrasts with the black suits and hats of the businessmen. Their scattered figures are held together by

**The Rehearsal
on Stage** 1873-4
Edgar Degas
METROPOLITAN
MUSEUM OF ART,
NEW YORK

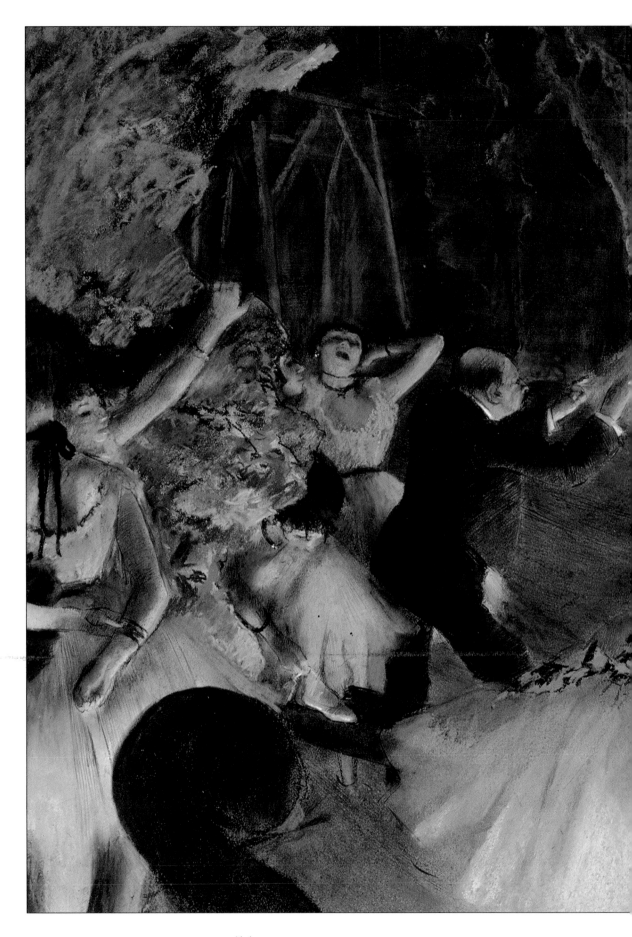

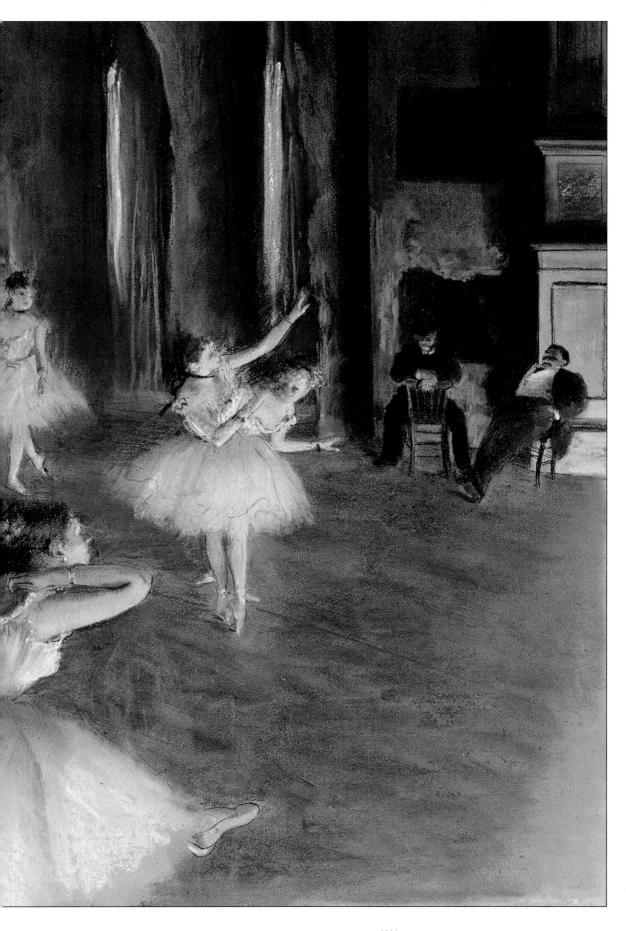

the large grid of the partition and a series of horizontals down the right-hand side, including the big ledgers and even the shirtsleeved arm of the clerk who is consulting them. Almost photographic in its clarity, the picture could easily be taken as a simple record of a place and persons, and as such it is an outstanding example of Degas' 'art that conceals art'. Surprisingly, he was prepared to sell this family picture, writing to his painter friend Tissot that he hoped to find a buyer in Manchester, the centre of Britain's cotton manufacturing industry. However, it is possible that Degas was trying to sound shrewder and more commercially minded than he actually was, playing up to Tissot's own flair for business. In the event, *The Cotton Market* became the first of Degas' works to be purchased by a French public museum (the municipal museum at Pau, 1878).

After 1870 Degas submitted no more works to the Salon, perhaps incensed by the negative response by the authorities to a letter he had written that year. He had complained about the hanging of works at the exhibition, arguing that there should be no more than two rows of pictures on any wall; in other words, he was proposing the kind of hanging policy that is now the norm. He also urged that paintings and drawings by the same artist should be grouped together. If the authorities were unimpressed, the main reason was probably inertia, but Degas' ideas did also have a subversive side to them. Hanging pictures in no more than two rows would invite spectators to give equal attention to each work on display, possibly undermining the size-based dominance of the big history painting on a crowded wall; and the jury would no longer be able to guide public taste by exiling 'lesser' efforts to the 'sky' or far, dark corners. Hanging paintings and drawings together also had unacceptable implications, putting a supposedly minor art, associated with preparatory work, on a level with works in the Grand Style, finished, after years of toil, down to the last invisible brushstroke.

Whether Degas was conscious of such implications is, of course, another matter. He would almost certainly have argued his point in more narrowly aesthetic terms, but his behaviour during the 1870s and 1880s suggests that he was taking a new and 'uncharacteristic' direction. His attitude of scornful independence towards the bourgeoisie (to which he belonged) makes it no surprise that he should have become disgusted with the false values of the Salon. It is also understandable that, when the idea resurfaced in 1873, he should have welcomed the prospect of

showing with an independent group of artists at an exhibition that owed nothing to sponsors, academies or jurors. What is less easy to explain is the way in which the aloof Degas threw himself into the project, taking part in the organizational chores, recruiting members from among his friends and generally behaving as though he was a committed member of the movement. Although he detested the term 'Impressionist' and would later quarrel with most of his colleagues, Degas had gone over to the opposition.

MONET

1840 – 1926

Monet has generally been regarded as the greatest landscape painter among the Impressionists. He was devoted to working in the open air, and he and Auguste Renoir were probably responsible for perfecting the distinctive Impressionist landscape technique, using blobs of pure colour, rapidly applied, to capture the fleeting atmosphere of a specific place and time of day; eventually Monet took this to its logical conclusion, devising series of paintings in which the same subject is seen at different times and in different light conditions. He was also the most ardent traveller among the landscapists, seeking out motifs as various as Riviera beaches, Norwegian mountains and the fogbound monuments of London's Thames Embankment. Finally, in old age, he painted his water garden as a personal paradise in which reality dissolved into wonderful harmonies of colour and light.

Oscar-Claude Monet was born on 14 November, 1840, in Paris, but he was brought up in Le Havre, where his father, Adolphe Monet, prospered as a partner in a wholesale grocer's and ship's chandler's. Le Havre was a commercial-maritime city at the mouth of the Seine, and the influence of its cliff walks and the open sea made a lasting impression on Monet, who would return time after time to paint at this and other exhilarating locations along the Normandy coast.

Most of our information about Monet's youth comes from his own recollections in old age, when there were no survivors left to contradict him, so his picture of himself as a lone, independent spirit and untutored genius should be taken with a pinch of salt. But whether or not he was the nature-loving truant of legend, his school career was certainly undistinguished, and by about the

age of fifteen he had achieved a degree of local celebrity as a cartoonist and instant portraitist, picking up ten or twenty francs a time with comparative ease.

A Decisive Encounter

His work as a cartoonist led directly to one of the most important encounters in Monet's life. His drawings shared the window of a local art shop with paintings by another local man, Eugène Boudin (1824–98), who took his paints and easel out into the open and worked directly from nature . If Monet is to be believed, he shared the general distaste for Boudin's 'sketchy' efforts and actually avoided meeting him, but eventually they turned up in the shop at the same time and were introduced by the proprietor. Boudin persuaded Monet to accompany him on a painting trip and Monet soon became a convert to open-air working. Although he later liked to imply, untruthfully, that he never so

much as touched up a canvas in his studio, it remains true that Monet's art was always based more or less directly on his vivid, passionate responses to nature.

Monet's early contacts with Boudin cannot be dated with any certainty, but he appears to have painted his first open-air landscapes in 1858. One of them, *Landscape at Rouelles* (page 58), is so accomplished that it is difficult to believe that it was done by a teenager without any formal training in the technique of painting in oils. Although smooth and lacking the energizing atmosphere of Monet's mature landscapes, this is already a performance in brighter colours and a higher key than canvases by distinguished older contemporaries such as Corot (page 20).

Boudin's dedication to his art may also have influenced Monet, making him realize that painting could be not just a hobby or even a career, but a vocation. When he announced his intention to become a professional painter, there was surprisingly little family resistance. Monet's mother, who is believed to have encouraged

BELOW:
The Beach at Trouville 1867
Eugène Boudin
MUSÉE D'ORSAY, PARIS

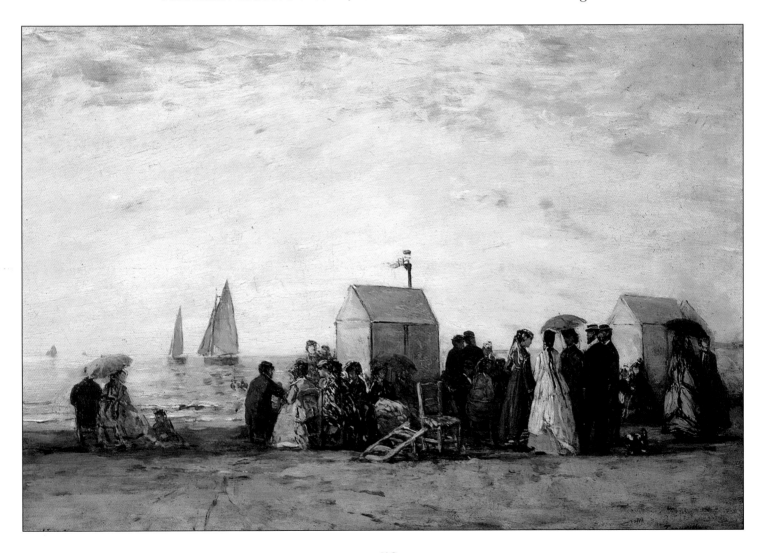

his interest in art, had died in January 1857, but although Adolphe Monet had no particular feeling for the arts, he accepted his son's declaration. Perhaps he was relieved that his unpromising offspring, who had done nothing of consequence since leaving school over two years earlier, had at last discovered an aim in life. Adolphe may also have been swayed by the advocacy of his sister Sophie (Monet's aunt and the widow of Adolphe's partner), who had already shown herself a generous friend to the young man.

Adolphe tried to persuade the Le Havre municipality to fund a course of study for Claude in Paris, but without success. Evidently this was not a crucial setback, for while he was still trying he allowed Claude to make his first trip to the capital. Monet arrived in May 1859, in time to visit the Salon and send Boudin a long letter filled with shrewd comments on the exhibits. Like many a young provincial, he was enchanted by the bohemian life of the capital, spending hours at the Brasserie des Martyrs, a beerhouse more rugged and radical than the cafés frequented by his later friend Manet. The Brasserie des Martyrs was populated by the admirers of Gustave Courbet, the rebel hero of the 1850s, whose paintings were to influence Monet for some years. When he had recovered from his initial excitement he settled down to work at the Académie Suisse, which Manet had frequented a few years earlier. As we have already seen, the Suisse was not a teaching institution but a 'free' studio where, for a modest fee, anyone could come in and work from the model provided. During his time at the Suisse, Monet became friendly with an older man, Camille Pissarro, who was destined to be one of his Impressionist comrades-in-arms; but this early contact was interrupted when Monet left Paris early in 1861.

His change of direction was caused by the fact that his number had come up in the lottery held to determine which young men in his age group would be called up for military service. Most middle-class parents were willing and able to buy a substitute who would serve instead of their sons, but for some reason Adolphe Monet did not do so. He may have felt that a spell in the army (but it was a long five-year spell) would cure Claude of the disreputable habits he had acquired in Paris. Alternatively, Monet himself may have been enticed by the prospect of wearing a scarlet uniform and living in hotter climes. He did both, serving with the cavalry in the French colony of Algeria, but his posting proved to be uneventful. In 1862 he suffered a bout of typhoid and was sent back home to convalesce. His aunt came to the rescue again, belatedly

buying him out for 3,000 francs, and no more was heard of Monet's military ambitions.

During his convalescence he painted in and around Le Havre with Boudin and a new friend, the talented but rather disreputable Dutch artist Johan Barthold Jongkind (1819–91), whose landscapes in some respects anticipated Impressionism. Adolphe and Aunt Sophie were upset by the company that Claude was keeping and insisted that he must stop wasting his time and study in earnest. Threatened with the loss of his allowance, he returned to Paris and enrolled in the studio of a leading academic artist, the Swiss-born painter Charles Gleyre.

The Rebel in the Studio

During Monet's first week in the studio, Gleyre is said to have watched him painting a male model and commented, 'Not bad at all! But it's too much like the model. The man you are looking at is short and broad, so you paint him as short and broad; he has big feet, so you show them as they are. That sort of thing's terribly ugly! Remember when drawing a figure to keep in mind the example of antiquity [Greek and Roman art]. Nature is all very well as an element of study, but it offers no interest. Style, you see, is everything.'

The story neatly encapsulates the difference between the academic and Impressionist attitudes: between the ideal and the real, the formulaic and the natural. In its conviction that 'style' was something that could be added to a work like a coat of varnish, Gleyre's teaching exemplified bad art through the ages. Whether he ever said anything of the sort is another matter. Such anecdotes have become part of the heroic myth of the Impressionist artists as men of genius, always in conflict with benighted authority. In practice, academic teachers such as Gleyre were often more easy-going (or negligent) than legend has made them. Gleyre seems to have been quite liberal-minded, and by the time Monet enrolled he was too preoccupied with his own failing health to trouble his pupils overmuch.

Although he sometimes liked to imply that he had walked out of Gleyre's after no more than a couple of weeks, Monet actually worked there until about the time, early in 1864, when Gleyre decided to shut it down and retire. Apart from anything else, Monet had made three wonderful friends of his own age in the studio: his future fellow-Impressionists Renoir and Sisley, and a tall

southerner, Frédéric Bazille, who did not live long enough for his undoubted gifts to reach maturity.

Monet established himself as the leader of this little group. He had certainly had a wider artistic experience than his friends and his forceful character - its force sometimes bordering on arrogance - gave him a natural authority. As an old man Renoir liked to reminisce about Monet's 'lordly' ways and glamorous presence: 'He didn't have a sou, but he wore shirts with lace cuffs'. As a matter of fact, Monet's partiality for lace cuffs and for high living in general were life-long traits that would keep him in financial difficulties for years to come.

During his vacations in 1863 and 1864 Monet returned to Normandy, painting the rural landscape. On the second occasion he was accompanied by Bazille, who was his closest friend for most of the 1860s. In 1863 the two men also made their first trip to the Forest of Fontainebleau, an area already very popular with young artists because it was close to Paris and celebrated for its association with Camille Corot and the Barbizon school of painters; Barbizon was a village in the forest, and Corot and the others were still to be seen working in the vicinity. Monet and Bazille stayed in the village of Chailly, and Monet found it sufficiently to his taste to come again in 1864 and 1865. Later on, he and the other Impressionists would turn away from the romantic lushness of such a spot, but at this time it was able to inspire a fine landscape in Barbizon style, *The Road to Chailly*; and by 1865 Monet was planning to use a forest glade as the background for his first really ambitious canvas.

Meanwhile, he had experienced a welcome public success when he submitted two fine views of the sea and the Norman coast to the 1865 Salon. Both were accepted, shown and praised as extremely promising by the critics, and *The Mouth of the Seine at Honfleur* (1865) became the basis of an engraving made for sale to the public.

Great Ambitions

Impatient to enjoy an even greater triumph, Monet returned to Chailly before the Salon closed. His new project was to be a *Déjeuner sur l'Herbe* (right) showing people in contemporary dress at a picnic in the forest. Although his most powerful impulse as an artist was to work from nature, at this stage in his career Monet's ambition drove him to attempt large-scale figure

RIGHT:
Déjeuner sur l'Herbe 1856-7 (central section) Claude Monet © DACS 1996 MUSÉE D'ORSAY, PARIS

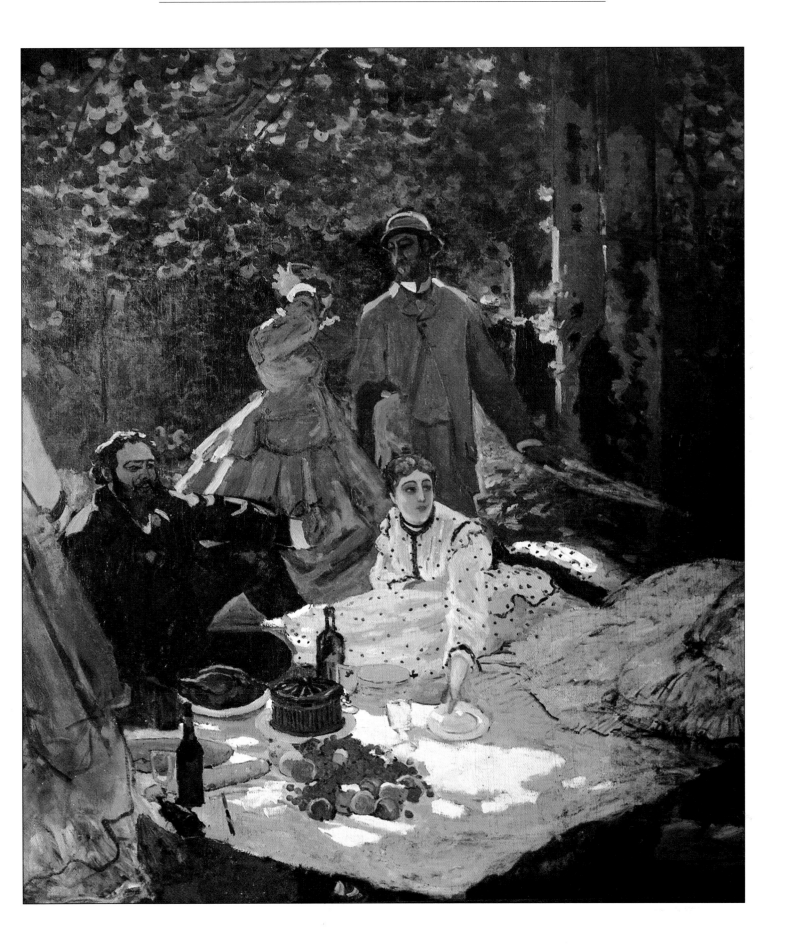

painting, which carried far more prestige at the Salon. And since a 'Luncheon on the Grass' was the very subject that Manet had painted in controversial style and exhibited only two years earlier (pages 28-9), there can be no doubt that Monet was deliberately challenging the older master for leadership of the modern-life school. Even the size of Monet's canvas proclaimed as much; the new *Déjeuner* was to be over four times bigger than the old. Working on this scale, he must have hoped to take the Salon by storm, perhaps believing that his picture would meet with less opposition because it avoided the innuendo and nakedness that had made Manet's work a moral as well as an aesthetic issue. If so, Monet was probably being over-optimistic, since the Salon jury was unlikely to approve of a painting whose size put a contemporary picnic on the same level as heroic events in history and myth.; and Monet's colours, so much brighter than Manet's, would also have been certain to offend.

As it turned out, the *Déjeuner* was never seen by the jury. The project got off to a bad start when Monet injured his leg and, instead of painting, had to put up with being painted, as an invalid, by Bazille. When he was better, he made many preparatory sketches and studies, including a large oil study which is the only surviving record of how the finished canvas was intended to look. He worked on the final version from the autumn of 1865, but when it became clear that he could not complete it in time for the 1866 Salon, he put it aside and turned to something else. Having put it aside, he never went back to it, an extraordinary decision in view of the amount of work he had invested in it. Twelve years later a hard-up Monet left the *Déjeuner* as a pledge with his landlord at Argenteuil. By the time he was able to reclaim it, the canvas had rotted in several places. Monet cut it up and kept two large fragments, including a large central section (page 63).

This is a striking painting in its own right, although the absence of its forest setting has inevitably changed the kind of impact it makes. Every figure except one seems to have been modelled - for reasons of economy - by only two people, Bazille and Camille Doncieux, an 18-year-old who had become Monet's mistress. The exception is the broad, bearded seated figure, who is probably the 'realist' painter Gustave Courbet. Courbet's *Burial at Ornans* (page12), which gave an everyday event the kind of treatment normally reserved for historical set-pieces, was an obvious precursor of Monet's *Déjeuner*. The replacement of Courbet's peas-

LEFT: **Women in the Garden**
1866
Claude Monet
© DACS 1996
MUSÉE D'ORSAY,
PARIS

ants by Monet's middle-class city folk at their leisure in the countryside was an important shift of emphasis, typical of the direction that Impressionist painting was to take.

The picture that Monet painted for the Salon was *Camille,* or *The Woman in the Green Dress,* a life-sized full-length portrait of his companion. Submitted with *The Road to Chailly,* it again won Monet critical plaudits and even inspired the publication of verses hailing Camille as a 'queenly Parisienne'.

Camille had been well received at the Salon in spite of its contemporary subject, and this encouraged Monet to tackle another ambitious 'modern' figure painting: *Women in the Garden* (above). Although he had sold some canvases as a result of the success of *Woman in a Green Dress,* he was still apparently short of funds since Camille was the model for all four women in the new canvas. It was very large, but Monet nevertheless decided to paint it in the open air with the help of a device that raised or lowered the

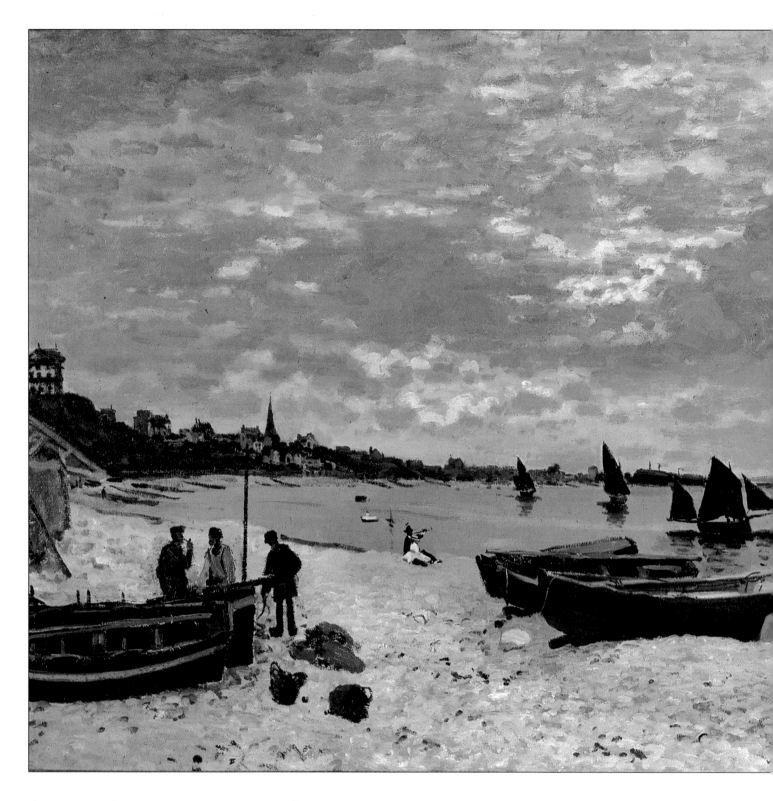

canvas into a trench so that every part of it was within reach of the artist's brush. Monet probably finished the work in the studio (although he never admitted the fact), but the trouble he took to work in the open at all is striking testimony to his belief in the virtues of *plein-air* painting.

Women in the Garden is an unusual, memorable painting, carefully composed with the small tree in the centre as its axis and the full, crisp, light-coloured gowns of the women making a vivid

contrast with the dark, lush greenery; the coloured blossoms serve to ease the transition between them. *Women in the Garden* is not entirely successful, since the almost life-size figures are a little stiff and there is something slightly disturbing about their activities which persuades us to look for a hidden significance in the picture that was probably never intended. In particular, one woman half-hides her face in a bouquet while looking meaningfully at us, while another appears to be rushing across the path although she is probably only reaching out to pluck a blossom from a bush.

Whatever its shortcomings, *Women in the Garden* was a work of high quality and its rejection by the Salon of 1867 must have been a heavy blow. Both of his submission were turned down, as a reaction set in against the relatively liberal outlook of the previous period. The timing of this could hardly have been worse from Monet's point of view, since he was in debt and Camille was pregnant. During the early months of 1867 he found refuge in Bazille's studio in the Rue Visconti, where a similarly penurious Renoir had already moved in. The friendship between the two men became deeper as a result and they spent some time in the spring painting views of Paris. Several of Monet's canvases were done from the balcony of the Louvre, an institution that, at the height of his anti-traditionalism, he had refused to visit until Renoir virtually dragged him into it.

Hard Times

In the summer of 1867 Monet went back to Normandy, staying with his aunt at Sainte-Adresse, just along the coast from his home town, Le Havre. His family may have been trying to separate him from Camille by keeping him short of money, but it is equally possible that Monet himself was holding back from a full commitment to her. He did make a brief, surreptitious visit to Paris for the birth of his son Jean in August, but only in March 1868 did he take the plunge by returning to the capital and setting up house with them. In the intervening months he wrote a string of desperate begging letters to Bazille, descending to near-insults when his generous friend was unable or unwilling to respond. Between times he painted energetically, producing splendid canvases such as *Terrace at Sainte-Adresse* and *Beach at Sainte-Adresse* (left), which any spectator might be forgiven for supposing were the work of a man without a care in the world.

On his return to Paris, Monet submitted two large harbour

views to the Salon jury. One was accepted, but only after the Barbizon painter Daubigny had made a scene and absolutely insisted on its inclusion. The painting has since disappeared, but it was praised by Zola - already a staunch supporter of Monet - for its 'rough touch'. In other words, the brushwork was free and visible in a fashion not much liked by juries or the general public. That was, no doubt, why Monet's works aroused so much opposition and attracted increasing attention from the cartoonists. One of these came out with a taunt that would be aimed again and again at avant-garde artists over the next century or so: Monet's work was really quite promising, he wrote, since it had been begun when the artist was only four-and-a-half years old!

Undeterred, Monet continued to paint with greater freedom, at first at Bennecourt on the Seine, in the area north-west of Paris which would become the main haunt of the Impressionist landscapists. Places whose names crop up again and again in the titles of paintings - Bougival, Argenteuil, Pontoise, Louveciennes, Marly - all belong to this area, in which still-rural communities survived at no great distance from popular riverside resorts frequented by Parisian trippers. Monet himself would live at several of these spots, never far from the river, until his eventual retirement to the most celebrated of them all, Giverny.

However, in 1868 his stay at Bennecourt was brief. In June he returned alone to Le Havre, where he won a silver medal at a local art show but sold no canvases. His desperate situation was relieved a little when he found his first patron, Louis-Joachim Gaudibert and painted portraits of Gaudibert and his wife. Only the richly textured portrait of Marguerite Gaudibert has survived; as far as is known, it is the sole commissioned portrait among his works.

In August, Monet brought his family to Fécamp, on the Normandy coast, from which he continued to write desperate-sounding letters to Bazille. One apparently records a suicidal impulse: 'I was so depressed yesterday that I was stupid enough to throw myself in the water. Luckily there were no ill effects.' But since Monet was still bombarding Bazille with pleas for help, this may have been just another move in the campaign.

Towards the end of the year matters improved. Monet at last managed to sell *Woman in a Green Dress*, which had remained in his hands despite its warm reception at the Salon two years before. His finances remained precarious, but Gaudibert came to the rescue again, and by December Monet was writing to Bazille in distinctly cheerful vein, relishing domestic life

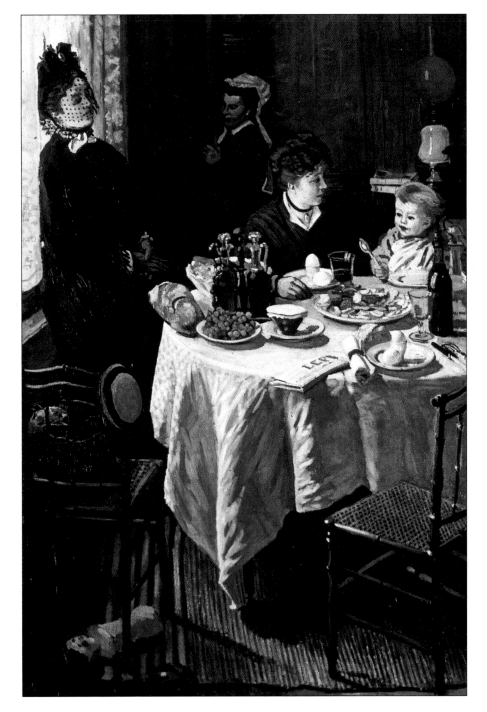

and getting on with another large figure painting for the Salon.

The painting was *The Luncheon* (above), which at first sight represents the very domestic pleasures that Monet was currently enjoying. The mother and child are shown with a touch of sentiment, in a familiar setting which Monet painted in low-key colours, doubtless intended to appeal to academic taste. More unusual is the empty place at the table, complete with an unopened copy of *Le Figaro*, which indicates that the head of the household has not arrived or is too busy recording the scene to take part in it. There are two even more ambiguous elements: the

visitor who has not taken a seat and appears to be leaning away, as if in distaste, from the mother and child, and the servant, whose slyly knowing look seems to confirm that 'something is up'. Attempts have been made to relate these mystery elements to Monet's family situation, but it seems just as likely that they were included to intrigue a public that enjoyed narrative painting. Given its size, colour scheme and hinted 'story', *The Luncheon* represented another attempt by Monet to triumph at the Salon with an ambitious figure painting - and, as it turned out, it was to be his last attempt of the kind.

So it is all the more puzzling that, at a relatively late stage, he decided against submitting this canvas in 1869, sending in instead a snow painting and a seascape. Both were fine paintings, yet both were rejected in a year when the jury was generally more liberal, admitting works by Monet's friends Renoir, Bazille and Pissarro. For some reason, Monet had become a marked man.

At the 'Frog Pond'

By June, with help from Gaudibert, Monet and his family had gone to live outside Paris at Saint-Michel, close to the riverside resort of Bougival. The Monets were now so miserably poor that even food and painting materials were in short supply. Claude's friend Renoir was hardly any better off, although a good deal more philosophical. He and his companion Lise Tréhot were living with Renoir's parents at Louveciennes, close enough for the two artists to see each other almost every day. On occasion Renoir was so worried about his friend's welfare that he took provisions from his parents' larder and brought them over to Saint-Michel. Somehow he and Monet found the wherewithal to go on painting and set out together on expeditions that later became celebrated in the history of Impressionism. At Bougival, and especially at the fashionable bathing and boating spot nicknamed La Grenouillère (The Frog Pond), working side by side, Monet and Renoir developed the techniques that made the Impressionist landscape so different from the academic ideal, and even from the works of more sympathetic artists such as the Barbizon painters.

Monet had already lightened his palette and had been painting with increasingly cursory brushstrokes, eliminating details in certain parts of his canvases (techniques used even earlier by Manet, for example, in his horse-racing scenes). At La Grenouillère Monet and Renoir began to work in a still 'rougher' and more

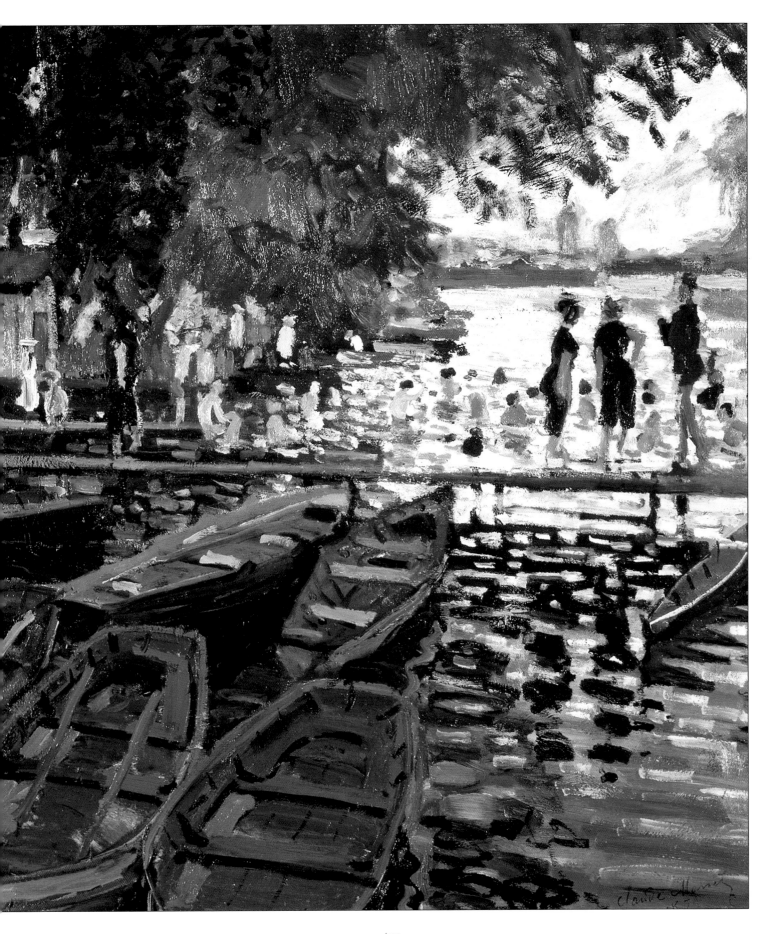

canvases he had painted in Renoir's company during the previous summer. Unfortunately, it has disappeared, almost certainly destroyed at some point in World War II. Its impact can only be inferred from one of the best-known of Monet's surviving La Grenouillère paintings, now in the Metropolitan Museum, New York (pages 64-5), which it resembled in size, technique and subject, although the circular platform was presented from a different angle, off-centre, and from a greater distance, enabling Monet to glamorize the scene by adding sailing and rowing boats. Like the painting illustrated here, it showed Monet's growing fascination with water, an element which mirrors reality, but when even slightly agitated breaks it up into a multitude of shifting, glittering facets. This is also apparent in the canvas in the National Gallery, London (page 67), with its cursorily painted yet lively little figures and solid cluster of rowing boats. The development of Monet's skill and technical resources becomes apparent in any comparison between *The River*, with its still reflections, and the rippling waters of *La Grenouillère*.

The rejection of Monet's other submission, *The Luncheon*, which he had held over from the previous year (page 60), is much more difficult to explain. Painted with the Salon in mind, it was far more conventional in style and subject. Once more it is worth recalling what rejection meant – not a tepid or hostile public response, but a judgement that thousands of other canvases were worthier of exhibition than Monet's. Either Monet was again being singled out as peculiarly subversive, for some reason we do not know, or perhaps the jury took the view that a man who had the nerve to paint *La Grenouillère* deserved to be punished by total rejection. Even at the time, the decision caused some stir: there were protests from two jury members, Daubigny and Corot, and Monet's patron Arsène Houssaye announced defiantly that he intended to leave *Woman in the Green Dress* to the Musée du Luxembourg, whose exhibits often eventually found their way into the hallowed halls of the Louvre.

The fact remained that Monet had been rejected two years running. Contrary to legend, although he was developing a fresh and original style, he was also ambitious and career-minded enough to compromise a little in order to please the art establishment, which made the blows he received all the more painful. Although he may not have come to a definite decision about it at once, after the rejections of 1869–70 Monet did not submit works to the Salon for a decade. Circumstances, rather than his own temperament, had turned him into an enemy of the system.

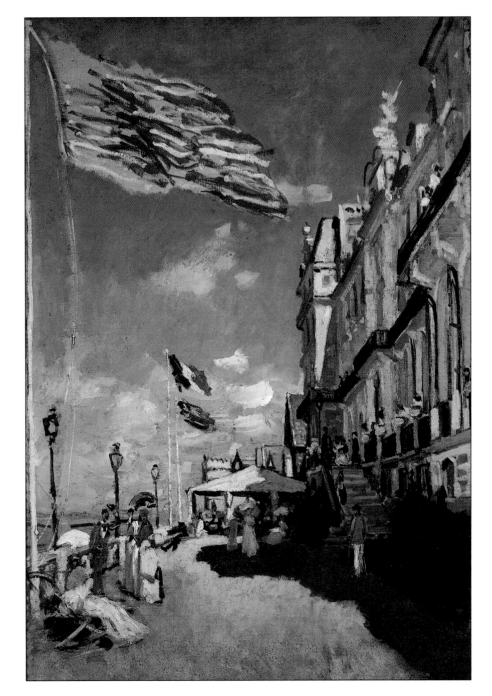

LEFT: **The Hôtel des Roches Noires** 1870 Claude Monet © DACS 1996 MUSÉE D'ORSAY, PARIS

Honeymoon at Trouville

One of the first things the enemy of the system did was to get married. Monet and Camille became man and wife on 28 June, 1870, at a civil ceremony at one of Paris's municipal town halls. Nobody knows why Monet married his mistress, and the mother of his three-year-old son, just when he did, or why the only artist of his own stature among the four witnesses was not a friend of his own age but the 51-year-old radical realist Gustave Courbet. Camille's father and mother paid a small advance on her dowry (the rest

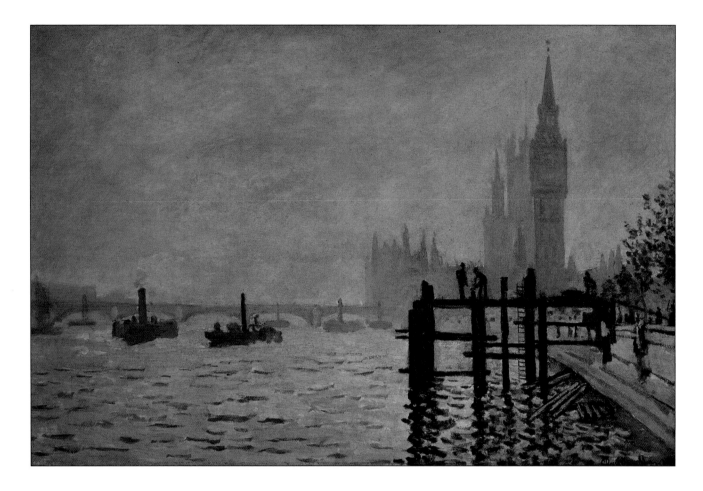

Paris. Then they went to spend the summer at Trouville, a smart
resort in Monet's home territory, the Normandy coast. *The Hôtel
des Roches Noires* (page 73) is one of at least eight canvases that
Monet executed in the course of a few weeks at Trouville. They
were all painted with great freedom and we know that the beach
scenes were done in the open because grains of sand have been
found lodged in the paint surface. *The Hôtel des Roches Noires* shows
the esplanade and one of the grand hotels that lined it; in this
instance the role of the painting technique in creating a breezy
seaside atmosphere is obvious.

When the Franco-Prussian war broke out in July 1870, Monet
stayed on at Trouville, possibly to avoid any danger of being
conscripted. As the Prussian armies advanced, he slipped across
the Channel and settled in London. Over the next few months he
met fellow-artists-in-exile including Pissarro, with whom he viewed
and admired the works of the English landscapists Constable and
Turner, and took part in two exhibitions without making any sales.
His participation was arranged by the dealer Paul Durand-Ruel, a
contact who would later prove to be immensely important to the
Impressionists. While in London, Monet painted half a dozen pictures

of the city's parks and the fog-shrouded river, notably *The Thames below Westminster* (left). But how he spent most of his time, and how he financed his long stay abroad, is not at all clear.

Argenteuil

When the war had ended and the Commune had been suppressed, Monet decided to leave England. Instead of going back to France, he spent several months in Holland, whose picturesque windmills and canals inspired him to renewed productivity. Towards the end of 1871 he returned to Paris for a few weeks; then he and his family moved out of the capital, down river once more, to Argenteuil. This little town was to be his home for six years, during which time he was extraordinarily prolific. Monet's Argenteuil canvases are now among his most popular works. In the majority of them the river is a living presence, whether seen in idyllic 'long shots', spanned by its two busy bridges, or alive with boats taking part in the weekend regattas for which the place was celebrated.

At Argenteuil Monet was often joined by visiting friends - Manet, Renoir, Sisley, Caillebotte - so that this small place inspired

BELOW: **Regatta at Argenteuil** 1872 Claude Monet © DACS 1996 MUSÉE D'ORSAY, PARIS

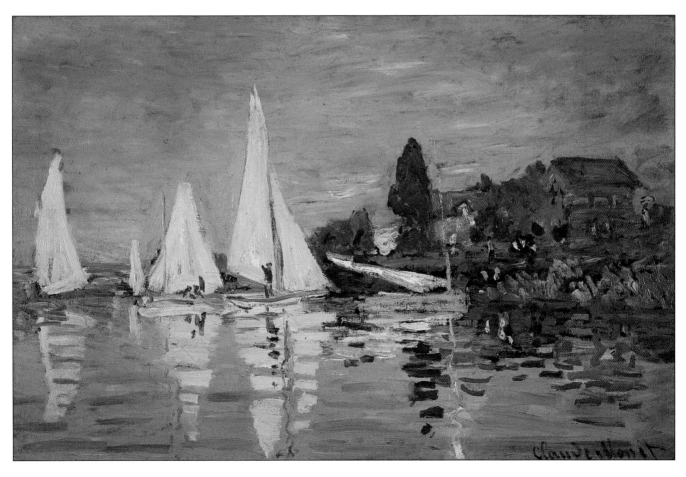

a wonderful group of canvases by great masters. It was also one of the headquarters of Impressionism as a distinct movement, prepared to separate itself from the academies. In the early 1870s Monet, like most of his friends, had concluded that it was a waste of time to send canvases to the Salon. He gladly fell in with plans to hold an independent exhibition, and took a leading role in the preparations for the first, momentous show in 1874.

RENOIR
1841 – 1919

More than any other great artist, Auguste Renoir celebrates the sheer joy of being alive. Apart from a few early works painted with the sombre tastes of the Salon jury in mind, Renoir's art is a sunshine art. It is filled with bright colours, rich textures, sunny places and people who are either actively enjoying themselves or, as with so many of his nudes, taking a quiet, sensuous pleasure in merely existing. Owing much to the festive eighteenth-century tradition of painting, Renoir translated the pastimes of its elegant aristocrats into contemporary pursuits, such as dancing and boating, practised with less finesse but more zest by ordinary men and women. Renoir himself, although highly strung, cultivated a happy-go-lucky outlook that covered up most of his doubts and fears; he often likened himself to a cork bobbing in a stream, carried along without resistance or reflection. He also took a resolutely no-nonsense attitude towards artistic issues, dismissing all dogmas, including those of his fellow-Impressionists. However, his development was far from straightforward or unpremeditated, although it was conditioned by his delight in the colour and beauty of the world; and if this put limits on his scope as an artist, within those limits he reigned supreme.

The Porcelain Painter

Pierre-Auguste Renoir was the only major Impressionist who can reasonably be described as working class. He was the fourth surviving child of Léonard and Marguerite Renoir, tailor and seamstress of Limoges, where Renoir was born on 25 February, 1841. When he was four his parents moved to Paris, and Renoir grew up in a decaying working-class area right in the centre of the capital, between the Louvre and the Tuileries Palace. He spent six

RIGHT: **Lise with a Parasol** 1867 Auguste Renoir MUSEUM FOLKWANG, ESSEN

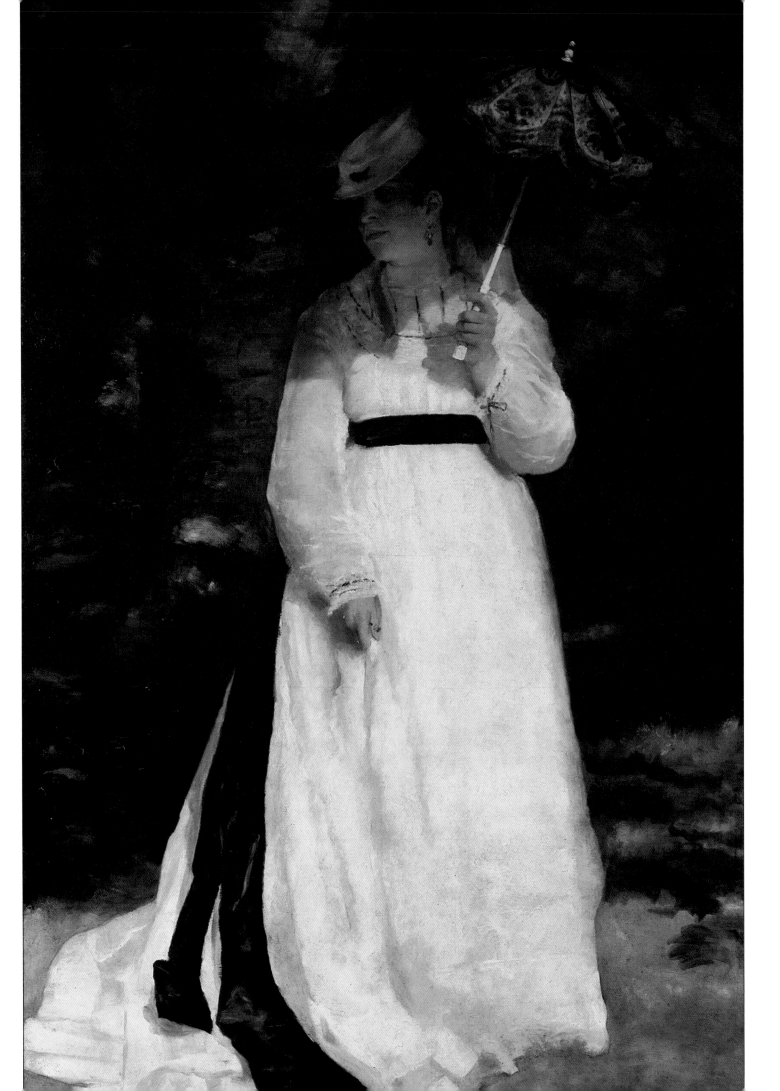

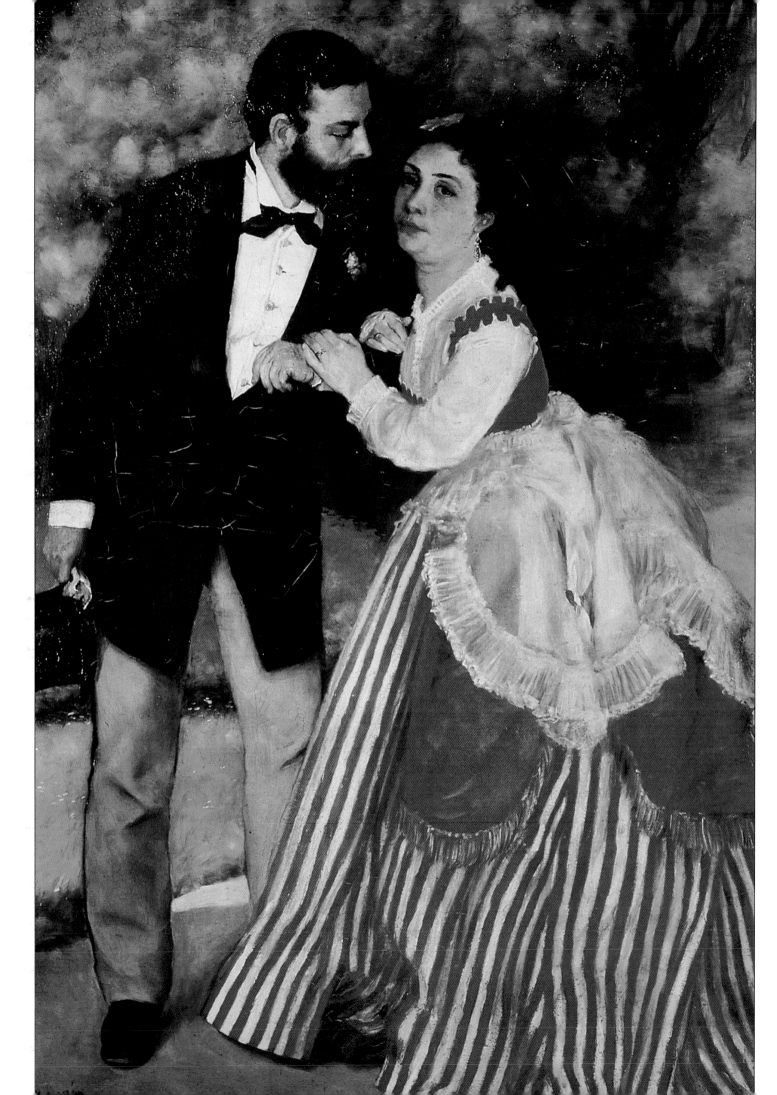

years at the Christian Brothers' school, leaving to make his way in the world when he was 13. As a chorister at the Church of St Eustache he had been noticed by Charles Gounod, later famous as the composer of the opera *Faust*. At this time an obscure choirmaster, Gounod failed to convince Léonard Renoir that his son should make a career as a singer. Léonard and his relatives knew that employees of the famous Limoges porcelain workshops earned good, steady money and consequently bound a willing Auguste to a four-year painting apprenticeship at a Parisian factory in the Rue Vieille-du-Temple. There he made his first professional paintings on plates and coffee-pots. Starting with little bunches of flowers, he was promoted to doing profiles of Marie Antoinette for which he was paid all of eight sous, and eventually he graduated to more sophisticated, mainly pastoral, figures. Still in his teens, he became skilled enough to be nicknamed by his workmates 'the little Rubens'. His works were all, in a sense, fakes, since the plates and pots were stamped 'Sèvres' and destined for gullible buyers who believed they were getting top-quality wares at bargain prices!

Renoir now seemed settled for life, and when his father's health failed, he was earning enough to help his parents buy a retirement home outside Paris. However, Renoir was already feeling the stirrings of artistic ambition, since he spent his lunch hours in the Louvre and went to drawing classes in the evenings. Then his 'job for life' ended abruptly: cheap transfer-printed wares began to flood the market and soon put the factory out of business.

Still only 17, Renoir took on a series of odd jobs, decorating fans and painting coats of arms and murals for cafés. His most lucrative task seems to have been painting sun-blinds for missionaries in tropical climes; decorated with religious scenes, the blinds functioned like stained-glass windows, lighting up interiors with uplifting images. In this kind of work, the deft touch Renoir had acquired at the porcelain factory stood him in good stead, enabling him to maintain a production-line speed of execution and earn enough to put some money by.

Renoir used his savings to undertake a course of study at the Ecole des Beaux-Arts. By this means he would acquire a passport to the world of fine art (painting and sculpture), which the nineteenth century regarded as entirely separate from, and infinitely superior to, the applied or decorative arts. Renoir the porcelain painter was an artisan; Renoir the painter of histories, myths or portraits

LEFT: **Sisley and His Wife** *c.*1868 Auguste Renoir WALLRAF-RICHARTZ MUSEUM, COLOGNE

would be a gentleman. In order to put his parents' minds at rest, Renoir painted a scene showing Eve being tempted by the serpent and gave it to a family friend, the painter Laporte, for his verdict. Laporte declared that Auguste had talent and the Renoirs happily gave their consent.

Getting into the Ecole des Beaux-Arts provided no great difficulty, since Renoir was gifted, skilful, prepared to conform and well-equipped, having already spent a good deal of time over the previous two years in the Louvre, copying its masterpieces. In later years he always regarded this museum work as the most important part of his training. However, he must have had shortcomings as an academic artist, for the Beaux-Arts examiners placed him sixty-eighth out of the eighty candidates who passed. In April 1862 he registered at the Beaux-Arts, studying mainly under Charles Gleyre and also working at Gleyre's studio, where students were taken on privately.

The Student

Like the other Impressionists at Gleyre's, in old age Renoir liked to picture himself as a rebel, repeating the story that Gleyre had spoken disapprovingly to him after looking at a work that was very freely sketched (that is, in academic terms, sloppily executed). 'Young man, you are very talented, but I suppose you took up painting just to amuse yourself.' Renoir is supposed to have replied, 'That's so: if it didn't amuse me, I shouldn't do it.' The point of view is Renoir's, but it seems unlikely that he would answer in such a rude fashion, especially since there is plenty of evidence for his nervousness and timidity in early life. In fact, his retort was probably what the older Renoir felt that he should have said. Like his Impressionist friends at Gleyre's, he found the studio tolerable enough to remain in it until Gleyre himself closed it down. From time to time in later life he quoted maxims of Gleyre's with approval and even claimed that his old master had taught him all his painting skills.

At Gleyre's, Bazille seems to have taken Renoir under his wing, introducing him to the life of the town and getting him out of scrapes. During this phase of his life, the thin, nervy Renoir seems to have attracted trouble, either from bullies or from ordinary members of the public whose suspicions were aroused by something about him. On one occasion Renoir was surrounded in a park by an angry mob of people who were convinced that

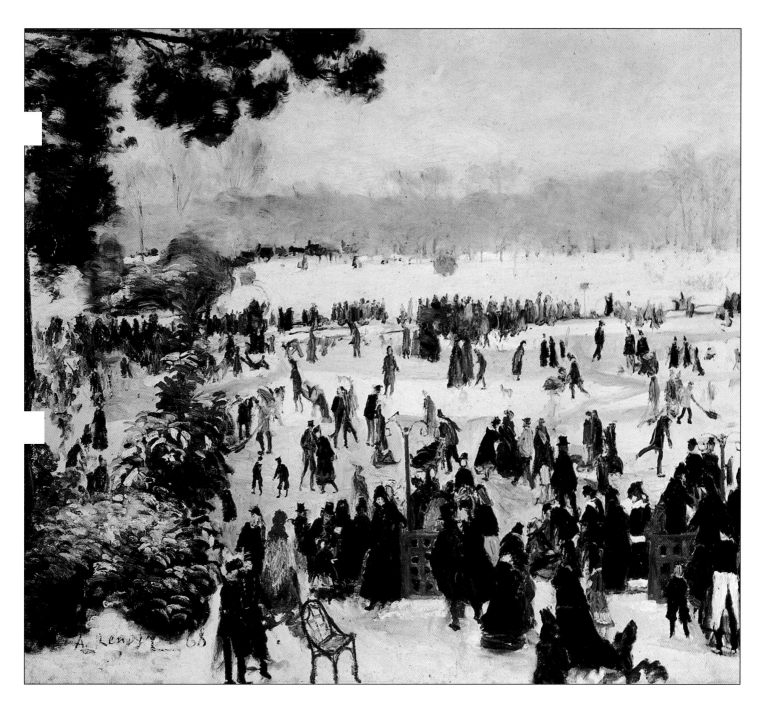

he had tried to kidnap a baby. If the tall, commanding Bazille had not intervened, he might well have been seriously injured.

Shortly after this important meeting, Renoir also made contact with Monet and Sisley, and the four artists began their celebrated association. After Gleyre's closed, Renoir accompanied his friends on a working trip to Chailly, in the forest of Fontainebleau. There he had another unnerving encounter, with a gang of young toughs and their girlfriends, who mocked the workman's smock he wore when painting. The smart young students at Gleyre's had behaved in much the same fashion, but on this occasion the mockery turned to horseplay and became rather menacing – until an energetic older man with a very big stick arrived and drove the

hooligans away. Renoir's rescuer turned out to be Narcisse Virgile Diaz de la Peña (1807–76), a fellow-landscapist; his mighty stick was normally used for more peaceful purposes, to support his wooden leg. Diaz belonged to the Barbizon school of painters, who had first discovered the joys of working at Fontainebleau, a practice that Renoir and his friends were now imitating. Diaz had himself been a porcelain painter in his youth and despite the 34-year difference in their ages, he and Renoir got on well. Diaz helped the younger man financially and also strongly advised him to lighten his palette. This suggests that Renoir, unlike Monet, was still very much under the influence of the academic manner promoted at the Beaux-Arts and was not yet painting in even a Barbizon-inspired style.

This seems borne out by the fate of *Esmeralda and the Goat*, a painting by Renoir that was accepted for exhibition at the 1864 Salon. The subject was taken from Victor Hugo's novel of medieval times, *Notre-Dame de Paris*, one of the landmarks of the Romantic movement. Esmeralda is a gypsy girl whose performances with a goat trained to execute 'magical' feats lead to her being accused of witchcraft. The picture obviously belonged to the literary-historical type of work that the Impressionists, once mature, generally avoided. To have a painting accepted by the Salon must have been a source of pride to an artist who was still only 23, but after Diaz told him that there was too much bitumen (dark brown pigment) on the canvas, Renoir waited until the exhibition was over and then destroyed it.

When Gleyre closed his studio, Renoir, like his friends, decided that his days of formal study were over. For a time he had enough money to set up on his own in Paris, while also spending much of the summer in Barbizon country. He now gravitated towards the village of Marlotte, which had become a centre of bohemian life. One of its best-known haunts was Mère Anthony's inn and in 1866 Renoir painted an interior which captures something of its atmosphere, with artists grouped round a table, the wall behind it covered with sketches, a servant collecting cups and plates, and Toto the poodle keeping a wary eye on the spectator. The newspaper on the table was *L'Evénement*, whose art critic, Emile Zola, was currently causing a scandal by defending Manet and the younger painters of modern subjects. By this time Renoir was evidently aware of such issues, although he did not become part of the Café Guerbois circle until late 1868 or early 1869.

The artists portrayed in *At Mother Anthony's* were probably Sisley and Jules Lecoeur. Renoir seems to have been very close to Sisley and his family during this period, taking a trip down the Seine with him as far as Le Havre, exhibiting a portrait of Sisley's father at the 1865 Salon and sharing a studio with him in 1865–66. This arrangement ended when Sisley and his mistress began to live together, but two years later Renoir painted a magnificent double portrait of them which usually carries the discreet title *Sisley and his Wife* (page 78).

Jules Lecoeur was an architect-turned-painter who owned a house at Marlotte, enabling Renoir to spend time in the village at no great expense. Jules's brother Charles was also one of Renoir's friends, securing a commission for him to paint decorations for the town house of Prince Bibesco, a young man-about-town who also became a friend and protector of the artist. Through the Lecoeurs Renoir met 17-year-old Lise Tréhot, who became his model and mistress. She is the central figure in most of his important works of the late 1860s and early 1870s, notably *Diana* (1867) and other nude studies, *Lise with a Parasol* (1867, page 77), *The Gypsy Girl* (1868) and *The Woman of Algiers* (1870, page 87). A surviving photograph suggests that Renoir greatly exaggerated her amplitude, perhaps influenced by Courbet's large forms and his own preference for buxom beauties; but Lise is certainly a strong, distinctive presence whenever she appears.

Diana shows Renoir doing his best to please the academicians. It originated as a straightforward painting of a nude, but Renoir then proceeded to mythologize it by equipping Lise with a bow, a strip of fur thrown round her loins and a dead fawn at her feet. However, Lise herself remained too non-ideal to pass as Diana, the goddess of the chase, and the painting was rejected when Renoir submitted it to the 1867 Salon. By this time his savings had run out and he was living in Bazille's studio on the Rue Visconti. Early in 1867 they were joined by Monet, who was even more penurious. Although Renoir and Monet had known each other for several years, their close friendship seems to date from this period, when they made expeditions to the Louvre and elsewhere in Paris to paint townscapes. Renoir's *The Skaters* (page 81) is a rare winter scene. Unlike most of the Impressionists, he detested the cold too much to take any great pleasure in painting snow, describing it as 'a disease of the climate'. *The Skaters* is already typical of Renoir in

its cheerful quality and in the prominence given to the men and women in the scene; by contrast, Monet chose more distant views of the city in which people and vehicles are dwarfed by the buildings.

Incensed by the rejection of *Diana*, Renoir signed a petition asking (in vain) for another Salon des Refusés. The following year he had better luck with *Lise with a Parasol* (page 77), painted in the Forest of Fontainebleau in the summer of 1867. The painting is life-size, combining a clarity and simplicity reminiscent of Manet, with a sense of youth and vitality that was Renoir's own special gift; he had, in fact, come of age as an artist. Although the brushwork may have seemed overbold to academic tastes, as a whole the picture was not too unconventional, and it was accepted by the Salon jury. However, in its day it was seen as the latest statement of the moderns and as such it divided critical opinion. Zola, writing in *L'Evénement*, at once identified Lise as 'the sister of the Camille of M. Monet', daringly asserting that 'She is one of our wives, or rather our mistresses' (an interesting perception), painted with candour and in the modern manner. Zacharie Astruc, another defender of the Impressionists, gave a just appreciation of the painting's sunlit beauty and related it to Manet's *Olympia* and Monet's Camille as the third in a modern trinity. Conservative critics placed the canvas in exactly the same way but judged it in the opposite spirit, as an imitation, or even the ultimate degenerate product, of the Courbet-Manet school. Renoir would no doubt have scoffed at all this theorizing (in later life, at least), but the monumental quality of the painting and its sheer size suggest that it was meant to stake his claim to be considered on a par with artists such as his more precocious friend Monet. *Lise* certainly made enough stir for him to feel that he had succeeded in that respect, although the financial benefits were meagre or non-existent.

The year 1869 turned out to be a straitened one for both Renoir and Monet. Although one of his paintings of Lise was accepted for the Salon, Renoir was so hard up that he spent the summer at his parents' house in Louveciennes. This was when he travelled regularly over to St Michel, where the Monets were even worse off, and the two artists set up their easels side by side at La Grenouillère. Renoir's paintings of the 'Frog Pond' showed that his development had caught up with Monet's, the differences between their efforts originating in their temperaments rather than their skills. Renoir painted essentially the same scene as Monet's *La Grenouillère* (pages 70-1), with the little island as the focus of the

LEFT: **Bathers in the Seine, La Grenouillère**
1869
Auguste Renoir
PUSHKIN
MUSEUM,
MOSCOW

composition, but he chose a brighter day and a less distant view that gave the holidaymakers a more prominent role; they are even dressed less sombrely. In *Bathers in the Seine, La Grenouillère* (above), the casual gathering of people (and dogs) under the trees is more important in creating the mood of the scene than its riverside setting. Renoir's brushwork, rapid, spontaneous

and fluent, is perhaps even more successful than Monet's in creating the zestful, animated atmosphere of La Grenouillère.

Before the end of the summer, canvases like these would be on sale for 100 francs apiece in an art shop on the Boulevard Montmartre. Renoir and Monet continued to be poor and continued to paint together at Bougival in the spring of 1870, having taken time out in January to pose for Fantin-Latour's *Studio in the Batignolles* (pages 34-5). Although everyone else is bareheaded and dressed in indoor clothes, Renoir is shown as a curious, priest-like figure, wearing a hat and cape, his hands clasped in front of him as he devoutly contemplates Manet at his easel.

Back in Paris, Renoir lived from hand to mouth, initially putting up at Bazille's studio in the Rue de la Condamine, where he was included in another group portrait, *The Artist's Studio* (pages 104-5). He was successful again at the Salon, showing *Bather with a Griffon* and *Woman of Algiers* (page 87). The favourable notices of *Woman of Algiers* tell us a good deal about nineteenth-century taste, for this was a spectacularly opulent (some would say spectacularly vulgar) painting of Lise as an odalisque, lying among 'oriental' studio props and gazing at the viewer with a sultry, come-hither look. The picture could hardly have been more unlike the challenging modernity of Olympia, substitututing a fantasy Eastern world for Manet's less comfortable scene. There was a well-established tradition of orientalism in French art, associated with the two great rivals of the previous generation, Ingres and Delacroix. Paradoxically, the classicist Ingres painted voluptuous imaginary odalisques in steamy harems, whereas the Romantic Delacroix actually visited Algeria and made colourful but more accurate paintings of what he had seen. Renoir's canvas was painted in the studio, but instead of Ingres' smooth nudes he presented an unmistakably European woman wearing gorgeous fancy dress. Renoir's mastery is such that, for all its falsity, the painting is oddly memorable and appealing; and no objections can lessen our admiration for the extraordinary virtuosity with which Renoir has rendered the intricately patterned satins and gauzes that he has used to swathe his Lise.

War and Revolution

When Bazille had to go back to Montpelier to see his family, Renoir moved in with another friend, the music critic Edmond

Maître. Sharing Renoir's and Bazille's taste for the music of Wagner, Maître was prominent enough in Impressionist circles to feature in both of the 1870 group portraits by Fantin-Latour and Bazille; in Fantin's painting he is the third figure from the right, standing next to the towering Bazille.

After the outbreak of war in 1870, Renoir was called up and enrolled in a cavalry regiment, the 10th Chasseurs. He knew nothing about horses, so military thinking sent him to Libourne in the south-west, as a trainer. This ought to have been a safe posting, far from the front line, but Renoir caught dysentery and almost died. After recuperating with an uncle who lived at Bordeaux, he was sent to Tarbes in the Pyrenees, where he spent most of his time riding and teaching his commanding officer's daughter to paint.

More adventures awaited him after the armistice ended the war. He left the cavalry and returned to Paris in time to be trapped in the city when the Commune had been set up and the government at Versailles was preparing to drown it in blood. As Renoir told the story in later years, he escaped by an amazing stroke of luck. The Commune's police chief, Raoul Rigault, turned out to be a former student revolutionary whom Renoir had helped years before, passing him off to Napoleon III's gendarmes as a fellow-painter.

BELOW: **Woman of Algiers** 1870 Auguste Renoir NATIONAL GALLERY OF ART, WASHINGTON, DC

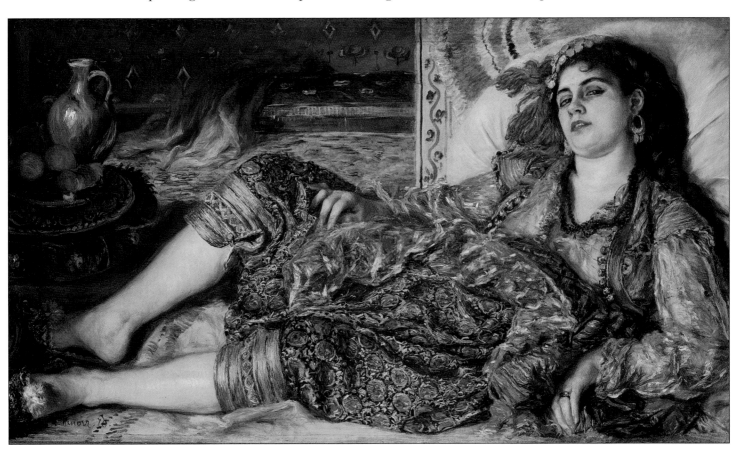

Returning the favour, Rigault gave Renoir a safe-conduct that would be accepted by any Communards he met. At the same time Rigault warned him that a man carrying a Communard safe-conduct would probably be shot by a government patrol! Fortunately Renoir was able to solve the problem by getting a government pass through his friend Prince Bibesco. Doubly equipped, he was able to leave Paris and take refuge with his parents at Louveciennes.

This ended Renoir's encounter with history in the making and by the summer of 1871 he was back at his old haunts, painting at Bougival and Marlotte. He also went back to views of Paris in response to a new buyer, the dealer Durand-Ruel. He was slowly building up a clientele (Théodore Duret was won over in 1873, buying *Lise with a Parasol* for 1,200 francs), but meanwhile important changes were taking place in his private life. Lise left him and married a young architect. Nothing is known of the circumstances and in old age Renoir merely said discreetly of a portrait of Lise that 'I lost sight of the model', although there can be no serious doubt about the nature of their relationship. They never saw or wrote to each other again. Coincidentally or otherwise, Renoir's friendship with the Lecoeurs ended soon afterwards; it was later believed that the cause was Renoir's attempt to seduce Jules' and Charles's youngest sister.

Lise remained a little longer as a painted image. In the spring of 1872 Renoir submitted one of his last paintings of her, *Parisian Woman in Algerian Dress*, to the Salon jury, but they rejected it. One possible reason is that, by making it over-obvious that the woman was not a 'native', Renoir undermined the very fantasies on which the popularity of such works was based, and perhaps even aroused the suspicion that his Parisian woman might be a professional, devoted to the satisfaction of such male fantasists.

Breaking with the Salon

The following year Renoir tried a new approach, submitting *Riders in the Bois de Boulogne* (right). This was a modern subject, but one with high-society appeal, painted in a quite conservative style. When the Salon, in one of its severe phases, rejected the *Riders* and many other canvases, Renoir again signed a petition calling for a new Refusés. This time it was successful, and when the *Riders* was shown there it attracted a good deal of favourable attention, adding to the widespread feeling that the Salon system

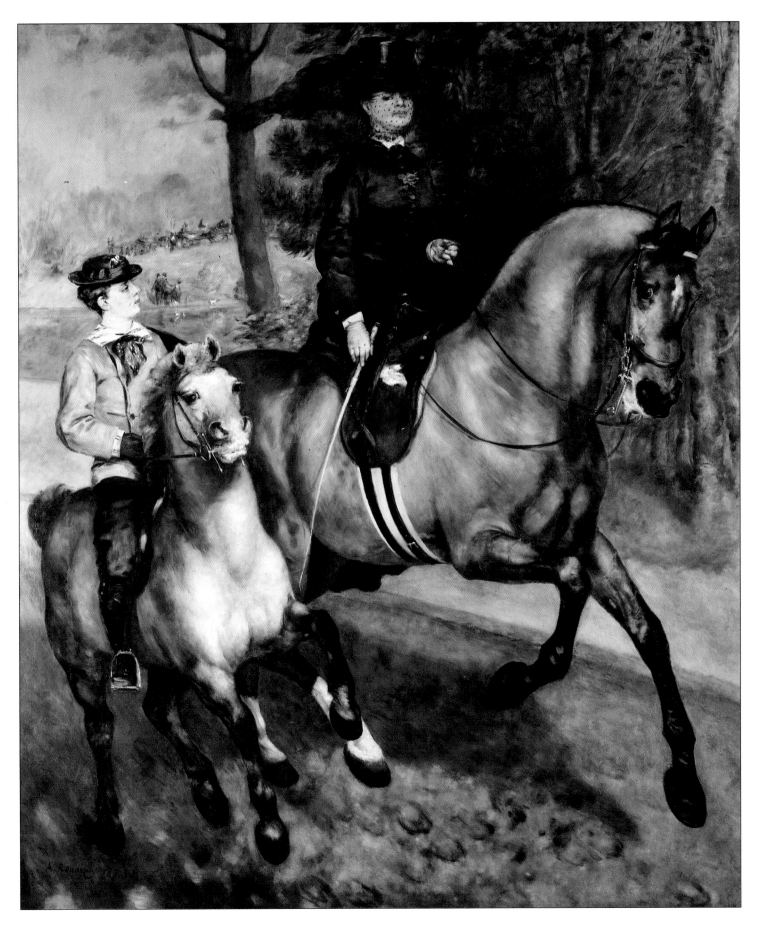

might have had its day. In the summer Renoir visited Monet at his new house in Argenteuil and let himself go again. Working side by side once more, the two artists were inspired by the river and the craft on it to produce some of the happiest, breeziest images of *plein-air* Impressionism. Renoir had been delighted by the river and boating ever since his trip with Sisley in 1865, but in the summer of 1872 he translated interest into art. During the 1870s he returned to the subject from time to time, and *The Skiff* (pages 206-7) shows him working (up river at Asnières) in the same vein,

contrasting summery orange-yellows and river blues and creating a shimmering web of brushstrokes over the canvas to match the rippling of the water.

Working with Monet may also have reawakened Renoir's sense of solidarity with his old friends. Unlike Sisley, Pissarro and Monet himself, he had continued to send works to the Salon, although with woefully little success. By 1873 he was ready to take part in a new and independent attempt to reach and win over the public.

PISSARRO
1830 – 1903

Camille Pissarro was the oldest of the Impressionists. Born on 10 July, 1830, he was older even than the 'first generation' painters Manet and Degas. However, his talent developed over a long period and his work as an artist is closest to that of the younger men born around 1840, Monet, Renoir, Sisley and Cézanne. Pissarro was on friendly terms with them, but his age, and perhaps his origins and politics, set him a little apart and he was most comfortable in the patriarchal role he was able to adopt towards Cézanne and later Gauguin.

Exotic Origins

Pissarro was one of those artists who might very easily have missed his vocation. He was born far from Europe, at Charlotte Amalie, the main town on the island of St Thomas in the Danish West Indies (now the American Virgin Islands). His father, Frédéric Pizarro, was French, having left Bordeaux in 1824 for the island, where he ran a successful import-export business. Registered as Jacob Abraham Pizarro, the future Camille Pissarro was brought up as an orthodox Jew and destined for the family business. If there had been a good secondary school on St Thomas, he might have attended it; but there was no secondary school at all, so he was sent to a boarding school at Passy, just outside Paris. His artistic bent was encouraged by a perceptive teacher and an alternative future opened up before him.

Nevertheless, when he was 17 Pissarro went back to St Thomas and took his place in the family business. Two or three years later, while he was sketching around the harbour, he met a

ABOVE: **The Banks of the Marne at Chennevières** 1865 Camille Pissarro NATIONAL GALLERY OF SCOTLAND, EDINBURGH

PREVOUS PAGES
92-3: **View of
Pontoise, Quai
de Pothuis** 1868
Camille Pissarro
STÄDTISCHE
KUNSTHALLE,
MANNHEIM

young Danish painter, Fritz Melbye, who was making a leisurely artistic tour of the New World. The two became friends, worked together and, when Melbye was ready to move on, Pissarro went with him. Their destination was Caracas, the Venezuelan capital. Although the city must have seemed like a great metropolis after Charlotte Amalie, it comes as a surprise to learn that Pissarro spent almost two years with Melbye in Venezuela, apparently surviving by painting portraits while his friend taught him the essentials of painting and the graphic arts.

In August 1854 Pissarro returned to St Thomas. By now he seems to have broken down his father's resistance to his intended career as an artist, and the Pizarros may have already decided on a family move to France. Camille left in the autumn of 1855, arriving in Paris in time to see the last few days of the great International Exhibition, where he particularly admired the landscapes of Corot. At some point over the next two years he met Corot, who never established a teaching studio but was free with advice to interesting newcomers. He seems to have been the first artist of stature to tell Pissarro to paint out of doors – 'The Muse lives in the woods' – and until the mid-1860s Pissarro described himself in catalogues as 'pupil of Corot'.

Meanwhile, his family had returned to France and Pissarro found himself involved for a time in business and living at home again in Paris. However, by the late 1850s his father had made him an allowance and he was able to paint in his own studio, or in the rural areas north and west of Paris where so much of his life was to be spent. He never received a conventional training, although he entered the Ecole des Beaux-Arts for a short time before quitting it in disgust at the staleness of its teaching methods. He did work from the model at the 'free' Académie Suisse, where in 1859 he met Monet, although their contact was cut short by the younger man's call-up for military service. Two years later, also at the Suisse, Pissarro got to know two future Impressionists, Paul Cézanne and Armand Guillaumin.

In conventional terms his career began promisingly (if a little late) in 1859, when *Landscape at Montmorency* was accepted for the 1859 Salon. The painting was Corot-like, with rich dark woodland greens and a pleasant bucolic picnic in progress, but the road in the foreground, drawing the spectator into the landscape, became one of Pissarro's characteristic devices.

In 1860 one of the crucial events in Pissarro's life occurred. He formed a relationship with his mother's housemaid, Julie

Vellay. When Julie had a miscarriage, she was turned away by the Pizarros, but Camille went with her. Their first child, Lucien (later a well-known artist), was born in 1863 and, over the following 20 years, six more survived. Although he still received some help from his parents, Pissarro now had to support a family. During the 1860s he established a certain reputation, but evidently it failed to lead on to enough commissions and sales. In 1865 he was even reduced to working for a while as a bank messenger. At the best of times money was in short supply, and it remained in short supply for most of Pissarro's life. That was one important reason for settling where he worked, in the rural environs of Paris, where the cost of living was low.

After several moves, in 1866 Pissarro and Julie took a house in the little town of Pontoise, in the valley of the Oise. As a townscape, *View of Pontoise, Quai de Pothuis* (pages 92-3) is unusual in his work of this period, and all the more so since he has placed a tall, steaming chimney in the centre of the canvas – the sort of gesture often seen by the Impressionists' contemporaries as an 'affront to the dignity of art'. In canvases painted a few years earlier, such as *The Banks of the Marne at Chennevières* (pages 90-1), the influence of Corot and Daubigny was still strong, but his views of Pontoise at first echoed the strong forms of the realist Courbet (some have a highly structured 'Cubist' look that is remarkable for their period) and then became increasingly concerned with the atmosphere enveloping the scene. By the time he painted *The Diligence at Louveciennes* (pages 96-7), Pissarro had found the appropriate technical means, using visibly broken brushwork to capture waterlogged surfaces, unstable shadows and reflections, and the gloomy, overpowering sky. Although his palette remained relatively dark-toned, he was developing the Impressionist landscape in his own sober style.

How much Pissarro learned from – or taught to – the other Impressionists during these years will probably never be known, for by this time, a good deal of cross-fertilization must have taken place. Pissarro had certainly renewed contact with Monet by about 1866, and met Renoir, Sisley and Bazille either through him or in the informal evening gatherings at the Café Guerbois.

With his marked taste for discussing art and politics, Pissarro seems to have turned up at the café fairly often, despite living outside the capital. By this time he was a political radical and a militant atheist; he had of course given proofs of his sincerity by crossing religious and class lines to make his alliance with Julie

Vellay. Although most shades of opinion were represented among the Impressionists, only Pissarro was consistently interested in politics and 'the social question'. Yet his artistic choice – to be primarily a landscapist – seemed politically more 'escapist' than that of upper-middle-class painters such as Manet and Degas, who were at least superficially closer to new social realities.

It would be wrong to suggest that Pissarro's radicalism was caused by poverty, but it may well have fuelled his sense of living in an unjust society. Curiously, he remained poor even though his canvases were regularly shown at the Salon, year after year, from 1864 (1867 was the only exception). The only dealer who took much interest in his work was Père Martin, a man in a very small way of business who paid rock-bottom prices – usually around 40 francs, scarcely enough to cover the cost of the materials. In 1868 Pissarro was forced to spend time in Paris, where he and Armand Guillaumin were reduced to earning money by painting blinds and shop signs. In 1869 the Pissarros moved from Pontoise to another small town, Louveciennes, this time on the left bank of the Seine and not far from Bougival, where Monet and Renoir were spending the summer painting.

In 1869, and again in 1870, two of Pissarro's canvases were accepted for the Salon; but what might have been a steady progress to success and security was rudely interrupted by the outbreak of war in July 1870. Living outside Paris, Pissarro and his family were more vulnerable than the city-dwellers to the all-engulfing Prussian advance, and he hastened to take his family to safety in Brittany. Once the Napoleonic regime, detested by all radicals, had fallen, Pissarro declared his willingness to fight for the republic, but a letter from his mother, reminding him of his family obligations, quelled his ardour! In December Pissarro, Julie and their children crossed to England, where other members of the family were already established.

Pissarro in London

Family support must have been important during this period, for Pissarro sold only two paintings during his months abroad. He settled in Norwood, at that time a semi-rural suburb to the south of London, and did a good deal of painting in the Norwood-Sydenham-Dulwich-Penge-Crystal Palace area. Among the best-known of his London paintings are a lovely, crisp Norwood snow scene and *The Crystal Palace* (pages 98-9), a canvas featuring the

ABOVE:

**The Diligence at
Louveciennes** 1870
Camille Pissarro
MUSÉE D'ORSAY,
PARIS

gigantic iron-and-glass construction put up in Hyde Park for the 1851 Great Exhibition and subsequently re-erected in South London as a showpiece and leisure centre. The silvery atmosphere softens the mass of the Crystal Palace, but the neatly delineated vehicles and people in city clothes give the picture an unusual (for Pissarro) 'modern life' quality.

Pissarro's most important contact in England was with Paul Durand-Ruel. When he left a painting at Durand's Bond Street gallery, Durand was impressed and ensured that Pissarro's work was seen in his exhibitions and in the South Kensington show where Monet was also represented. However, the British liked Pissarro's pictures no better than Monet's, and the only two canvases he sold in England were to Durand-Ruel himself.

Through Durand-Ruel, Pissarro made contact with his fellow-refugee Monet. They do not seem to have worked together

BELOW: **The Crystal Palace** 1871 Camille Pissarro ART INSTITUTE OF CHICAGO

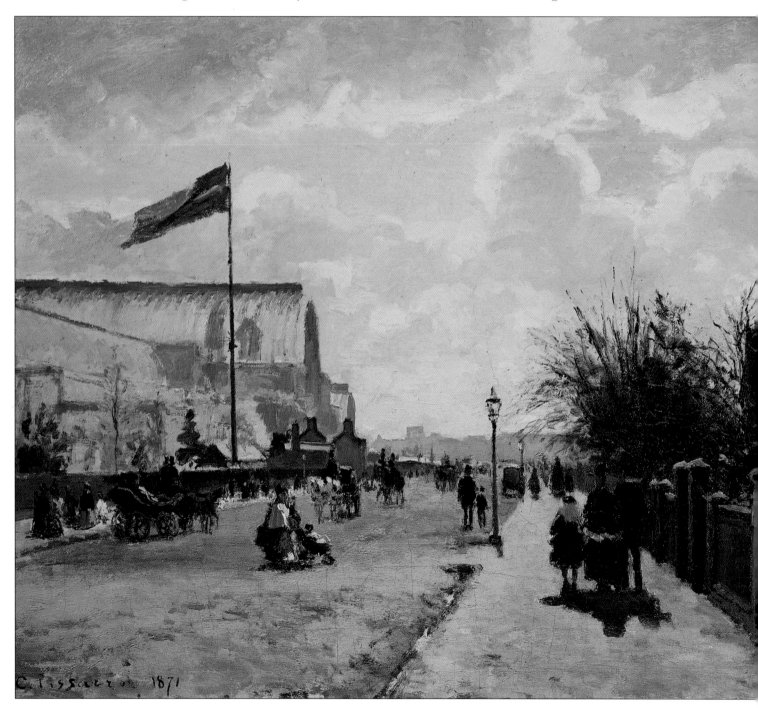

(Monet preferring the parks and the riverside at Westminster), but they visited galleries and museums and became acquainted with the British landscape tradition, notably Constable, Turner and the Norwich painter Old Crome. Pissarro spoke some English and found no difficulty in getting about, but he was impatient to go home. In a letter written to Théodore Duret in June 1871 he explained why: 'I'm set on returning to France. Yes, my dear Duret, I shan't stay here. It is only abroad that you realize how beautiful, great and hospitable France is. What a difference you find here! You receive only disdain, indifference, even rudeness; even colleagues are driven by egotism, jealousy and resentment. Here there is no art; everything is a matter of business.'

Evidently some unrecorded experiences embittered Pissarro's view of England, although his ill-success cannot have helped. 'My paintings just aren't catching on here, but that seems to be my fate everywhere' – a lament that would frequently be heard in the years to come. Home life in England was also fraught, for Julie's always uncertain temper was at its worst in an alien environment. A peasant girl, she was unwilling to adapt to England, making no attempt to learn the language even to go shopping. However, she was pregnant with their fourth child and she and Camille decided to legalize their union discreetly by marrying at the Croydon Register Office in June 1871.

Louveciennes and Pontoise

Soon afterwards they returned to Louveciennes. Pissarro expected the worst, since he already knew that the occupying Prussian troops had made a shambles of his house and had used his canvases as duckboards to protect their boots from the mud. He declared that only 40 paintings out of 1,500 had survived, and although that may have been an exaggeration (it has been plausibly suggested that the figure included drawings and studies as well as finished works), the loss was a serious one to an artist who, at 41, might have supposed that he had already accomplished much of his best work. Fortunately, as the future would show, Pissarro's years of high achievement had only just begun.

Sisley also lived at Louveciennes and he and Pissarro often worked together; *Chestnut Trees at Louveciennes* (page 21) is typical of the strong, simple style that Pissarro had developed in the early 1870s. But within the year the Pissarros had made up their minds to move. Camille decided that he preferred the landscapes around

ABOVE: **The Little Bridge, Pontoise**
1875
Camille Pissarro
STÄDTISCHE KUNSTHALLE, MANNHEIM

Pontoise, of which the family had happy memories from the late 1860s; and another attraction was that Julie had relatives there. They settled in August 1872 in a picturesque corner of the town known as L'Hermitage, which would feature in many of Pissarro's paintings (for example, *La Côte des Bœufs*, page 212).

Pissarro's left-wing outlook made him sympathetic to the idea of co-operation and communities, and at Pontoise he was joined by Armand Guillaumin and other artists with whom he worked side by side and held long discussions. He was also joined by his old friend Paul Cézanne, who lived briefly in Pontoise and then settled nearby at Auvers. Cézanne, not yet a great master, was working his way out of his wild early manner and found the ideal mentor in Pissarro. A patriarchal yet mild, undogmatic figure, Pissarro was

able to stay on good terms with the eccentric, touchy Cézanne in spite of a master-pupil relationship that Cézanne would have found intolerable with almost any other artist. Pissarro behaved as a colleague rather than a teacher, and his own willingness to learn is apparent in the strongly-structured pictures that he created in the 1870s, which undoubtedly owe something to Cézanne's influence. *The Little Bridge, Pontoise* (left) has a conspicuous strength and solidity, with firmly brushed-in forms that anticipate Cézanne's masterworks almost a decade later.

Despite his former successes at the Salon, Pissarro decided not to submit anything to the 1872 and 1873 shows. The event proved him right: under new post-war rules the jury was even more conservative than before, rejecting the canvases sent in by Renoir, the only one of the younger male Impressionists to keep on trying his luck. Yet Pissarro badly needed recognition and an outlet for his work. He was still miserably poor. Durand-Ruel bought his canvases for 200 francs each, but when money was tight, Pissarro was often forced to sell for less elsewhere. The long-awaited breakthrough seemed to have occurred in January 1873, at an auction of paintings collected by the department-store tycoon Ernest Hoschedé, when six works by Pissarro were knocked down at prices between 210 and 950 francs. Pissarro wrote optimistically to Théodore Duret, 'You are right, my dear Duret, we are beginning to make our mark.' But the Hoschedé sale proved to be a flash in the pan and Pissarro was soon complaining again that he was penniless. His hopes turned to the formation of a society of artists that would bypass the Salon and exhibit and sell independently. His friends were moving in the same direction, and Pissarro prepared with enthusiasm for the launching of a new type of co-operative venture.

BAZILLE
1841 – 1870

The only Impressionist to fall in the Franco-Prussian War, Frédéric Bazille died before his potential could be realized and we can only guess at the direction his art would have taken if he had lived. In most accounts of Impressionism he inevitably figures as an 'extra', taking a supporting role in the lives of his poorer but longer-lived friends, Monet, Renoir and Sisley. However, the small body of work he had time to produce is rather

different from theirs and interesting in its own right. Decades later, Monet would declare 'A picture by Bazille – that's something worth seeing!'

Bazille was born into a wealthy wine-producing family at Montpellier, in the South of France, on 6 December, 1841. He went to Paris to continue his medical studies, but, already in love with painting, began to frequent Gleyre's studio, where he met Monet, Renoir and Sisley. His tolerant, cultivated parents hoped that their son would prove capable of combining medicine and art, but after he failed his examination in 1864, they accepted that he was determined to make a career as a painter. Unlike Monet and Renoir, Bazille received an adequate allowance and never experienced serious financial difficulties, although he may on occasion have overstretched his resources to help his friends. When he shared a studio with one or the other of them, he almost certainly paid the rent and most of the running expenses. He remained remarkably patient even when bombarded by letters from the improvident Monet, who angled for every form of assistance, from cash to a barrel of the Bazille family wine; and in 1867 he arranged to buy his friend's *Women in the Garden* for 2,500 francs (far more than Monet could have hoped to get for the painting elsewhere) in instalments of 50 francs a month – in effect a discreet pension that should have ensured that Monet and his family never lacked the necessities of life.

Rescuing Renoir

All this lay in the future when the four young hopefuls met at Gleyre's. 'Tall Bazille', self-assured and agreeable, may have been the key figure in bringing them together. He was certainly the first to make contact with Auguste Renoir, picking him out as 'someone' (artistically if not socially) and saving him from one of the menacing crowds that the young Renoir seemed to attract. This episode occurred when Bazille and Renoir were strolling in a park. Renoir spotted a baby crying in its pram and, since its nursemaid was preoccupied with her hussar boyfriend, he rocked the pram to quieten the baby. When the nursemaid noticed a strange man interfering with her charge, she set up an outcry and the hussar and the bystanders prepared to do something drastic. Then Bazille intervened, quieted the fuss and settled matters with a patrician gesture: he handed his card to the park attendant, who respectfully accepted his explanations but could not resist ticking

off the much less patrician Renoir. Even in his old age Renoir recalled 'the friend of my youth' with affection and something like awe, as 'the sort who gives the impression of having his valet break in his new shoes for him'.

During the early 1860s Bazille was even closer to Monet. The two friends discovered the pleasures of painting in the Forest of Fontainebleau, at Chailly, in 1863, only taking Renoir and Sisley

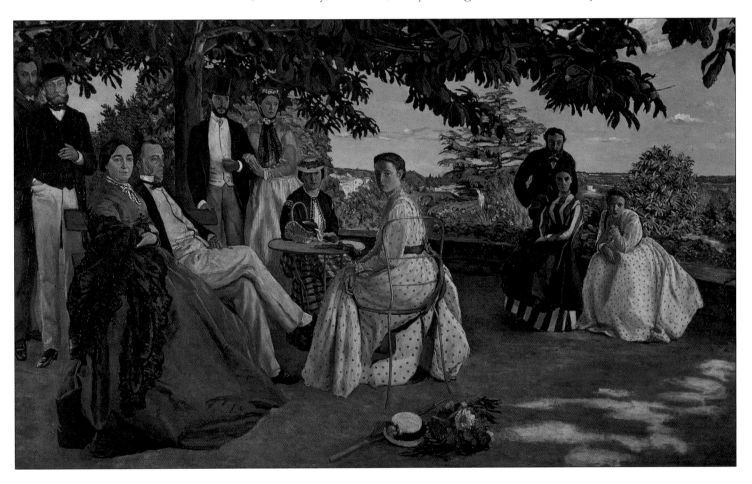

with them for a second visit the following summer. Bazille also accompanied Monet on a working trip to Normandy in March 1864. While he was there he met Boudin and Jongkind and helped to convince Monet's family that it was possible to be both an artist and a gentleman. The trip was so successful that Bazille joined Monet at Honfleur again later in the year.

Early in 1865 the two artists shared a Paris studio in the Rue Furstenberg. Bazille's first well-known painting dates from later that year, when he made a third visit to Chailly, where Monet was impatiently waiting to use him as a model for his ambitious *Déjeuner sur l'Herbe*. By the time Bazille arrived, Monet had injured

ABOVE: **The Artist's Family**
1867
Frédéric Bazille
MUSÉE D'ORSAY, PARIS

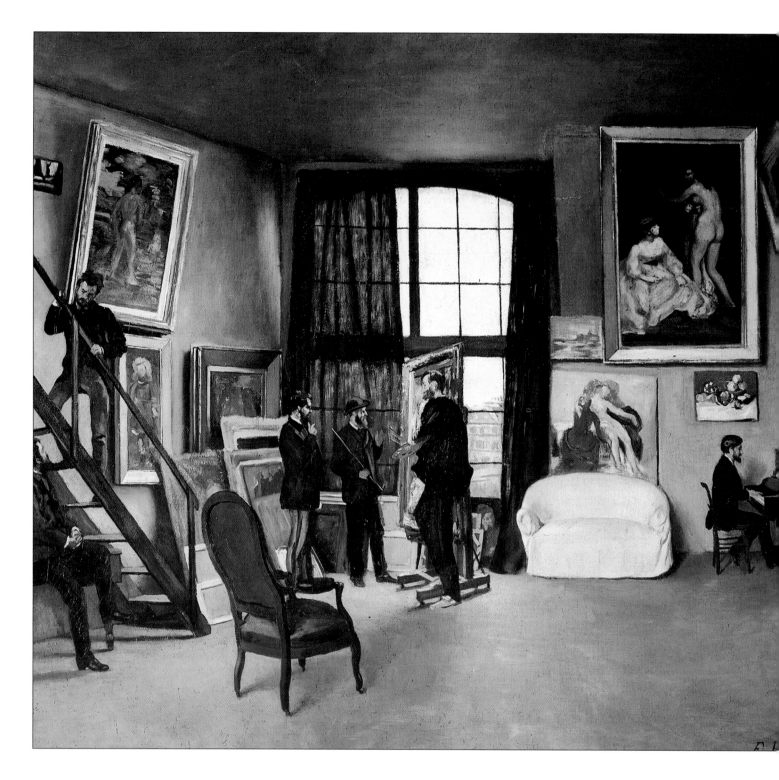

ABOVE:

**The Artist's
Studio**
1870
Frédéric Bazille
MUSÉE D'ORSAY,
PARIS

his leg and was confined to bed. Bazille's medical training enabled him to make his friend comfortable, and he set up a device that eased Monet's pain by steadily dripping water onto the injured leg. Then he commemorated the situation by painting *Monet after his Accident*, showing the woebegone artist lying propped up in bed with the drip suspended from the ceiling above his exposed leg; the device looks as though it was nothing more than a large

pottery jar with a hole in it. When Monet had recovered, Bazille did pose for the *Déjeuner*; his tall form is unmistakable in at least two of the painted figures, and most of the remaining male picnickers may be imaginative variations on his appearance.

According to Renoir, Bazille proclaimed his ardent belief in painting nature and contemporary life at their very first meeting, but like most anecdotes of the kind, this probably puts back the artist's acquisition of Impressionist ideals by several years. In 1866, however, we do find Bazille writing to his parents that he had chosen to paint the modern age because it was the subject he knew and understood best and 'has most life in it'. He was conscious that this was still a minority position and predicted correctly that his *Girl at a Piano* would be rejected by the Salon jury.

Another disappointment followed in 1867, when a large family portrait was turned down. This was a bad year for most of his friends and Bazille joined Renoir, Sisley and Pissarro in petitioning for a revival of the Salon des Refusés. For the first time, too, some of these artists contemplated holding an entirely independent exhibition, as we know from another of the letters written by Bazille to his parents. The scheme was not just an expression of youthful rebellion: 'Courbet, Corot, Diaz, Daubigny and others have promised to send us pictures and very much approve of our idea. With these people and Monet, who is stronger than all of them, we are certain to succeed.' Unless Bazille was name-dropping for the benefit of his parents or to angle for funding, by 1867 the young painters had made a set of first-rate contacts, although none of these established figures would come in with them when the first Impressionist show was actually mounted in 1874. The other point of interest is Bazille's confident assertion of Monet's greatness at this early date; to place him above Courbet and Corot showed either wilful partisanship or future-piercing insight.

Winning at the Salon

The proposed exhibition failed to materialize and Bazille made ready for another Salon. During 1867 he had shared a studio in the Rue Visconti with Renoir and, a little later, a near-destitute Monet. At the beginning of 1868 he moved from the Left Bank to the Batignolles quarter, taking a large studio in the Rue de la Condamine, not far from the Café Guerbois. He was already friendly with Manet and seems to have been one of the more assiduous patrons of the café. Manet's influence may have

been partly responsible for the crisp style of figure painting that Bazille was developing. *The Artist's Family* (page 103), probably Bazille's best-known work, exemplifies this. It was a new version of the painting rejected in 1867, showing Bazille's father and mother seated on a bench, in company with other members of the family, on the terrace of their home outside Montpellier; Bazille himself stands on the extreme left. The solemnity of the group is irresistibly reminiscent of an early photograph in which the sitters have obviously been 'holding still' for an uncomfortably long time; the figures and the landscape might come from two different paintings; and yet the picture exercises a considerable fascination for the viewer, who is as much the scrutinized as the scrutineer.

Although its colouring was brighter than that of most Salon paintings and its subject was modern, *The Artist's Family* was accepted by the jury in 1868; no doubt its dignified, respectable subject spoke in its favour. The present state of the picture is rather different from the Salon version, since Bazille retouched it a year later, re-doing at least two of the heads and painting in the still-life group (hat, umbrella, flowers) at the front.

He was shown again at the Salon of 1869, where *View of a Village* (right) was noticed favourably by Berthe Morisot, whose reference to 'tall Bazille' in a letter to her mother suggests that they were acquainted. Morisot felt that Bazille had been successful in rendering a figure in outdoor light – certainly a difficult feat when the figure concerned was large and placed in the foreground, so that it tended to look detached from its surroundings. In this respect, *View of a Village* was an advance on a painting such as Monet's *Women in the Garden* (page 65), although Impressionists in the 1870s and 1880s, including Morisot, mastered the difficulties even more completely. Bazille's painting is most notable for two effects that obviously delighted him: the contrast between the crispness and bright geometrical design of a dress and the softer forms and colours of nature; and the almost vertiginous sensation given by viewing a large foreground figure with distant but rising ground behind it, its role emphasized by the presence of a village. As early as 1865, Bazille had painted a sort of reverse image of this one, *The Pink Dress*, in which the girl is facing away from the viewer. As in *View of the Village*, the effect is striking and unusual.

By 1870 Bazille must have felt that he was beginning to make a name for himself. Unlike Monet, whose precocious success had

RIGHT: **View of a Village** 1868 Frédéric Bazille MUSÉE FABRE, MONTPELLIER

been followed by a string of rejections, Bazille seemed to be winning over the Salon jury with contemporary scenes, in bright, open-air settings, of a kind to which it was supposed to be resolutely hostile; yet only his tighter, more finished painting style, close to the approved academic manner although employed to different ends, seemed designed to please the authorities.

Nevertheless 1870 saw one of his 'modern life' paintings hung again. This time it was *Summer Scene*, in which a group of young men are shown swimming, loafing or wrestling. Their striped bathing drawers add an almost jazzy 'modern' note to the scene and, while the figures are photographically distinct in Bazille's most characteristic vein, the pool and the intensely bright landscape background are also beautifully painted. In the late 1860s Bazille had developed an original style that made him an artist with – it seemed – a future.

Group Portraits

Two paintings serve to record the appearance of Bazille and most of his friends in the early months of 1870. In Fantin-Latour's *Studio in the Batignolles* (pages 34-5) Bazille features among Manet's admirers; he stands on the right, unmistakable because of his great height, between Edmond Maître and Claude Monet. A few months after posing for Fantin-Latour, Bazille painted a very different kind of record, *The Artist's Studio* (pages 104-5). By contrast with Fantin's formal, reverential group, Bazille shows his big studio on the Rue de la Condamine as a place where friends do as they please. Emile Zola is standing on the stairs, calling down something to Renoir, who sits below him on a table. On the other side of the room Edmond Maître is playing the piano. At the easel stands a pipe-smoking Manet and, beside him, Monet with the hat and stick, looking at a large framed picture which is presumably by Bazille; painted in by Manet, he is shown, author-like, looking at the critics rather than at his own work. The walls of the studio are covered with paintings, some of which can be identified. The canvas above the couch, between Bazille and Maître, is an entertainingly cursory variation on a canvas, *La Toilette*, which Bazille had not long before submitted to the Salon. Although in reality meticulously finished and vaguely 'oriental', in a style that generally appealed to the jury, it was rejected by the same men who accepted the 'modern' *Summer Scene* – a prime example of the vagaries of a jury system even where there was supposed to have

been a consensus about what constituted fine art.

 The war with Prussia broke out in July 1870. In August Bazille joined the Zouaves, and on 28 November he was killed in an insignificant encounter at Beaune-la-Rolande in Burgundy.

SISLEY

1839 – 1899

Appreciation of Alfred Sisley's work has always been a little half-hearted. His reticence and lack of self-assertion limited his impact on his contemporaries and even on posterity, which is often strongly influenced by the survival of letters and anecdotes that bring the artist's personality to life. In the case of Sisley these are largely absent, and his paintings have had to make

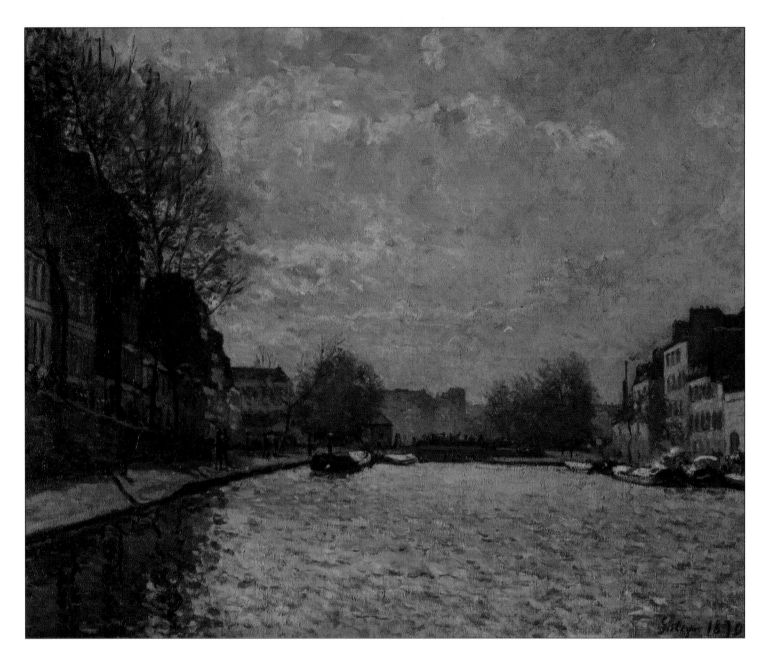

ABOVE: **Canal Saint-Martin**
1870
Alfred Sisley
MUSÉE D'ORSAY, PARIS

a place for themselves without biographical props. They have done so very slowly, since their subject matter is limited to landscapes and their quiet poetry is easy to overlook in a crowded gallery. In the nineteenth century, when even the more varied and flamboyant work of Monet took so long to establish itself, lack of appreciation for Sisley's art was not really surprising. Twentieth-century neglect has been more culpable, but amends finally began to be made with major exhibitions of his work in the early 1990s.

Alfred Sisley was born on 30 October, 1839, in Paris. Although there was a notable French strain in the family, his parents were English and Sisley himself was never technically a Frenchman. However, he was French by upbringing and habit – so much so

that his father, William Sisley, sent him to London for four years (1857–61) to acquire English and a commercial training that might be useful to a family firm dealing in silks and other materials. Alfred did master the language, but his commercial skills seem to have been less in evidence. At any rate, William Sisley quickly agreed to allow his son to study art instead of taking part in the business.

In 1862 Sisley enrolled at Gleyre's studio, where he encountered Monet, Renoir and Bazille. For a time he seems to have retained conventional ambitions, planning to enter for the Prix de Rome, which held out the tempting prospect of a four-year painting scholarship in Italy. Nothing came of the project and when Gleyre closed his studio, Sisley made no attempt to find another master. In June 1864 he went on a trip with his friends to Chailly in the Forest of Fontainebleau and there, if not earlier, became a convert to *plein-air* painting.

During these years Renoir seems to have been his closest friend. At any rate Renoir's fine portrait of William Sisley must have been commissioned through Alfred; apart from earning Renoir some money, it was accepted for exhibition at the 1865 Salon. The two artists spent the spring of 1865 together at Marlotte, took a summer trip down the Seine and then went back to Marlotte. *A Village Street in Marlotte* was one of two pictures shown in the 1866 Salon by Sisley, who was still conventional (or polite) enough to describe himself in the catalogue as 'pupil of Gleyre'.

Alfred and Eugénie

In 1866 Sisley was sharing an apartment with Renoir, but he left in the course of the year to live with Eugénie Lescouezec. Until recently Eugénie was believed to have been Sisley's wife, and Renoir's superb double portrait of 1868 is still usually called *Sisley and his Wife* (page 78), but evidence has been found to prove that they never actually married. Since they remained utterly devoted to each other for the next thirty-odd years, this is something of a mystery,; but no plausible explanation of it has yet been put forward. Several of the Impressionists lived with women for years before legalizing the union and legitimizing the children, often when time or circumstances had weakened the opposition of their middle-class families; it was the convenient as well as the conventional thing to do and even the radical Pissarro succumbed. But despite the birth of two children in 1867

OVERLEAF PAGES 112-13:

Footbridge at Argenteuil
1872
Alfred Sisley
MUSÉE D'ORSAY, PARIS

111

and 1869, the Sisleys never did.

According to Renoir, Eugénie had been a model, which was not really respectable; Renoir, however, praised her sensitivity and blamed the financial ruin of her family for her choice of occupation. The attitudes of the couple in his double portrait bring out the woman's trust in Sisley's protection and Sisley's tender care of her. Sisley's gentleness was the quality Renoir emphasized. He was especially moved by women and indeed (again according to Renoir), was irresistible to them and incapable of resisting them. Renoir's painting owes much of its appeal to an informality that we now hardly notice. A more 'dignified' arrangement would make us conscious of Sisley's proper outfit,

BELOW: **A Rest Beside the Stream, Lisière de Bois** 1872 Alfred Sisley MUSÉE D'ORSAY, PARIS

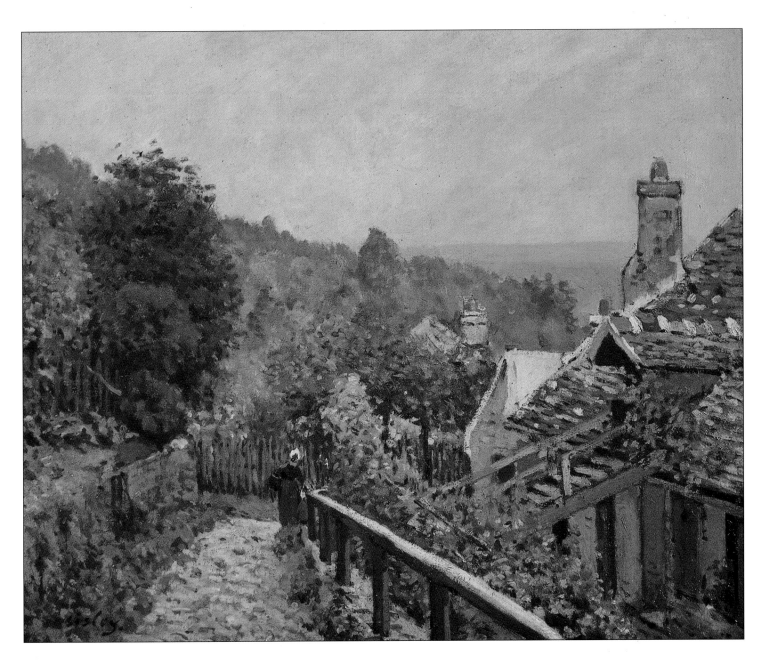

including the top hat and gloves that have been relegated to the side of the picture, and of the symmetry and low centre of gravity of Eugénie's fashionably cumbersome dress. Renoir's use of cropping in his composition, although not as dramatic as Degas', is highly effective.

In the later 1860s Sisley had only one canvas accepted for the Salon, although his painting was still relatively conventional. One of his earliest known works, *Avenue of Trees at La Celle Saint-Cloud* (1865), is an excellent, lush green landscape in the manner of Corot and the Barbizon school. As late as 1869, *View of Montmartre from the Cité des Fleurs* (page 109) showed no great stylistic change: the colours are dark, the paint is applied with traditional

ABOVE:
Louveciennes, The Heights of Marly 1873
Alfred Sisley
MUSÉE D'ORSAY, PARIS

smoothness and the buildings are outlined with almost exaggerated care. The only hallmarks of the later Sisley are the big sky and the sense of rural peace which fills this scene, painted from a Paris apartment.

As Sisley's rendition of the view suggests, Montmartre was still a hill village outside Paris, although the capital would engulf it within a few years. The Cité des Fleurs was in the Batignolles quarter; Sisley had moved there in 1869, taking a studio in the same building on the Rue de la Condamine as his friend Bazille. Renewed contact with his old friends (for Renoir and Monet, both impecunious, were very much in evidence at Bazille's) may well account for the dramatic change that occurred in Sisley's work at this time. In his paintings of the Canal Saint-Martin (page110) he went over almost completely to the broken brushwork technique used by Monet and Renoir in the summer of 1869, applying the colours with small strokes to create a sense of moving water and shifting clouds under a wintry light.

Ruin – and Mastery

Two of these canal views were accepted for the Salon of 1870. In July of that year France went to war, and although Sisley's English nationality meant that he was not called on to serve, the conflict had momentous consequences for him. He is generally believed to have stayed in Paris until the end of the siege, but it is also possible that he took refuge in England; in old age Durand-Ruel claimed to have been introduced to Sisley in London, although other sources place their first meeting later. During the Commune, Sisley and his family moved out to Louveciennes, perhaps intending to return to the capital; but the war ruined William Sisley, who died soon afterwards, and Alfred suddenly found himself without resources. For once we have a clear report, in a letter written by Pissarro, on his situation: 'His father suffered severe financial reverses shortly before his death and Sisley and his wife and two children no longer enjoy the material comforts of earlier years.'

Sisley's material comforts had been provided by a generous allowance from his father. They may have encouraged him to behave as a gifted amateur rather than a dedicated artist. This would explain why he developed quite slowly and why fewer than 20 of his canvases survive from the pre-war period. From 1871 necessity made him a professional painter, compelled to work

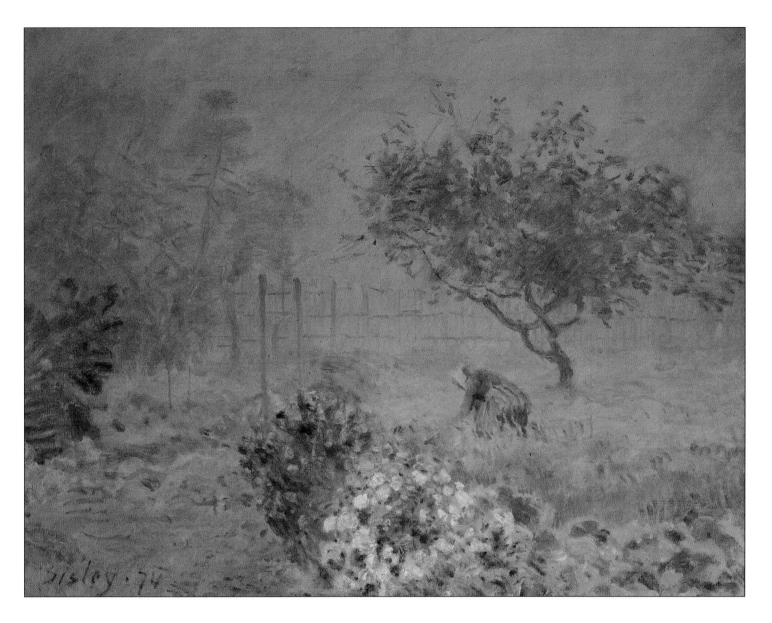

regularly, and urgently in need of sales. It also meant that he continued to live outside Paris, where life was cheaper, although that seems to have suited his quiet nature very well. For some years he was not isolated (as he later became), since Monet, Renoir and Pissarro were all living and working nearby and in much the same situation. Like Renoir, Sisley visited Monet at his new house in Argenteuil and was evidently delighted with the little resort. He painted not only the river but the town's little square and, rather uncharacteristically, *Footbridge at Argenteuil* (page 112-13), with its strong sense of the timbers of the bridge and the people crossing on a dull day.

Sisley's paintings of the early 1870s seem filled with the confidence born of new discoveries and a new sense of his own powers. Although his mood is nearly always tranquil, considerable

ABOVE: **Misty Morning** 1874
Alfred Sisley
MUSÉE D'ORSAY,
PARIS

variety is offered by pictures such as *A Rest Beside the Stream, Lisière de Bois* (page 114), *Louveciennes, the Heights of Marly* (page 115) and the celebrated *Misty Morning* (page 117), a virtuoso rendition of early morning mist in summer. Even in reproduction, something of the vigour of his brushwork can be made out.

Like his friends, Sisley no longer submitted canvases to the Salon. In 1873 he was among the artists who announced their intention of holding an independent group show, but we know almost nothing about his involvement in its organization. Already at the height of his powers, he may have hoped for great things from it.

RIGHT: **The Balcony** 1868 Edouard Manet MUSÉE D'ORSAY, PARIS

MORISOT
1841 – 1895

In the nineteenth century, hundreds of thousands – perhaps millions – of women painted well. But almost none of them became professional artists or produced work that was anything more than charming and accomplished. In a respectable girl, the ability to draw and paint, like the ability to play the piano or sing, was a pretty accomplishment that might well prove to be an asset in the hunt for a husband, but it was not to be taken too seriously and would inevitably be neglected once she was safely married and the children began to arrive. Only a tiny minority of middle-class girls continued to paint in adult life and aspired to anything resembling a professional career. Of these, Berthe Morisot was not only the greatest but also the most daring artist, since she made common cause with a group of painters whose works provoked unprecedented outrage and abuse.

Berthe was the third daughter of Tiburce Morisot, one of France's administrative elite. She was born, on 14 January, 1841, at Bourges, the capital of the Cher department of which Tiburce was the prefect. She was brought up in conventional fashion, with an English governess, and when she was 11, the family moved to Passy, an upper-middle-class area on the outskirts of Paris where she lived for the rest of her life.

Morisot was very close to her sister Edma, who was almost two years older, and as allies they were able to make more of their shared passion for painting than most girls of their station. After taking lessons from a local drawing master, they were allowed to study with an established painter, Joseph Guichard, who introduced them to the treasures of the Louvre and in 1858

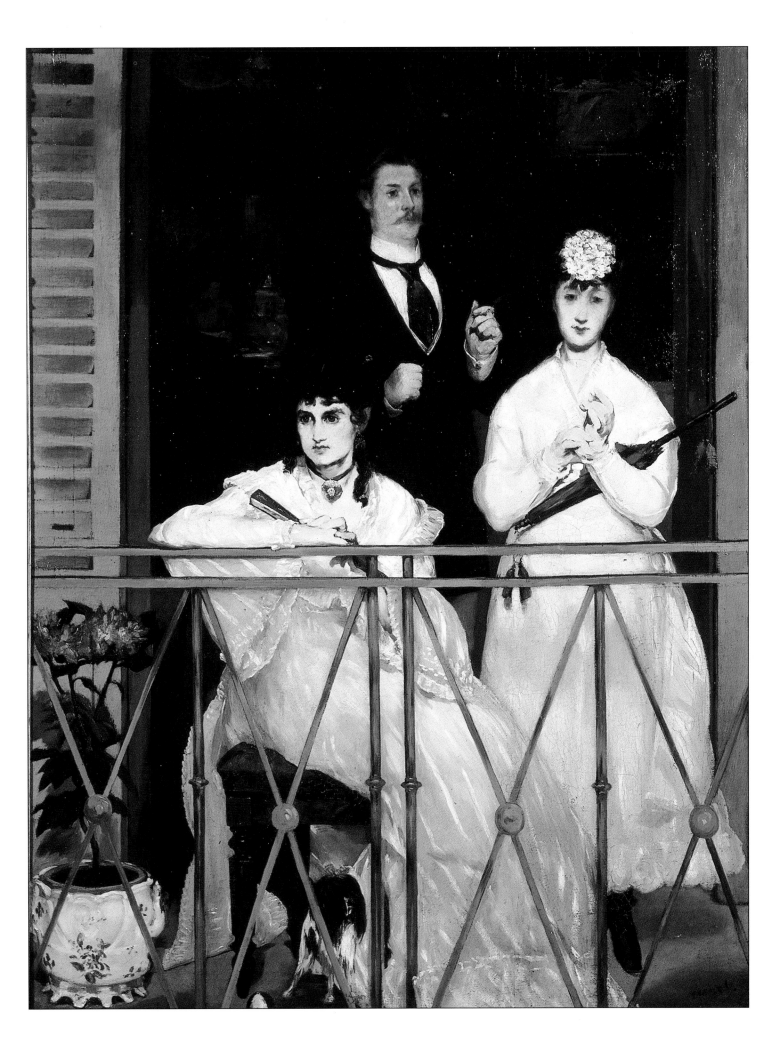

arranged for them to work there on the special days set aside for copyists. Then in 1860, when they decided that they wanted to paint in the open air, they were put under the guidance of the greatest landscapist of his generation, Camille Corot. As we have seen, it was actually much more acceptable for women – amateurs, or amateurish, by definition – to work outdoors than it was for their male counterparts.

The Constraints of Femininity

Clearly the Morisot sisters led a privileged existence and their paths were smoothed for them. But there was a negative side to it all from the point of view of their development as artists. Berthe and Edma could never put painting first in quite the same way as male artists could. Because they were not expected to shut themselves away or go out to work, they were caught up in a time-wasting social round. As respectable women, they were disbarred from many valuable experiences and enjoyed others only under supervision. They could not go to the Louvre without being accompanied by a chaperone, let alone wander in the Forest of Fontainebleau or spend an evening in a café or studio with fellow artists, discussing form, style or technique. Moreover, when the sisters showed their work, privately or publicly, it would often be treated with kindly indulgence rather than the rigour and respect from which an artist can benefit. Although smooth, their paths were narrow and were not intended to lead them to the republic of art.

Even so, Berthe and Edma were alarmingly able, and Guichard felt that it was his duty to warn their mother of the possible dangers. In a remarkable letter he predicted that his teaching would turn the girls into painters, not talented amateurs, an outcome that could only be viewed as disastrous for daughters of the *grande bourgeoisie*!

Fortunately, Guichard's warnings went unheeded. Berthe and Edma continued to work with Corot and then, from 1863, with the minor Barbizon painter Achille François Oudinot. Later they broke with Oudinot after some kind of three-way entanglement and never acknowledged him as one of their masters. Meanwhile, in 1864 they took the crucial decision to submit their works to the Salon jury. In doing so they were not necessarily putting themselves forward as professional artists, but they were implicitly making a claim not far short of it – that their canvases could stand

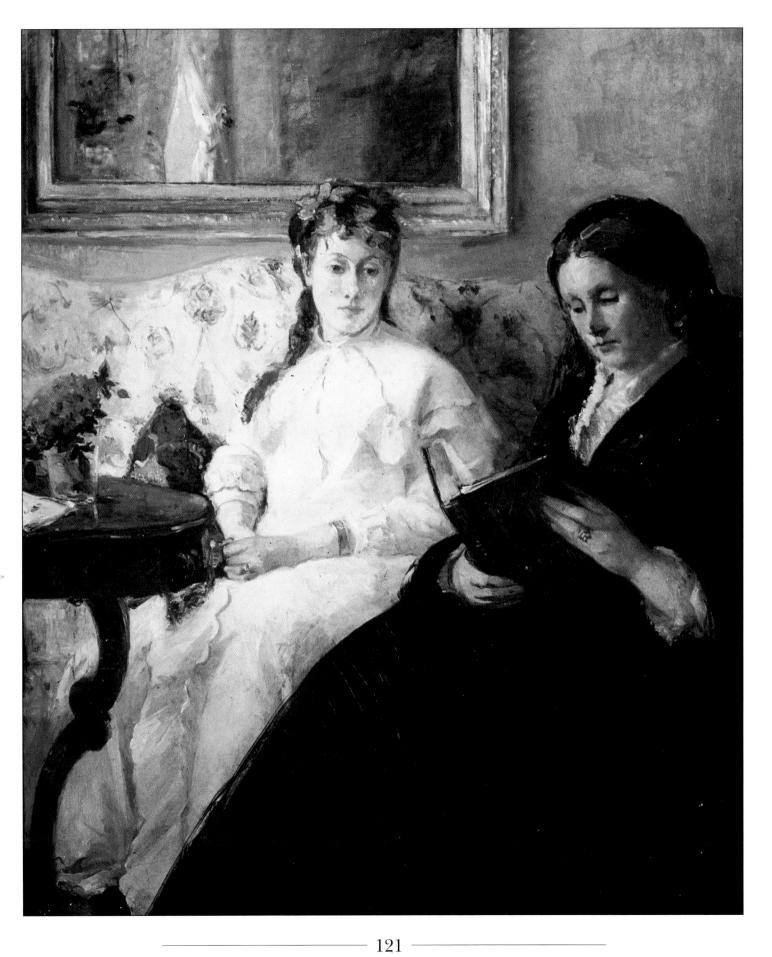

comparison with the submissions of most professionals. The result justified them, for all their paintings were accepted. Berthe afterwards showed work at the Salon almost every year, and as far as we know, only one of her pictures was rejected between 1864 and

1873. Whether the Salon jury found her style genuinely to its taste, or whether the acceptances represented patronizing gestures, is hard to tell from the few items which have survived Morisot's ruthless purging of her early work.

PREVIOUS PAGES
122-3:

**Harbour at
Lorient** 1869
Berthe Morisot
NATIONAL
GALLERY OF ART,
WASHINGTON, DC

Morisot and Manet

As the years passed, the mother of the Morisot girls began to worry about their marriage prospects. In 1868 Berthe made the most important contacts of her life when Fantin-Latour introduced her to Edouard Manet, through whom she also met the painter's brothers, Gustave and Eugène. The Manets and Morisots belonged to the same class (both fathers had been higher civil servants), and close relations were established between the two families. Berthe agreed to pose for the seated figure at the front in *The Balcony* (page 119) and when the canvas was shown at the 1869 Salon, she was amused to find herself spoken of as a 'femme fatale'! Although also entertained by Manet's alternating expectations of triumph and disaster, she found him charming and sat for him ten more times over the next few years.

As this studio association was voluntary on both sides, it is hard to avoid the conclusion that there was a strong bond of sympathy between Manet and Morisot. Inevitably, their relationship has been interpreted as a love affair, although the presence of Morisot's mother as a chaperone would certainly have prevented any very dramatic developments. The novelist George Moore asserts that 'there can be little doubt that she would have married Manet if Manet had not been married already', but Moore was always so anxious to parade his insider status that he often made statements that should be taken with a pinch of salt. More convincing are the facts that in 1872 Manet painted *Berthe Morisot with a Bouquet of Violets* and a little picture with just the bouquet (violets were well-known love offerings), the fan Morisot had flourished in *The Balcony* and the glimpse of a note from the painter to his sitter.

Morisot's involvement with Manet, whatever its exact nature, seems to have had a negative effect on her work. Extended contact with Manet's art and personality may have been inhibiting, for in the late 1860s she not only painted less but was also more reluctant to show anything she had done. Another disturbing event was the marriage of her sister Edma to a naval officer, Adolphe Pontillon, in March 1869. Berthe lost her companion, her fellow enthusiast and a useful arrangement whereby each girl chaperoned the other, reducing their dependence on their mother and giving them relative freedom of movement. The indispensable part played by a chaperone is illustrated by a remark in one of Morisot's own letters: she strolled about the 1869 Salon with Manet and his wife and mother,

but found herself in a quandary when she lost sight of them, as 'it hardly seemed respectable to circulate alone'.

Edma's marriage undoubtedly led Berthe to wonder whether she would, or should, ever be a wife and mother, the 'natural' career for a woman. After visiting the Pontillons at their home in Lorient, Brittany, in the summer of 1869, she felt 'lonely, disillusioned and old', despite the fact that while she was there she had painted the splendid *The Harbour at Lorient* (pages 122-3). Manet's interest in Eva Gonzalès, whom he had taken on as a pupil, also increased Morisot's sense of isolation. Although she had never been – or wanted to be – Manet's pupil, her letters reveal her jealousy of Gonzalès and her pleasure when Manet praised *The Harbour at Lorient* and made her feel that 'apparently I'm doing decidedly better than Eva Gonzalès'. Whatever her doubts, she resisted her mother's increasingly desperate matchmaking, possibly strengthened by the realization that the talented Edma was finding it impossible to reconcile marriage with serious painting. Said to have been as talented as Berthe, she failed to realize her potential.

Late in 1869 a pregnant Edma returned to Passy to have her first child in the family home. While she was there, Berthe began *Portrait of the Artist's Mother and Sister* (page 121). She was still struggling to get her mother's head right in March 1870, when it was almost time to send it to the Salon. Manet promised to help, turned up at Passy, admired the painting, added a few delicate touches and then became more and more carried away, putting on paint here, there and everywhere until, in Morisot's view, it had become a caricature – which had to be sent into the jury forthwith. The condescension implicit in Manet's behaviour wounded Morisot deeply and the picture was withdrawn and then submitted again before it finally appeared, along with *The Harbour at Lorient*, at the Salon of 1870. As it is actually a grave and lovely picture, Morisot's understandable resentment may have led her to exaggerate the damage inflicted by Manet, unless she did some rapid repainting between withdrawal and re-submission. Possibly he may have given the canvas a greater degree of 'finish', for *The Harbour at Lorient* shows that Morisot was already capable of remarkably cursory brushwork, as unacademic as anything being done by her male contemporaries. The fact that such a painting was passed by the Salon jury reinforces the suspicion that its attitude towards talented but well-brought-up young ladies was very different from the sternness with which a 'sketch' by a male artist could expect to be treated.

Artistic Maturity

In 1870–1 the Morisots lived through the siege of Paris in their house at Passy, which lay behind the French lines. Berthe, like many others, lost weight because of the food shortages. When the Commune was proclaimed, the family moved to stay within the Versailles government's lines, and so Berthe had no direct experiences of the savage fighting in either of the conflicts which ravaged France.

RIGHT: **The Cradle** 1873 Berthe Morisot Musée d'Orsay, Paris

Meanwhile she was maturing rapidly as an artist and re-creating herself as a personality. Now 30, she was a striking figure, slender, hollow-eyed, nervously abrupt, always dressed in black and white; much of her almost haunted quality is conveyed by Manet's later portrait of her. As an artist she was concentrating on domestic and feminine subjects, and in 1871 she produced what has become her most celebrated painting, *The Cradle* (right), the first canvas in which she exhibits the restrained, unsensuous sweetness that distinguished her work from that of the other Impressionists.

At the same time she was striving to become a true professional. Although she exhibited at the Salon and occasionally at provincial shows, Morisot knew that the mark of the professional was to sell work regularly and for good prices. She had no need of the money (although there must have been a good deal of pleasure in being able to dispose of resources freely, without considering anyone's opinion), but monetary rewards would prove that she was no longer a lady amateur. It is doubtful whether she (any more than several of her male colleagues) made enough to support herself, but she put her works up for sale in the windows of art shops and, in July 1872, had the pleasure of selling four pictures to Paul Durand-Ruel.

By giving her his custom, Durand-Ruel virtually classed Morisot as a member of the new school of painters, later to be called the Impressionists, in which he was mainly interested. However, the only Impressionists she seems to have known at this time were Manet and Degas. When the idea of an independent group show was mooted, Manet was against it, so it is almost certain that the invitation to take part came from Degas. We do not know exactly why Morisot, the successful Salon exhibitor, said Yes: perhaps because the sincerity of an invitation was by definition more certain than the gestures of a Salon jury, or because joining a breakaway group was an adventure and one of the few available to her. Even so, there was an element of risk in courting

such public exposure. As it turned out, the year of the First
Impressionist Exhibition, 1874, became a personal as well as
an artistic landmark for Berthe Morisot.

CÉZANNE

1839 – 1906

Paul Cézanne was by far the oddest character among the Impressionists: a man of extreme tensions and neuroses who was out of step with almost everything and everybody. Until he was over 30 Cézanne worked in a strange, violent style of his own, taking up the Impressionist landscape only a couple of years before the first group exhibition. Nor did he stay an Impressionist long. After a few years he abandoned the style and, working in solitude, became one of the great pioneers of an even more 'modern' art.

Cézanne was also unlike most of his future colleagues in being a Southerner. He was born on 19 January, 1839, at Aix-en-Provence, where his father, a hat merchant who had done well for himself, owned one of the town's banks. The banker, Louis-Auguste Cézanne, was also a tight-fisted domestic tyrant who ruled his claustrophobic household as an autocrat, right up to his death in 1886. Even when Paul was middle-aged, Louis-Auguste routinely opened letters addressed to him; and his financial dependence on his father meant that Paul had to lie like a schoolboy about important aspects of his life. Cézanne's extraordinary personality – timid, bottled-up, suspicious, touchy, and given to strange, sudden theatrical gestures – may well have been formed in reaction to his father's suffocating presence.

The emotional centre of Cézanne's boyhood was his Three Musketeers friendship with Emile Zola and Baptistin Baille. Zola was the future novelist and art critic who became so deeply involved with the Impressionists; Baille was to have a less sensational life as a teacher at the Ecole Polytechnique. The three boys spent idyllic summer days by the river, swimming and reciting Romantic poetry, experiences that Cézanne never forgot and that undoubtedly colour many of his later paintings of bathers.

A False Start

Zola had to make his own way in the world and in 1858 he left for Paris. Cézanne stayed in Aix and studied law as his father wished, but he also took drawing lessons and came to realize that he wanted to be an artist. Zola urged him to leave for Paris, but Louis-Auguste's resistance was not easily overcome. In view of everything else we know of the relationship between father and son, it is remarkable that Cézanne nerved himself to tackle Louis-Auguste

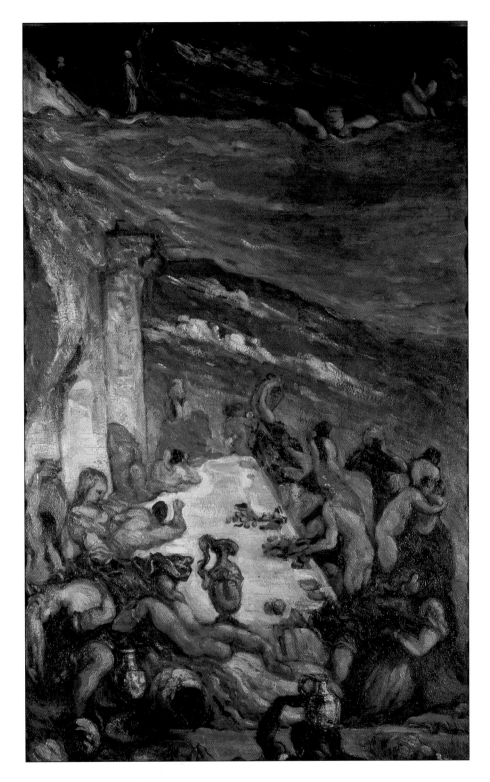

LEFT: **The Orgy**
*c.*1867-70
Paul Cézanne
PRIVATE
COLLECTION

on the subject. He may have got his way and become an artist by convincing his parent that he was fit for nothing else.

In April 1861 Cézanne finally arrived in Paris to study painting. He enrolled at the Académie Suisse, where other students laughed at his efforts; but Camille Pissarro was there and, perceiving that the 'strange Provençal' had talent, tried to encourage him.

Pissarro's friendship was to be a decisive influence on Cézanne, but not for some years. Disappointed, or perhaps daunted, by Paris, Cézanne almost immediately thought of going back home. Zola, knowing that Cézanne had 'fought for his trip for three years', was appalled and did everything he could to persuade him to stay. Cézanne resolved and hesitated, packed and unpacked, but eventually, in September 1861, he left for Aix.

After this false start he worked in his father's bank for a few months, evidently without proving indispensable. He was soon painting again, and before the end of 1862 he had been allowed to return to Paris. He never again turned his back on painting, although over the next few years he suffered one setback after another. Surviving drawings from 1862 show how hard Cézanne tried to work in the academic style in order to enter the Ecole des Beaux-Arts, but he failed the examination all the same. Year after

BELOW: **A Modern Olympia** _c._1873
Paul Cézanne
Musée d'Orsay, Paris

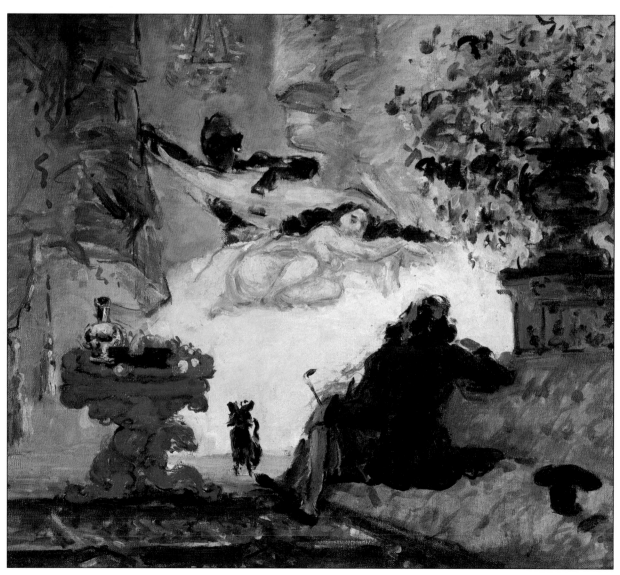

year, he submitted paintings to the Salon, but not one was accepted. His only exposure to the public was at the Salon des Refusés of 1867, when his work did not even occasion a scandal. All the way through the 1860s he experienced nothing but failure.

During this period Cézanne seems to have developed a form of 'character armour', concealing his timidity and intensities by behaving outlandishly. On his occasional outings to the Café Guerbois he would turn up in his working clothes and, lest anyone should fail to notice, insist on how dirty he was. Thickening his Provençal accent, he played the boor until some chance remark sent him rushing away in a rage. At the Guerbois he was, to a greater extent than he may have liked, a tolerated eccentric, but his personality and his equally strange paintings made it hard for the habitués to take his talent seriously.

Unfortunately, the titles of the paintings Cézanne submitted to the Salon, and even those he exhibited at the Refusés, are not known. However, if they were anything like the canvases that have survived from the 1860s, the verdicts of the jury were foregone conclusions. Cézanne's early works were, in their way, as original as anything he ever painted. Apart from a few portraits and still lifes, they are dark fantasies that seem to have erupted from his unconscious. *The Rape, The Murder* and *The Orgy* have the energy and power of obsession. A comparison between *The Orgy* (page 129) and its academic equivalent by Couture (page 18) illustrates the difference between conviction and convention. Cézanne's raw emotion, the strange, rubbery human forms and the thickly layered, generally dark-toned paint gave these canvases a distinctive quality not found in academic art or in the outward-looking works of the Impressionists.

Landscapes from Nature

Cézanne's first serious landscapes, painted from nature, were done in 1870–1 at L'Estaque, a village on the Mediterranean not far from Aix. Cézanne was in hiding there, fearful of being called up to serve in the war and equally (perhaps even more) fearful that his father would discover that he was co-habiting with Hortense Fiquet, a young model he had met in 1869. He remained in the South until after the birth of his son Paul in January 1872. By the summer he had moved to Pontoise, taking Hortense and Paul with him, and was working side by side with Pissarro.

In a letter from Cézanne to Zola, dating from 1866, the artist

wrote that 'pictures painted inside, in the studio, will never be as good as those done out of doors ... I shall have to make up my mind to work only outside.' This declaration is something of a curiosity, since Cézanne failed to follow through, and the Impressionist landscape was developed by others. The heaviness and emotionalism of Cézanne's 1860s style persisted even in his L'Estaque canvases. It was only from Pissarro that he learned the recently-perfected techniques of *plein-air* painting.

Prickly though he was, Cézanne failed to quarrel with Pissarro, who taught by discussion and example, without any assumption of superiority. Cézanne even took away one of Pissarro's canvases and copied it in order to master the technique used in painting it. Another of Pissarro's great virtues as a teacher was that he recognized and respected talents different from his own, which in Cézanne's case meant an impulse to create firm, magisterially structured pictures. Even at his most Impressionist, Cézanne never painted landscapes that seemed to melt under the impact of the light, but maintained a sense of the outlines and volumes of houses and trees. Nevertheless, his absorption of Impressionist technique was astonishingly rapid and in a great burst of creativity he painted a series of masterworks such as *The House of the Hanged Man* (pages 146-7) and *Dr Gachet's House at Auvers* (right).

When he painted the *House at Auvers,* Cézanne was lodging with the owner, Dr Gachet, who deserves a brief mention as one of the most interesting figures connected with the Impressionists. He was a homeopathic doctor, a patron of the Café Guerbois and an etcher whose enthusiasm prompted Pissarro and Cézanne to take up the medium. Much later, in 1890, a distraught Vincent van Gogh came under his care. Van Gogh painted a celebrated portrait of him 'with the sad expression of our time' (page 253) but killed himself shortly afterwards. It is almost needless to add that Gachet accumulated a collection of works of art that would be the envy of any modern millionaire.

Working outdoors with Pissarro, painting in his own version of the Impressionist style, gave Cézanne a stability and a sense of direction he badly needed. However, the impulses which created his earlier style surfaced from time to time, notably in various versions of *A Modern Olympia* (page 130). Cézanne seems to have harboured obscure feelings of rivalry towards Manet, manifested earlier in works like *The Picnic* (*c.*1869), which might be regarded as a sinister variation on Manet's *Déjeuner;* the balding, bearded man seated in

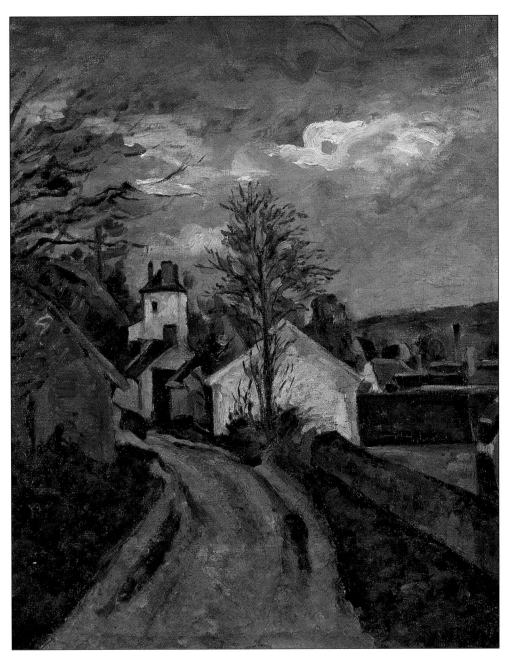

LEFT: **Doctor Gachet's House at Auvers** 1873 Paul Cézanne MUSÉE D'ORSAY, PARIS

front of the meagre spread is probably Cézanne himself. The links are even clearer in *A Modern Olympia*, where Cézanne seems intent on emphasizing the sex-for-sale aspect of Manet's scene, furnishing the room like a brothel and giving the black servant an enhanced role as she unveils 'Olympia' with a flourish.

In view of Cézanne's acquaintance with the Impressionists and his current work, his inclusion in the group show ought to have seemed a matter of course. It says a good deal about his 'wild man' reputation that several members of the group felt reluctant to prejudice the show's chances by associating it with Cézanne. However, Pissarro's advocacy won the day and not only *The House of the Hanged Man* but even *A Modern Olympia* were among the works shown to the public in April 1874.

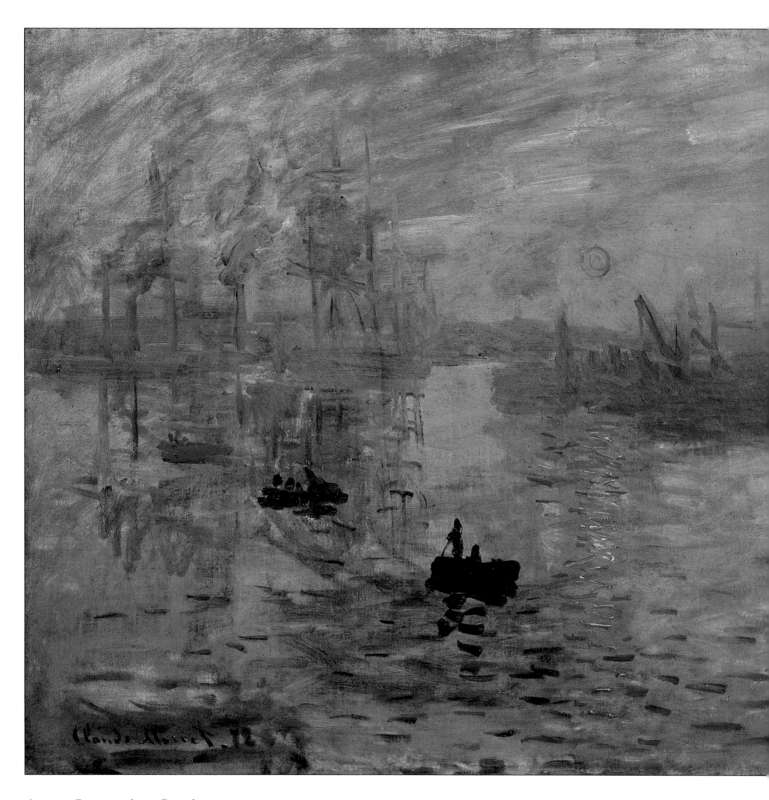

ABOVE: **Impression: Sunrise**
1872
Claude Monet
© DACS 1996
MUSÉE MARMOTTAN,
PARIS

Exhibition Years

By the early 1870s, better times seemed to be in store for the painters whom we now call the Impressionists. A handful of enlightened patrons, including Théodore Duret, the opera singer Jean-Baptiste Faure and the department-store tycoon Ernest Hoschedé, had started to buy their works; and, thanks in part to the post-war boom, their prices were rising. An even more important role was played by the dealer Paul Durand-Ruel, who regularly bought Impressionist paintings and was compiling a three-volume catalogue of his holdings in which these young men – most of them still in their thirties – appeared side by side with established older masters such as Corot and Daubigny.

Despite these promising developments, the Impressionists were still denied general recognition by their ill-success at the Salon. In public life, the imperial regime had given way to a republic, but the politics of the art world had hardly changed at all. The jury, although by no means consistent in its preferences from one year to the next, invariably viewed Manet's canvases with suspicion and had no time for those of the younger Impressionists. Most of

these had despaired of acceptance to such an extent that they no longer bothered to submit their works. Of those who continued to send in – Manet, Berthe Morisot and Renoir – only Morisot was regularly hung. As we have seen, this was not a matter of the jury's good taste, but probably reflected its tolerant, condescending attitude towards paintings by a woman.

There were, however, some indications that the grip of the Salon on public opinion was weakening. After the trauma of the Franco-Prussian war, critics looked hopefully for works of talent and originality that would signal the rebirth of French genius, and they complained loudly when they failed to find them at the Salon. In 1873 there was even another Salon des Refusés, but this time the massed ranks of the rejects seemed no better than the official selections. The chief exception was Renoir's ambitiously large *Riders in the Bois de Boulogne* (page 89) but Renoir was less grateful for the praise it received than resentful of its initial rejection. He, too, became increasingly rebellious in mood.

This was the situation when the project of an independent group show, mentioned by Bazille as early as 1867, was revived. Even seven years later, the enterprise was a daring one, for nothing of the sort had ever been attempted before, and the main precedents – the one-man pavilions put up by Manet and Courbet at the International Exhibition – were not encouraging. Unsponsored, with no official stamp of approval, the Impressionists were inviting the general public and the critics to judge for themselves: a situation familiar enough now, but virtually unknown at the time.

The first hint that something was afoot came in May 1873, when the writer Paul Alexis published an article in the newspaper *L'Avenir National*, criticizing the Salon and the jury system and calling on artists to organize their own exhibiting societies. Alexis was a close friend and follower of Emile Zola, so it is highly likely that his article was a 'plant', prearranged to give the Impressionists some free publicity. Two days later Monet replied in a letter to Alexis, also published in *L'Avenir*, announcing that he and his friends were making the kind of plans envisaged by Alexis and saying that he hoped the newspaper would support their efforts. From time to time other items – we should now call them press releases – were published to keep interest alive.

Arguably the campaign began too early. It was December before the artists ironed out all their differences and formed the Société Anonyme des Artistes (Peintres, Sculpteurs, Graveurs, etc.). The 'Anonymous Society' was a legal term indicating that

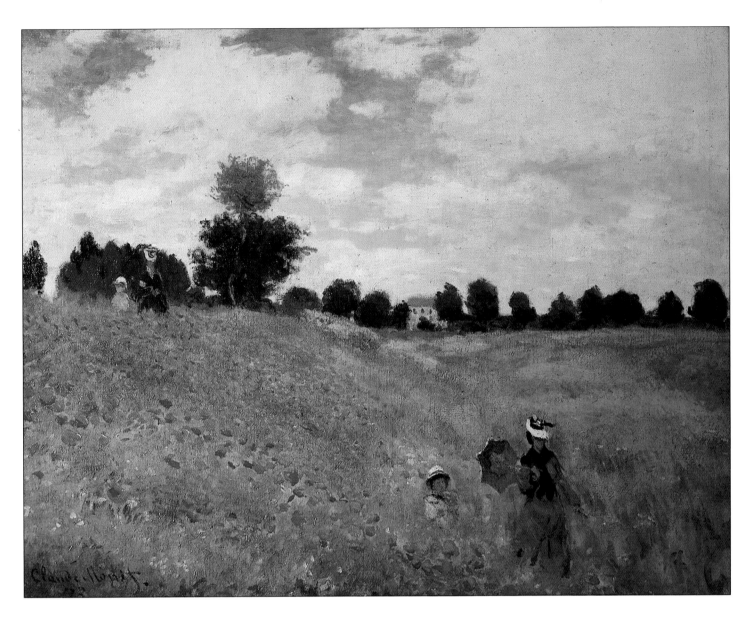

the venture was a joint stock company, not an individually owned concern, so the company name chosen by the Impressionists was the equivalent to calling it Artists PLC. Although uninspired, the title was useful, as it avoided identifying the members as belonging to a group or working in a single style. In effect, Artists PLC was a co-operative in which the members held equal shares; each paid a subscription of 60 francs to provide the society with capital and agreed that ten per cent of any subsequent sales should go towards running costs.

The 11 founder-members of the Société Anonyme included Degas, Pissarro, Monet, Renoir, Sisley and Berthe Morisot. The most notable absentee was Manet. Conventional as ever – except in his art – he was convinced that the Salon was 'the real battlefield'. Besides, he had just enjoyed a great success with *Le Bon Bock*

ABOVE:
Poppy Field at Argenteuil 1873 Claude Monet © DACS 1996 MUSÉE D'ORSAY, PARIS

which made him believe he was winning, whereas the jury almost certainly admired the picture because it resembled a Dutch Old Master canvas rather than a painting in Manet's own distinctive style! By contrast, Degas' aloof personality and artistic dedication made any hint of dependence on the Salon irksome to him, and despite his relatively assured position he was one of the most energetic members of the new association. Initially, however, the lead in actually setting up the society was taken by the socialist Pissarro, who already had some experience of co-operatives. Monet, always combative and always hard up, was also an activist.

The most unlikely member of the founding group was Berthe Morisot, since she was neither poor nor unsuccessful. Although Manet tried to warn her off, she seems to have joined in order to display her solidarity with fellow artists whom she found sympathetic; her adoption of a freer brushwork and outdoor working helped to bring her closer to Monet and Renoir in particular. And of course participation in a 'revolt', however bloodless, must have been an exciting experience in the life of a well-brought-up young lady.

1874: The First Show

The exhibition took place in spacious, well-lit studios that had not long before been vacated by Nadar, a pioneer photographer and caricaturist who was at that time far more famous than any of the Impressionists. He may, in fact, have arranged for them to use the rooms at no charge. Then, as now, location was an important factor in attracting custom, and the studios were on a prime site at 35 Boulevard des Capucines, close to the Opéra, in one of the most fashionable parts of Paris.

The exhibition was opened to the public at 10 a.m. on 15 April, 1874. The timing, a fortnight before the Salon began, certainly represented a deliberate effort to pre-empt the established show. The studios on the Boulevard des Capucines could be visited from ten in the morning until six o'clock, and again in the evening between eight and ten o'clock. The unusually long hours suggest that the exhibitors were very much in earnest – eager to bring in every last spectator, including business people and workers who were occupied during the day. Admission was cheap at one franc a head and 50 centimes for the catalogue, prepared by Renoir's journalist brother Edmond.

Visitors who were used to the Salon, with its picture-crowded

RIGHT: **The Dance Class** *c.*1874 Edgar Degas MUSÉE D'ORSAY, PARIS

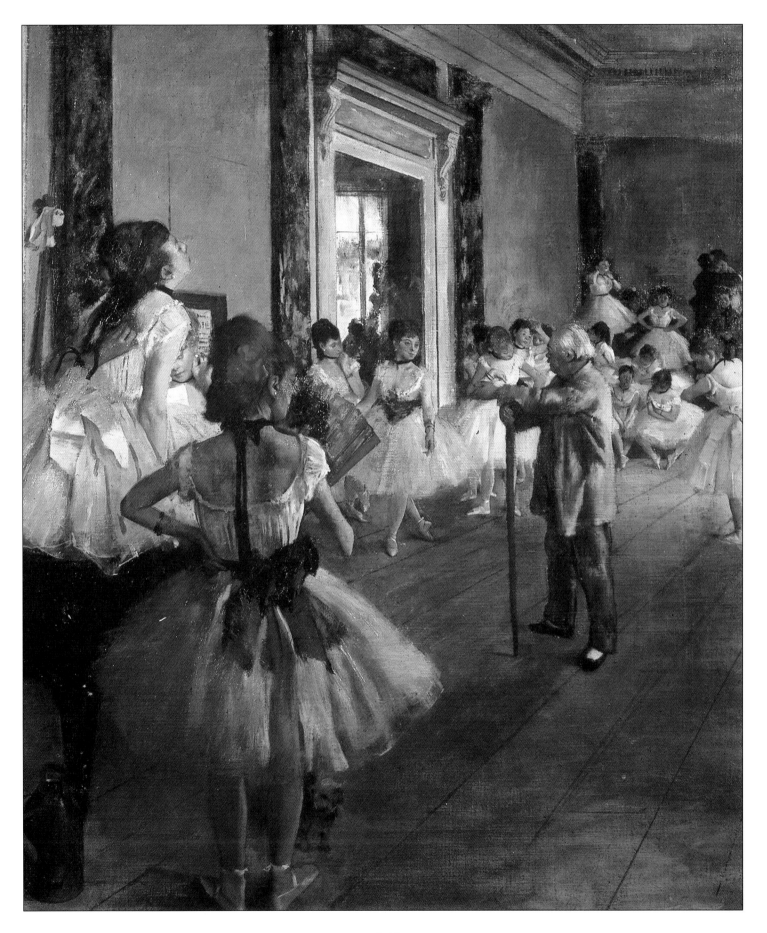

walls, must have been taken aback by the arrangement at the Boulevard des Capucines, where the 165 exhibits were hung (by Renoir, none of his colleagues having turned up to help) in small groups, not more than two deep, on red walls inherited from Nadar. With no jury to place favoured works at eye level and relegate others to the 'sky', position was decided solely by lot. The scene, now so familiar, was bound to disconcert a public that was accustomed to being told, or shown, what it should like best.

This event became known as the first Impressionist Exhibition and is rightly regarded as a landmark in the history of modern art. However, on 15 April, 1874, the term 'Impressionism' had not yet been invented, and this was far from being an exclusively Impressionist or 'Batignolles' occasion. The anonymous 11 had now expanded to 30; of the additional 19 only Cézanne, Boudin and Armand Guillaumin had a great deal in common with the six Impressionist leaders. The rest were friends or contacts of the founders, ranging from a 'Sunday painter', such as the sympathetic journalist Zacharie Astruc, to Degas' friends, the society painters Stanislas Lépine and Giuseppe de Nittis. Degas himself had insisted that the exhibition must include artists with diverse styles, so that its pictures would not be taken for the work of a clique of *refusés*. Despite his own reasoning, Degas evidently did see some connections between the exhibitors, since he wrote in unusually fierce, partisan terms to another friend, the painter James Tissot: 'The realist movement no longer needs to fight with others. It is, it exists, it has to show itself *separately*. There has to be a *realist Salon.*'

However, all the outstanding works in the exhibition were by artists whom we now agree to call Impressionists. They were also the works singled out by the critics, whether for praise, ridicule or expressions of outrage. (In that respect, even the most wrong-headed writers showed an appreciation of what was crucial.) To name only the very well-known paintings, they included Monet's *Poppy Field at Argenteuil* (page 137), *Impression: Sunrise* (pages 134-5) and *Boulevard des Capucines* (pages 138-9), Degas' *Dance Class* (page 141) and *At the Races in the Country*, Renoir's *La Loge* (page 145), Morisot's *The Cradle* (page 127), and Cézanne's eccentric *Modern Olympia* (page 130) as well as his Impressionist *House of the Hanged Man* (pages 146-7).

The exhibition ran until 15 May and was visited by about 3,500 people, an acceptable though not outstanding public response. Sales were disappointing, failing to cover the costs of the

society or of most of its individual members. Cézanne, who had been admitted only on Pissarro's insistence, did better than most, selling *The House of the Hanged Man* for 300 francs. However, soon after the show Monet sold *Impression: Sunrise* to an important new admirer, Ernest Hoschedé, and the dealer Père Martin paid 450 francs for Renoir's *La Loge*.

Whatever the visitors may have felt about the pictures they had come to see, they behaved decorously enough on the premises; and the newspapers and periodicals carried at least as many favourable reviews as diatribes by hostile critics. All in all, the exhibitors might have been justified in feeling that the effort had been worthwhile and that they had made an important beginning. Unfortunately, it soon became obvious that the hostile diatribes had struck home more effectively, crystallizing the public attitude towards the Impressionists into one of incredulity and ridicule.

From this time onwards, they were Impressionists – and nothing but Impressionists – in the public mind. The word was, of course, used as an insult, implying that they flung down rough-and-ready versions of their subjects without taking the trouble (or perhaps lacking the skill) to render them precisely, with all their details visible. The most influential review appeared in the pages of the satirical magazine *Charivari*. Since *Charivari's* stock-in-trade was fault-finding in amusing descriptions and cartoons, its strictures were not often taken very seriously, but for some reason Louis Leroy's review of the 'Exhibition of the Impressionists' had a real impact.

Leroy evidently realized the amusement potential of Monet's painting *Impression: Sunrise*, an atmospheric view of the harbour area of the artist's home town, painted on a return visit a couple of years earlier. The catalogue compiler, Edmond Renoir, asked Monet to give him a title for the work and Monet said on the spur of the moment, 'Oh, call it *Impression*'. Renoir is said to have been responsible for adding the poeticizing *Sunrise*.

Taking this as his cue, Leroy wrote a sketch in which 'impression' and 'impressionist' became the basis for some relentless satirical wordplay that fixed the terms once and for all in the public consciousness. He cast his article in the form of a tour of the exhibition by 'Leroy' and an imaginary, much-bemedalled academic painter, Joseph Vincent. Apoplectic from the first, Vincent rages against the exhibits while 'Leroy' puts in a few words in their favour. When Vincent denounces the 'palette scrapings' in

Pissarro's rendering of the furrows in a ploughed field, 'Leroy' says 'Perhaps, but the impression is there.' After this, 'impression' is bandied about while Vincent's mind begins to collapse under the strain of his experiences.

Monet's painting proves to be the last straw. 'There he is, there he is ... Papa Vincent's favourite!' shouts the demented academician. 'What's it about? Have a look at the Catalogue.'
'*Impression: Sunrise.*'
'Impression. I was certain of it. I was just saying to myself that as I was impressed, there was bound to be an impression in it. And what freedom, what ease of handling! Wallpaper in its embryonic state is still more finished than this seascape!'

Vincent is now so far gone that he believes himself to be an Impressionist, stops to admire Degas' *Laundress* and, once he spots Cézanne's *Modern Olympia*, denounces even Monet as, by comparison, a compromiser whose works are too highly finished. Finally, in his delirium, Vincent takes an 'Impressionist' view of the guard on duty at the exhibition, declaring his two eyes, nose and mouth to be absurdly unnecessary details; with the materials used up on him, Monet could have painted 20 guards!

Finally Vincent breaks into a kind of savage war-dance, shouting 'Ho! I am impression on the march, the vengeful palette knife, Monet's *Boulevard des Capucines*, M. Cézanne's *House of the Hanged Man* and *Modern Olympia*! Yo ho ho!'

As satire, this was not exactly inspired, but it obviously found receptive readers. By hammering so relentlessly at the notion of paintings as 'impressions', Leroy probably did more than anyone else to give the Batignolles painters the name by which they are now known. But his paternity can be disputed. Five days earlier, a more serious (or solemn) journalist, Jules Claretie, had also castigated the show in *L'Indépendant*, lamenting that 'these impressionists' had 'declared war on beauty'. And on 29 April a sympathetic critic, Jules Castagnary, wrote in *Le Siècle* that 'If we characterize them [the exhibitors] with one explanatory word, we should have to coin a new term: *impressionists*. They are impressionists in that they render not the landscape but the sensation evoked by the landscape.' Castagnary, too, made the connection with Monet: 'The very word has entered their [the painters'] language: not *landscape* but *impression*, in the title given in the catalogue for M. Monet's *Sunrise*.' Clearly 'impression' was in the air, even if it meant different things to different people. Although the term has since been criticized as inaccurate or

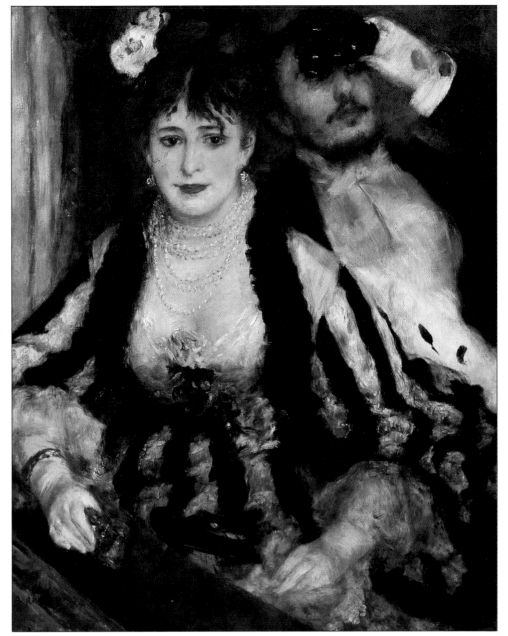

LEFT: **La Loge**
1874
Auguste Renoir
COURTAULD
INSTITUTE
GALLERIES,
LONDON

meaningless, it did seize on the common feature of the new art – the indifference to detail and high finish – that made it so offensive to academic sensibilities.

The Drouot Disaster

When the first Impressionist Exhibition ended, the participants resumed their separate careers. However, the leading Impressionists remained in close contact, especially through Monet, who had been living since 1871 in the pleasant little town of Argenteuil on the Seine. Manet had a holiday home on the other side of the river, and he and Monet saw a good deal of each other and of Renoir and Sisley. Inspired by the riverside views, the

145

regattas and the breezy holiday atmosphere, the four artists created some of the brightest, finest and freshest of all *plein-air* Impressionist paintings.

A very different atmosphere prevailed in December 1874, when the members of the Société Anonyme met in Renoir's studio. Renoir himself took the chair and when the treasurer's report revealed that the society was in deficit (needing 184 francs from each member to clear its debts), it was unanimously decided to wind it up. At this point it may have seemed that the first independent group show put on by artists would also be the last. Times had already become harder, since the post-war boom had collapsed even before the opening of the 1874 show, making potential buyers more cautious and perhaps promoting a more conservative atmosphere. Worse was to come, for Durand-Ruel got into serious difficulties, abruptly suspending his regular purchases, and was eventually forced to close down his London gallery.

Since money was short and business slow, Renoir suggested that he and his friends should make another appeal to the public. This time they should put their works up for auction, a course that avoided the expense of an exhibition and had not long before achieved good results for the Barbizon landscapist Daubigny. Evidently failing to sense the hardening of public feeling against them, Monet and Sisley were persuaded to take part. Berthe Morisot, although not in need of money, again joined as a gesture of solidarity. The sale was held at the leading Parisian auction house, the Hôtel Drouot, with Paul Durand-Ruel supervising the proceedings.

Durand later claimed that he had tried to improve the Impressionists' prospects by putting fine new frames on their paintings. If so, their failure was all the more complete, since the prices bid were so low that some would scarcely have covered the cost of the frame. The average price for the 73 works offered for sale was a mere 150 francs. Ironically, Morisot's paintings fetched the highest prices, whereas the worst sufferer was the instigator of the sale, Renoir.

An even more disturbing feature of the proceedings was the presence of a large crowd of people who had turned up solely to hoot and jeer. They became so vociferous that at one point the police were called in to restore order. This was a remarkable thing to have happened at an event so banal and bourgeois as an art auction. It demonstrated the extent to which the Impressionists had become identified as a group, and a group whose productions were, for some reason, by definition ridiculous.

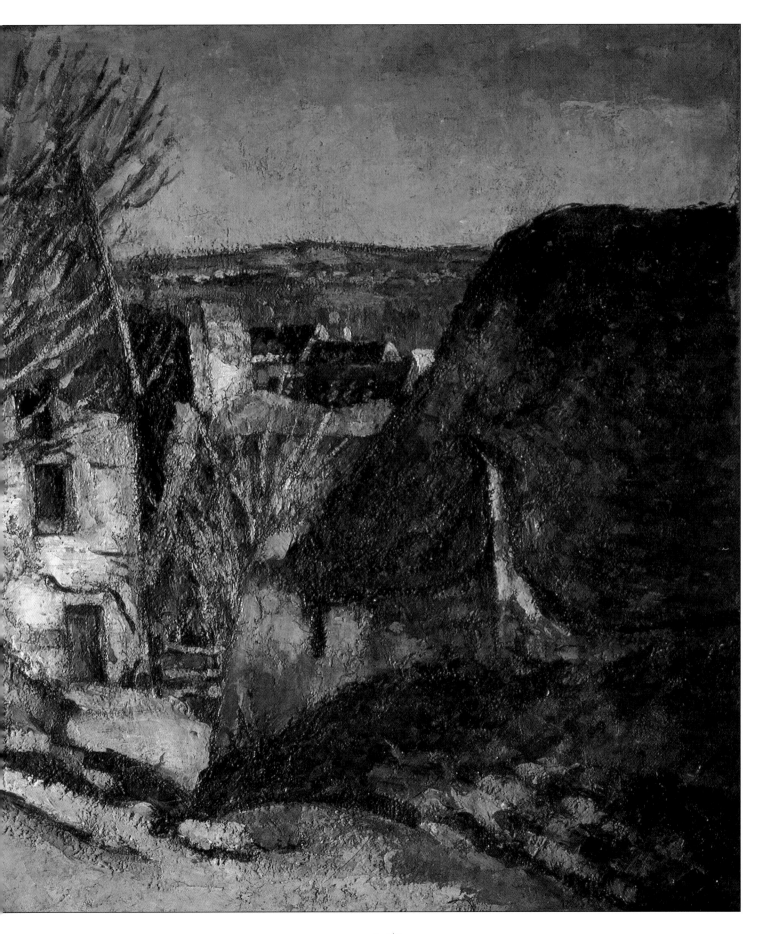

As a result of this fixed attitude, during the 1870s they were regarded as fair game by any cartoonist who had run short of ideas. The basic 'joke' was that the Impressionists intended to paint horrors and were all too successful in their efforts. So when an Impressionist is told that a figure he has painted is corpse-like, he replies cheerfully, 'Unfortunately I couldn't capture the smell'. A lady, advised that the paintings shown at the Boulevard des Capucines were best viewed from a distance, answers tartly 'Agreed: that's why I'm getting as far away from them as possible', and heads for the exit. A particularly popular variation on the basic joke, probably suggested by Papa Vincent's madness, was inspired by the idea that something as awful as Impressionism must be bad for the health: one cartoonist showed an alarmed official

barring a pregnant woman from entering an exhibition ('Madame, it would be unwise to enter'), while another pictured Impressionist paintings as lethal weapons that had been issued to Turkish (i.e. 'barbaric') soldiers, who had only to hold them up in full view to put their enemies to flight!

1876: The Second Show

In the wake of their reception in 1874, the farcical auction at the Hôtel Drouot was a demoralizing blow for the Impressionists. Now mostly in their mid-thirties, they faced up to the fact that their work was actually less respectable than it had been before the war. For Pissarro, who was 45, the situation was even more depressing. He had wisely decided not to take part in the Drouot sale, but the verdict it had delivered on his kind of painting was unmistakable. Nevertheless Pissarro, Cézanne and Guillaumin were soon involved with a new co-operative, the Union, which they abandoned only when it became clear that their comrades of 1874 had come round to the idea of a new group show.

So a second Impressionist exhibition was mounted in April 1876 at Durand-Ruel's gallery in the Rue Le Peletier, which, like all the Impressionist venues, was centrally placed, close to the Boulevard des Italiens. 'Impressionist' was still a term of abuse, ignored by the artists themselves, for whom this was simply the 'Second Exhibition of Painting'. Some of the more conventional artists who had shown in 1874 abstained on this occasion and the number of contributors was down from 30 to 20. There were also newcomers, notably Gustave Caillebotte, a wealthy young man who had already befriended Monet at Argenteuil, and Marcellin Desboutin, a bohemian painter now better remembered for his portrait etchings and as the model for Manet's painting *The Artist* and the glassy-eyed drinker in Degas' *Absinthe* (page 158), which was finished just too late for inclusion in the show. Two paintings by Frédéric Bazille were also hung as a tribute to the Impressionists' dead comrade.

Among the masterpieces on show were Degas' *Cotton Market* (page 52), Renoir's *Nude in Sunlight* (left) and a large, quite uncharacteristic canvas by Monet, *The Japanese Girl* (page 151). In this, a blond-wigged Camille poses in a kimono among scattered fans. By emphasizing Camille's western appearance, Monet evidently wished to insist that his picture was not an imitation of a Japanese print, and the cheeky exactness with which the fierce

Japanese warrior is made visible – with not a fold in the kimono to obscure his attitude – might suggest that the artist did not take it all very seriously. However, Monet had appraised his market correctly this time, for *The Japanese Girl* was one of the commercial successes of the exhibition, selling for a much-needed 2,000 francs.

One of the most-discussed exhibits was Caillebotte's *The Floor Strippers* (page 152-3), a fine painting in the artist's clear-cut style, seen from above in a way that made for a striking composition (a technique probably derived from Degas) but also emphasizing the humble status of these workers, stripped to the waist and down on the floor. Interest in *The Floor Strippers* and also in Degas' *Cotton Market* was strengthened by the fact that they were not just 'modern' but 'realistic' in the sense of showing the operations of a business- and industry-oriented, urban society. In modern jargon, such paintings seemed 'relevant' and it was this aspect of them that writers such as Zola and Edmond Duranty found it easiest to understand and interpret. Before the 1876 show closed, Duranty (page 155) had published a 38-page pamphlet, *The New Painting*, the first study devoted to 'the Durand-Ruel exhibitors' (he never called them 'the Impressionists'), discussing their work intelligently although with a strong emphasis on its modernity. He was above all an admirer of Degas, whose art most easily lent itself to such an identification. This was, of course, accurate as far as it went, but left out a good deal. However, during this period of struggle the Impressionists were not inclined to turn away well-wishers of any stripe.

The response of the critics continued to be mixed, with the big guns on the side of the enemy. The most favourable reviews tended to appear in left-wing periodicals, a fact that may not have helped Impressionism's public image. In the mainstream newspaper *Le Figaro*, Albert Wolff pronounced his verdict on Renoir's lovely dappled *Nude in Sunlight* without the slightest hint of self-doubt: 'Try to explain to M. Renoir that a woman's torso is not a mass of decomposing flesh, with green and violet patches signifying that the corpse is in an advanced state of putrefaction': you could try, but it would be a waste of effort. Pissarro's 'violet' trees and 'yellow' skies received the same treatment, followed by the assurance that it would be equally futile to attempt to set the painter on the right path: 'It would be as much of a waste of time as trying to make an inmate of Dr Blanche's [asylum], who believes he is the pope, understand that he lives in the Batignolles

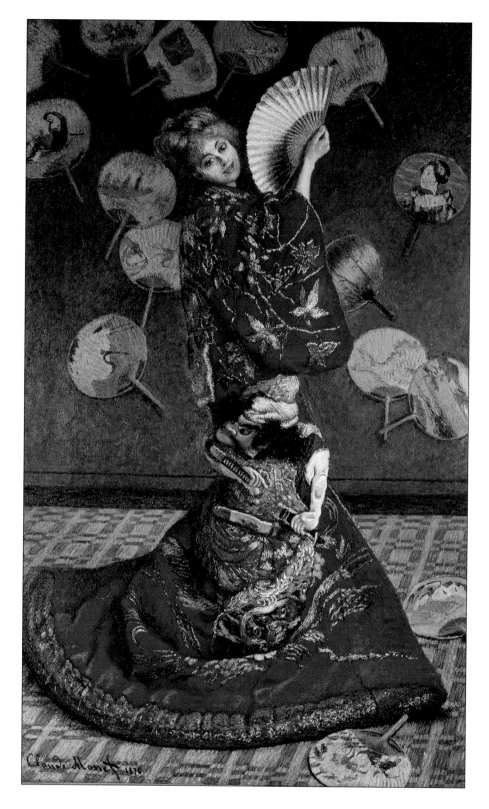

and not the Vatican'. The cartoonists were not the only people who confidently equated the new painting with madness and disease.

Nude in Sunlight was bought by Gustave Caillebotte, whose purchases, gifts and backing for exhibitions helped to sustain the

BELOW: **The Floor Strippers**
1876
Gustave Caillebotte
MUSÉE D'ORSAY, PARIS

Impressionists over the next few years. They were beginning to build up a network of clients and admirers, but the process was slow and uncertain. Some were people of limited means like the ex-Communard Père Tanguy, who was usually willing to hand out artists' materials from his shop in return for a painting, or the somewhat better-off Victor Chocquet, a customs official who took up first Renoir and later Cézanne. Chocquet's enthusiasm for Impressionism was so fervent that he is said to have buttonholed disgruntled visitors to the 1876 exhibition and attempted to

explain the finer points of the pictures to them. A young man named Paul Gauguin was also buying Impressionist canvases, encouraged by his mentor Camille Pissarro. Gauguin was a fairly successful businessman with a family to keep, so although he took art very seriously, it seemed unlikely that he would ever be anything but a 'Sunday painter'. Other patrons were lavish but unreliable, notably the tycoon Ernest Hoschedé, a buyer one day and a bankrupt the next, and the dealer Paul Durand-Ruel, prepared to buy Impressionist works in quantity when he was in funds, but not yet in control of his roller-coaster career.

Impressionism and the Anglo-Saxons

Durand-Ruel had made a protracted effort to introduce French art, including Impressionist paintings, to the British, but he had enjoyed only limited success, and financial difficulties had forced the closure of his London gallery. Leading newspapers such as *The Times* generally took an aloof, somewhat disapproving attitude towards artistic and other goings-on across the Channel. The scandals created by Manet's *Déjeuner sur l'Herbe* and *Olympia* in the 1860s had reinforced British distrust of French art as improper or even immoral. Even a gifted Pre-Raphaelite artist like Rossetti could see nothing in Manet's lithograph illustrations for *The Raven*, the poem by Edgar Allan Poe, which had been translated into French by Stephane Mallarmé. In this atmosphere there can only have been limited interest in 'The Impressionists and Edouard Manet', an article by Mallarmé, written in English, that was published in the *Art Monthly Review* for September 1876; Mallarmé's mastery of the language was not entirely adequate to the sophistication of his thought, but in general terms his praise of Impressionist light, colour and movement was clear enough.

Distant echoes of the battles in Paris also reached New Yorkers, thanks to an article in the *Herald Tribune* by the novelist Henry James. This is of considerable interest, since it helps us to understand just what a puzzle the new painting was to an observer who was by no means lacking in sensibility and yet unable to escape from conventional expectations. The exhibition 'of the little group of irreconcilables, otherwise known as the "Impressionists" in painting ... is being held during the present month at Durand-Ruel's, and I have found it decidedly interesting. But the effect of it was to make me think better than ever of all the good old rules which decree that beauty is beauty and ugliness

is ugliness ... The contributors to the exhibition of which I speak are partisans of unadorned reality and absolute foes to arrangement, embellishment, selection, to the artist's allowing himself, as he has hitherto, since art first began, found his best account in doing, to be preoccupied with the idea of the beautiful.' James interprets the Impressionists as avoiding the pursuit of beauty, as something that may or may not be achieved as an incidental: 'the painter's proper field is the actual, and to give a vivid impression of how a thing happens to look, at a particular moment, is the essence of his mission.'

In a sense, then, the Impressionists were all too successful in convincing an observer such as Henry James that their paintings were uncomposed transcriptions of reality. He saw the casualness, the informality, the 'photographic' croppings, but failed to realize that these things were not the product of chance but of art. Moreover, James's responses are entirely conditioned by the classical view of art as a medium that is used to eliminate accidents ('how a thing happens to look') in order to represent the essential and permanent – an approach that is perfectly legitimate but does not invalidate alternative approaches. Given these preconceptions, James is simply unable to see Impressionist paintings as we see them. Although he writes more temperately than Albert Wolff and makes an effort to describe what he believes to be the Impressionist point of view, his sight is no keener; or rather his vision is limited by the same conventions of seeing.

A final point of interest in James's article is his belief that the Impressionists and Pre-Raphaelites shared a good deal of common ground. This has often been mocked and is indeed absurd for a number of obvious reasons, starting with the Pre-Raphaelites' medievalizing and their religious, moral and literary bent. But it does remind us that the English 'Brotherhood' was once regarded as shockingly unconventional and even squalid, for example in representing Jesus as an ordinary boy in his carpenter father's workshop, where tools and lengths of wood are ready to hand and the floor is covered with shavings (Millais' *Christ in the House of his Parents*, 1849). Although we can never quite see through the eyes of nineteenth-century convention, such considerations do at least help us to understand how it created an exclusive mode of perception that seemed normal and based on common sense. Amusingly, James interprets the difference between the Pre-Raphaelites and the Impressionists in national terms: in true English fashion, the Pre-Raphaelites try to make up for their

RIGHT: **Portrait of Edmond Duranty**
1879
Edgar Degas
BURRELL COLLECTION, GLASGOW

unconventionality by laborious workmanship, whereas the Impressionists, presumably because of their Frenchness, 'abjure virtue altogether, and declare that a subject which has been crudely chosen shall be loosely treated. They send detail to the dogs, and concentrate on general expression ... The Englishmen, in a word, were pedants, and the Frenchmen are cynics.' Probably the most

distinguished Anglo-American literary figure of his day to give general consideration to the phenomenon of Impressionism, Henry James ended his article with neatly turned obtuseness.

1877: The Third Show

For most of the Impressionists, things seemed to be going from bad to worse in 1876–7. Monet was finding it as hard as ever to make ends meet, Sisley remained sunk in poverty, Pissarro was getting into difficulties, and Degas' comfortable life-style was threatened by heavy family obligations which he had taken over as a point of honour. As for Renoir, he once complained that everywhere he went with a picture under his arm, hoping to make a sale, he was told that Pissarro had got there first. The customer had bought from the older artist because he had a family to feed – to the annoyance of Renoir, who pointed out that even a bachelor had to eat! 'Nobody says "Poor Renoir!"' he grumbled.

Had there been any possibility of the Impressionists giving up their group effort, that disappeared with the arrival in their ranks of Gustave Caillebotte. Caillebotte was determined that the group should make its mark, and he possessed the means, as well as the will, to finance a new attempt. In January 1877 he called a meeting with Monet, Pissarro, Renoir, Sisley, Degas and Manet to make plans for a new show. Manet still refused to desert the Salon, but the others hammered out arrangements whereby Caillebotte would advance the rent on exhibition rooms and an advertising campaign; the money would be repaid in due course out of the receipts.

The third Impressionist show opened on 6 April, 1877, in a suite of rooms at 6 Rue Le Peletier, almost opposite the previous year's venue. The word 'Impressionist' was still avoided in the title of the exhibition, but the artists made free with it and a weekly journal, *The Impressionist*, was published for the duration of the show. The editor of its four issues was a young journalist named Georges Rivière, who was particularly friendly with Renoir. The artist probably helped with the text and, coincidentally or otherwise, received even more praise in its pages than his colleagues. However, it is also true that one of Renoir's undoubted masterpieces, *The Moulin de la Galette* (page 159), became the great talking-point of the show, widely admired in spite of the free and easy dancehall atmosphere, which obviously made some critics not quite certain that it was morally sound. It was purchased by Caillebotte,

who was already accumulating a superb art collection.

The exhibition represented a major effort by the Impressionists to win over the public. The number of exhibitors had fallen to 18, making the core group of Impressionists the dominant element in the show. As if to emphasize the fact, they hung more paintings than before, many of them on loan from helpful owners. Monet, for example, was represented by 30 works, Degas by 25, Pissarro by 22 and Renoir by 21. Sisley sent in 17, Cézanne returned to the fold with 16, and only Morisot among the major figures sent in fewer than in 1876. Moreover, the quality of the exhibits was as high as ever. Monet's contributions included seven canvases from his series paintings of one of the Parisian railway termini, the *Gare Saint-Lazare* (below), and *Turkeys*, one of a set of large decorative panels done for the country house of Ernest Hoschedé, whose generous loans bulked out the exhibition. Among the works by Degas were his now well-known *Absinthe* (page 158) and *The Star* (page 161), a pastel which, typically, contrasts the glamour of the dancer, at the height of her solo, with the

BELOW: **Gare St Lazare** 1877 Claude Monet © DACS 1996 Musée d'Orsay, Paris

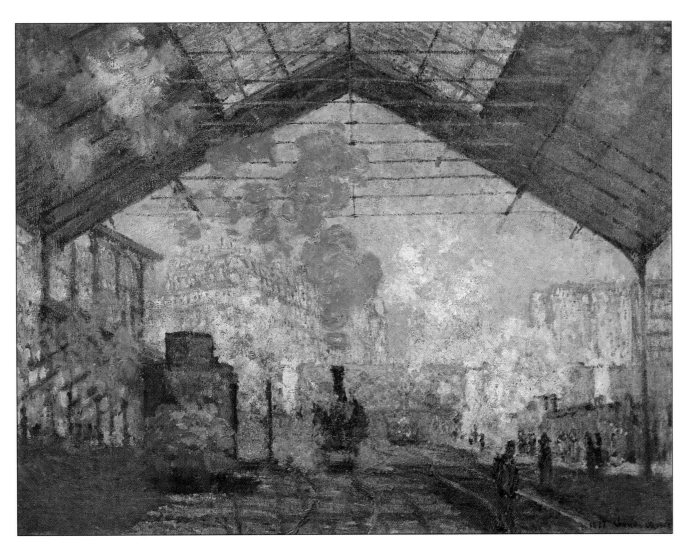

matter-of-factness of the other girls and a man in evening dress, close to her but concealed from the audience by a piece of theatrical scenery. Other exhibits of outstanding quality were Sisley's paintings of the floods at his new home town, Marly (page 163), and two canvases by Caillebotte, *The Pont de l'Europe* (pages 236-7) and his just-finished *Paris, A Rainy Day*.

By the time it closed on 27 April, about 8,000 people had visited the exhibition, so the receipts must have been reasonable in spite of the paucity of sales. The critical reception was mixed, as usual, with *Le Figaro* as insistent as ever that the 'Impressionist Salon' was a 'museum of horrors'. Nothing had happened to suggest

that the Impressionists were really making progress, but all the same a group of them decided to repeat the experiment of 1875 and sell works by auction at the Hôtel Drouot. Renoir and Sisley took part again, this time joined by Pissarro and Caillebotte. Presumably the wealthy Caillebotte, like Morisot in 1875, took part out of solidarity and a determination to support the campaign to publicize Impressionism. The others are more likely to have felt the need to raise instant cash, whatever the consequences.

The auction took place on 28 May, hardly a month after the exhibition had closed. Forty-five works went under the hammer, for prices that were still dismally low. The total receipts of 7,610 francs represented an average of less than 150 francs a picture. Ironically, the best price was obtained by the already well-off Caillebotte, who sold a picture for 635 francs.

BELOW: **Moulin de la Galette**
1876
Auguste Renoir
MUSÉE D'ORSAY,
PARIS

During this period, disappointments seemed to multiply and at one point Renoir was so despondent that he tried to wangle a job as the curator of a provincial museum. Two sales in 1878 confirmed the Impressionists' low standing and made it harder for them to get decent prices for their works, since they could, apparently, be picked up for next to nothing at public auction. The singer-collector Jean-Baptiste Faure sent in 42 paintings to the Hôtel Drouot, but the prices bid were so low that he bought back most of them; his decision to sell appears to have been a momentary lapse, as he afterwards continued to collect Impressionist pictures. An even bigger blow was the bankruptcy of Ernest Hoschedé, which put an end to his generous activities as a collector and meant that his art collection followed Faure's within a few weeks in going under the hammer at the Hôtel Drouot. The outcome was another disaster, in which paintings by Monet and Sisley went for only 100 francs or so.

The only positive note in 1878 was the publication of *The Impressionist Painters*, a book by Théodore Duret which treated the work of the group seriously enough to include separate biographies of its leading members. Interestingly, Duret interpreted 'Impressionist' in a mainly *plein-air* sense, excluding Manet and Degas. His principals were Monet, Sisley, Pissarro, Renoir and Morisot. Duret was of course a long-standing supporter of the Impressionists (with pen and purse), but such substantial literary recognition was nevertheless heartening, and on the whole Duret's remarks were those of a well-informed insider.

1879: The Fourth Show

The disappointments had their effect, generating disagreements and bringing about the first defections. Renoir broke ranks in 1878 by sending a canvas, *The Cup of Chocolate*, to the Salon. It was accepted, and in the following year he was joined by Sisley and Cézanne. By now it had become a rule that those wishing to exhibit with the Impressionists could not also submit work to the Salon, so the three artists were absent when the fourth Impressionist show opened in April 1879 at 28 Avenue de l'Opéra.

The rule seems to have been imposed by Degas, who has often been blamed for the divisions that increasingly appeared among the Impressionists. Another notable absentee in 1879 was Berthe Morisot, probably because she was preoccupied with her recently-born child, Julie. By contrast, Monet was definitely

RIGHT: **The Star**
1876-7
Edgar Degas
MUSÉE D'ORSAY,
PARIS

160

disillusioned, only agreeing to exhibit after making it quite clear that he was doing so for old time's sake; but he refused to put in an appearance and the ever-helpful Caillebotte took the responsibility for hanging his canvases. Inevitably, Monet, Degas and Pissarro dominated the show, but there were two interesting newcomers, Pissarro's protégé, the young businessman Paul Gauguin, and an American woman, Mary Cassatt, who worked in a distinctively bold, linear style.

Degas' contributions included some celebrated works with widely different subjects, notably *Miss Lala at the Cirque Fernando* (page 165), *Portrait of Diego Martelli*, and *Portraits at the Bourse*, a stock exchange scene whose conspiratorial tycoon-figures can be read as brilliant caricatures. *Miss Lala* is a typical Degas off-centre composition, using the geometry of the roof to form a grid that emphasizes the isolation and humanity of the performer, who is hanging from a rope by her teeth. Seen from far below, the painting is as audacious in its way as Miss Lala's act, although there was no reasonable way in which Degas could reproduce the finale, the firing of a canon attached to the other end of Miss Lala's rope!

The fourth Impressionist show was a modest success, attracting 15,400 spectators and yielding each exhibitor a share of about 440 francs. Sales remained sluggish, however, and the press noted with satisfaction the thinning of the Impressionists' ranks.

1880: The Fifth Show

In April 1880 the fifth exhibition opened in premises on the Rue des Pyramides that were still being constructed. The noise of building work added to the discomforts of bad lighting and, it was alleged, slapdash hanging of the pictures. Practical difficulties only emphasized the fact that the show revealed the Impressionists in disarray; indeed, it was now Impressionist in only a very limited sense. Morisot returned, but Claude Monet decided that it was time to try his luck at the Salon again, perhaps moved by Renoir's success the year before with his *Portrait of Madame Charpentier and her Children* (page 205). Cézanne was not missed (his genius was as yet unrecognized), but the absence of Monet, Renoir and Sisley destroyed the representative nature of the exhibition, as well as most of the controversy that could be expected to surround it.

Nevertheless, disputes were as acrimonious as before, with Caillebotte and Degas disagreeing on every point of policy and Pissarro trying to hold the ring. More than anything else,

Caillebotte disapproved of Degas' intransigence towards the defectors and continued to hope that all the Impressionists could be brought together again. For the same reason he resented the way Degas had brought in a number of his friends and protégés (Raffaëlli, Rouart, Zandomeneghi, Forain and others) as exhibitors, whom Caillebotte regarded as constituting a hostile faction.

Since none of these excitements became known to the public, the general response to the show was tepid rather than hostile. If

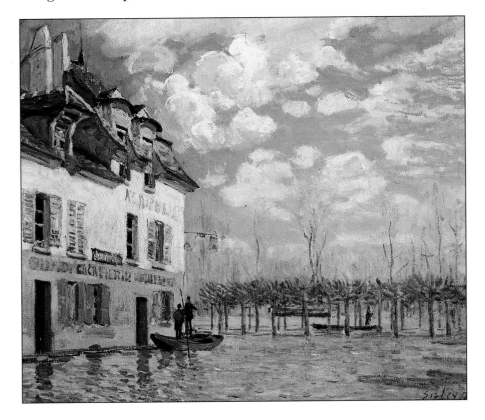

LEFT: **Floods at Port-Marly**
1876
Alfred Sisley
MUSÉE D'ORSAY, PARIS

any artist had a success, it was Berthe Morisot, whose *Woman at her Toilet* and other domestic scenes were increasingly admired. But for critics and public alike, Impressionism was no longer new and shocking and there was a general feeling that, as a movement, it was foundering.

1881: The Sixth Show

This seemed to be confirmed by the events of the following year. Paradoxically, Impressionist exhibitions had become an annual event just when their impact was weakest. This time the show was back on the Boulevard des Capucines, but the cramped quarters and bad lighting again invited ill success. The exhibitors had finally been reduced to two groups, friends of Pissarro and friends of

Degas. Monet had given up the Salon again but had not returned to the fold, and Caillebotte had dropped out. There were still good things to be seen, including paintings in an unusual rural-life vein by Pissarro, a remarkable large wax sculpture, *The Little Dancer, Aged Fourteen Years*, by Degas, and lively paintings by Morisot and Cassatt, who could almost be described at this time as having come into fashion.

All the same, there was a sense that the Impressionist shows were no longer the centre of avant-garde events. Since 1878 Georges Charpentier's magazine *La Vie Moderne* had provided a forum for advanced ideas and its offices hosted occasional one-man shows. Durand-Ruel was buying again after a long period of financial difficulties. Even the Salon seemed to be changing, as the state released its hold and turned the administration over to a committee of artists.

1882: The Seventh Show

Just when Impressionism seemed finished as a movement, most of its great figures came together again in a last great show. However, this was not a grand reconciliation but something more like a happy accident. Caillebotte had tried, without success, to organize an event that would exclude Degas' 'faction' and had reluctantly handed over the task to Durand-Ruel. A bank failure had left Durand in difficulties and he was determined to promote sales of 'his' artists. It was made clear to Monet and others that, whether or not they chose to exhibit, Durand-Ruel would show paintings by them from his own collection. Even so, the artists made all sorts of conditions (Caillebotte would not participate without Monet, nor Monet without Renoir), but somehow, only a week before the opening, everything fell into place. When it became clear to Degas that Raffaëlli and his other friends would not be invited, he refused to take part and Mary Cassatt stayed out with him, but Monet, Renoir, Sisley, Morisot, Caillebotte and Pissarro exhibited. The only minor figures admitted were Pissarro's friends Guillaumin, Gauguin and Vignon; the fact that these three were the only exceptions is a testament to the general good opinion of Pissarro.

Although only nine artists were represented, the show was a big one, featuring 210 exhibits. It was held in the Rue Saint-Honoré in March 1882, running concurrently with the Salon. The catalogue was a curious, hand-written affair, mimeographed

instead of printed, presumably because of the last-minute nature of the arrangements. Interest among the general public was still at a low level (there were only 1,900 visitors), but many of the critics had begun to mellow, despite the occasional smart, sharp comment (the sun in Monet's *Sunset on the Seine* looked to one writer 'like a slice of tomato'). The talking-point of the show was Renoir's *Luncheon of the Boating Party* (page 19), a large, ambitious work in the harder 'classical' style he was starting to develop, but still

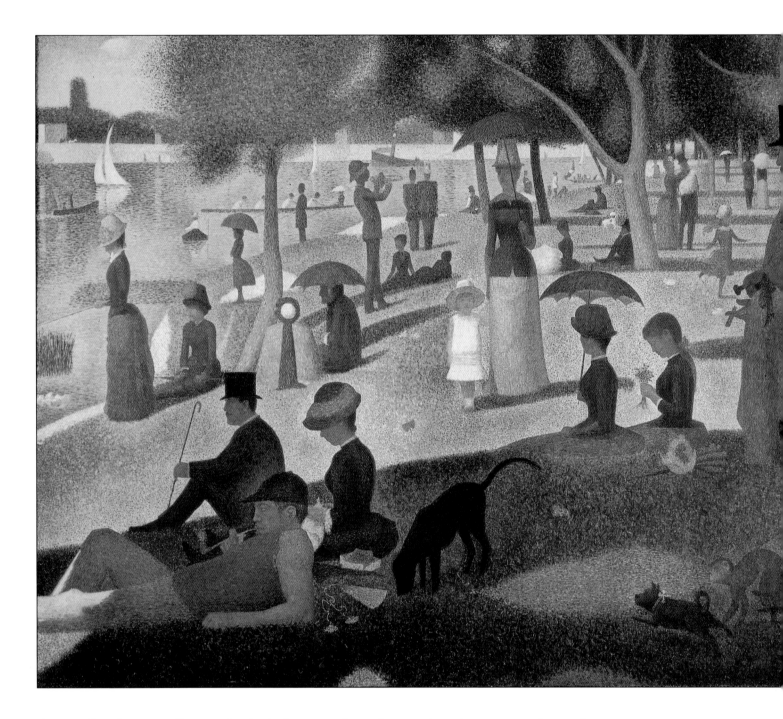

ABOVE: **Sunday Afternoon on the Grande Jatte** 1886 Georges Seurat ART INSTITUTE OF CHICAGO

Impressionist in its evocation of open-air enjoyment and casualness. The men's straw hats and singlets, and the slouching and leaning and disorder, seem to have been typical of the boating milieu, recalling the atmosphere of Guy de Maupassant's famous stories.

Interval

It was clear that the Impressionists had at last achieved a degree of acceptance, although not necessarily of prosperity; Sisley and Pissarro still had years of struggle before them. It was not too soon,

for most of them were feeling restless and dissatisfied with their work and ready to take new, divergent directions. Even at the time, they must have known that there would probably never be another show like that of 1882.

The next few years demonstrated that the Impressionist exhibitions had, after all, changed the climate of the art world. A conservative establishment would persist and remain powerful into the twentieth century, but its monopoly had been broken for good. The 'new' Salon proved disappointingly like the old one, but even there a brighter palette was becoming acceptable, provided it was combined with the requisite finish, and some artists were beginning to produce and sell a kind of slick, smoothed-out version of Impressionist art. More significant in the long run was the series of one-man shows held by Durand-Ruel in 1883, which further accustomed the public to this kind of viewing, implicitly more concentrated and critical than the endurance-test spectating at the Salon. In short order Monet, Renoir, Pissarro and Sisley had shows at Durand-Ruel's gallery; unfortunately, in most instances the precedent remained more important than the financial returns. Then, in 1884, the Impressionists' near-monopoly of dissent was itself broken when the Société des Artistes Indépendants was founded as an exhibiting body for artists rejected by the Salon. Despite rowdy beginnings, it survived and is still in existence.

Meanwhile, in the 1880s the Impressionists scattered and settled down. Like most people of a certain age, they abandoned regular comradeship for family life, although they kept in touch through monthly 'Impressionist dinners' at the Café Riche in Paris. However, past difficulties between them and the new directions they were taking seemed to ensure that there would be no more Impressionist exhibitions.

1886: The Eighth Show

In spite of this, another one was held at the Maison Dorée restaurant on the Rue Lafitte. But this swan song was very different from the 1882 show. Monet, Renoir and Sisley were absent again; Degas and his friends were back. Pissarro had undergone a change. He had been converted to Neo-Impressionism, which claimed to be a more scientific form of Impressionism. Its technique, known as divisionism or pointillism, involved the use of small, uniform dots of pigment, applied according to the most up-to-date colour theories.

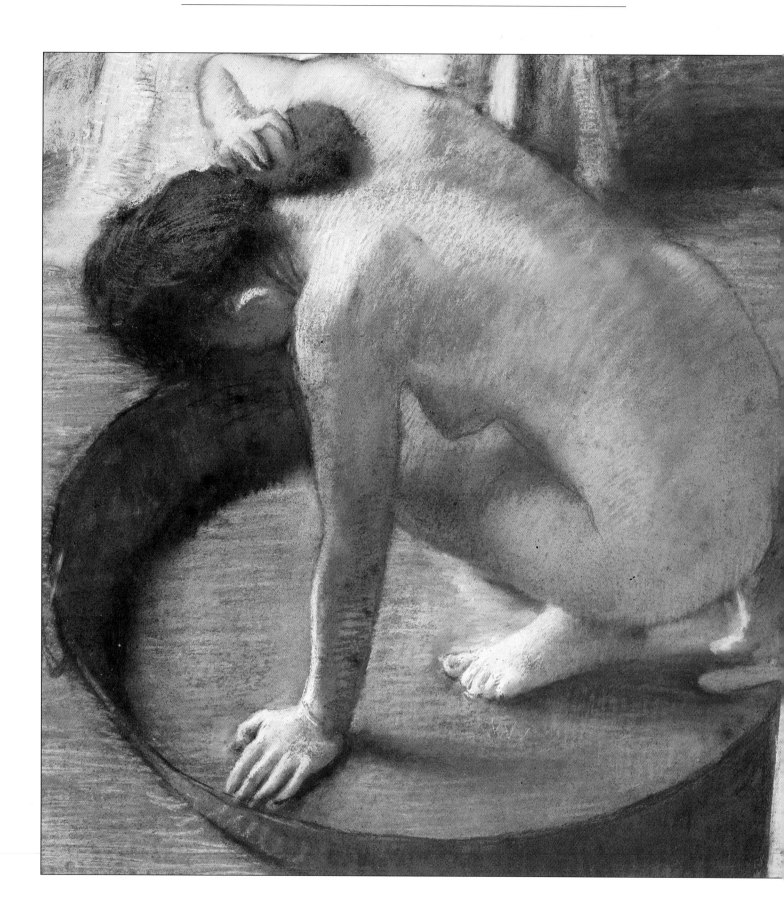

The chief of the Neo-Impressionists was not Pissarro but a young man named Georges Seurat (1859–1891), who exhibited at the Maison Dorée in a separate room with his fellow pointillists, Paul Signac and Camille Pissarro. The room was dominated by Seurat's large *Sunday Afternoon on the Grande Jatte* (pages 166-7), which is still the most famous Neo-Impressionist painting. The subject is typically Impressionist – people at leisure by the river – but the picture demonstrates how extremes can meet in art as in other things. Impressionist 'dotting', in its ultimate form, produced paintings that were not full of movement and tangible atmosphere, but still, solid and harmonious in a distinctly classical manner.

Among other works on show was a set of ten Degas pastels of women washing themselves. *The Tub* (left) is a superb example, all the more effective for the unusual viewpoint and Degas' subtle cropping. Like Manet's *Olympia* 20 years before, Degas' nudes puzzled and offended critics who had been brought up on idealized visions of smooth bodies and languorous poses. Degas' women, who now seem rather too well endowed to pass as a cross-section of female humanity, were berated by critics who harped on their ugliness and 'swollen flesh', evidently unable to come to terms with their self-absorption and non-inviting attitudes.

As well as Neo-Impressionist paintings, the 1886 exhibition featured works by Odilon Redon, whose mysterious and fantastic subjects foreshadowed the advent of a new movement, Symbolism: nothing could have been further from the sober factuality of Impressionist painting. Even before Impressionism had fully established itself, new forms of art were appearing. But individual Impressionists still had lives to live and great things to offer.

LEFT: **Le Tub**
1886
Edgar Degas
MUSÉE D'ORSAY,
PARIS

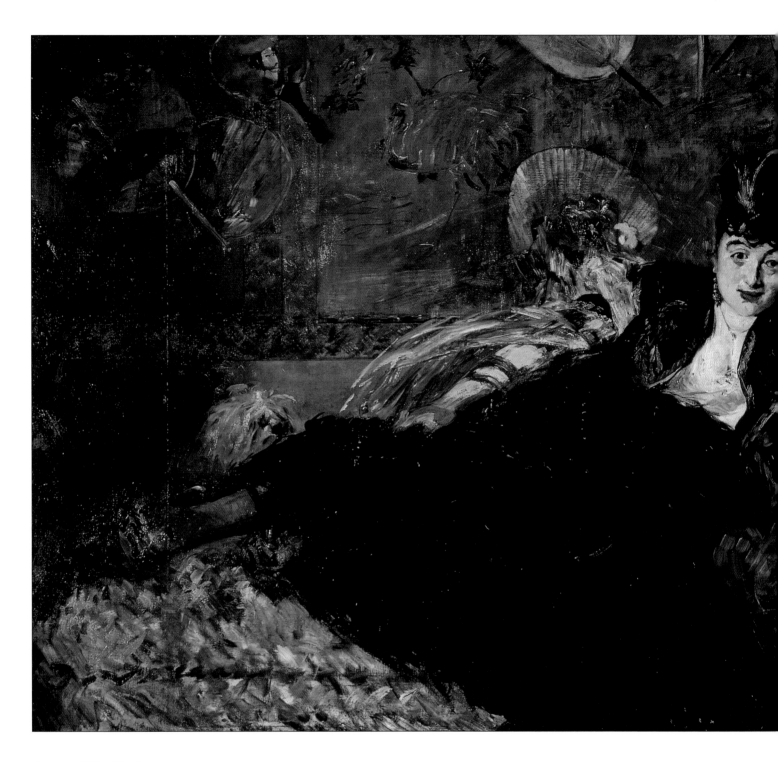

ABOVE: **The Lady
with the Fans**
1873-4
Edouard Manet
MUSÉE D'ORSAY,
PARIS

Divergent Destinies

═══ MANET ═══

H aving survived the siege of Paris, Manet spent three months in the south-west before returning to the capital in mid-May. The Commune had been crushed, but there was still some street-fighting and the troops of the Versailles government were on the rampage. Manet drew corpses and executions by firing squad which he later reworked and published as the lithographs *Civil War* and *The Barricade.* He was outraged by the brutality with which the Communards had been treated and had intended to paint a large canvas on the subject; but the project seems never to have got started, perhaps because of the rapidity with which life returned to normal. Despite the destruction, visible in well-known places such as the Tuileries and the Rue de Rivoli, there seems to have been a near-universal impulse to forget the immediate past and re-create a prosperous France. Manet may well have concluded that a large political painting was not likely to improve his already dubious chances of acceptance by either the artistic establishment or the public at large.

During the first year or two after the war, he seems to have been uncertain of the direction he should take, although 1872 started well when Durand-Ruel bought no fewer than 24 of his works for a reported 34,000 francs. Thanks to his inheritance, Manet was well-off, but he needed sales to boost his self-confidence and, in time, make his name known to a wide public. The other source of renown was the Salon. In 1872 he had nothing ready and he had to borrow back *The Kearsarge and the Alabama* from Durand-Ruel in order to exhibit. In 1873 he had his first real success with *Le Bon Bock* (Good Beer), probably inspired by a visit to Holland with Suzanne the previous summer. The picture showed a jolly bearded fellow, his waistcoat bulging, seated in front of a glass of beer, smoking a clay pipe. Manet's debt to seventeenth-century Dutch painters such as Frans Hals (of 'Laughing Cavalier' fame) was quite obvious, but it was just this familiarity that made *Le Bon Bock* popular with the critics and the public.

Artistically *Le Bon Bock* was a step backwards for Manet, but its success seems to have had the paradoxical effect of stimulating him to work in a vein of genuine vigour and originality. Over the following months he painted the exquisite *The Railway* (actually a picture of a woman and child against a steam locomotive background), *The Masked Ball* and *The Lady with the Fans* (page 170-1). The lady was one of the leading Parisian hostesses to 'artistic' society, Nina de Callias, who is shown lounging in vaguely 'oriental' style in front of a wall decorated with Japanese fans. Although primarily a portrait (of a person, but also of a type), it is also, like Monet's *Japanese Girl* (page 151), evidence of the extent to which *japonaiserie* had become a cultural cliché.

Manet at Argenteuil

His renewed confidence also encouraged Manet to experiment with painting on the spot, more or less as practised by his younger contemporaries – 'more or less' because most of Manet's early paintings of this kind seem to have been done through the windows of hotel rooms rather than in the open air. He had begun as long before as 1869, on holiday in Boulogne; had painted a fascinating *Harbour at Bordeaux* (1871) after the end of the siege of Paris; and, back in Boulogne in the summer of 1873, executed seascapes and a well-known beach scene featuring Suzanne and his brother Eugène.

However, Manet's best open-air painting was done in 1874,

RIGHT:
Argenteuil 1874
Edouard Manet
MUSÉE DES
BEAUX-ARTS,
TOURNAI

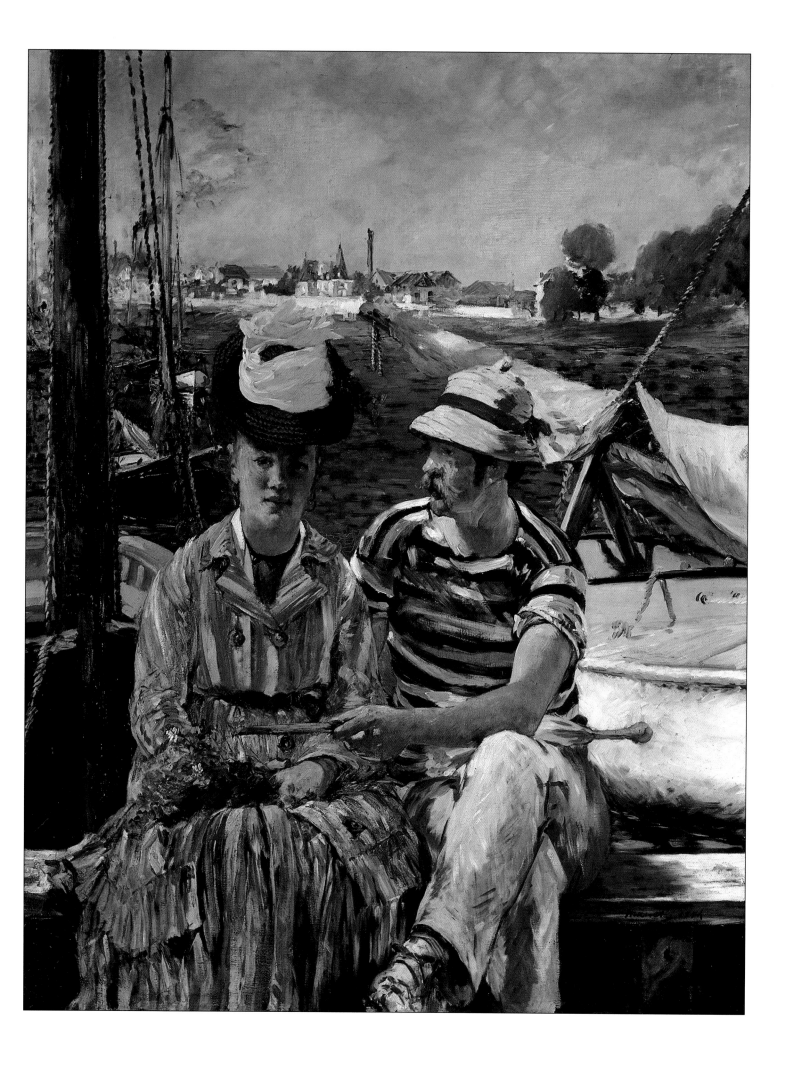

thanks to the double stimulus of Claude Monet and the boating fraternity at Argenteuil. Manet's family owned property at Gennevilliers, on the left bank of the Seine opposite Argenteuil, and he spent the summer there as one of a house party. He was already on excellent terms with Monet, and the company of a fellow painter evidently proved an irresistible attraction. Manet portrayed Monet and his wife Camille in the younger artist's studio boat and also left a record of Monet as a gardener, albeit in the background of a picture of Camille and the Monets' son Jean at ease on the grass. He also painted *The River at Argenteuil*, showing that, as much as Monet in his different way, he was a master at representing water and evoking the peaceful atmosphere of the riverside. The

BELOW: **Madame Manet on a Sofa** 1874 Edouard Manet MUSÉE D'ORSAY, PARIS

paint is applied with great freedom, but Manet preferred longer, slashing brushstrokes to the technique using a multitude of tiny dabs developed by Monet, Renoir, Pissarro and Sisley. And the human presence almost always looms larger in Manet's canvases. Where Monet painted the boats sailing on the river, Manet concentrated on the enthusiastic weekenders who did the sailing, clad in their summer shirts and straw hats. His most ambitious set-piece was *Argenteuil* (page 173), in which a man and a woman sit on a bench in front of boats and boating tackle, with Argenteuil across the river behind them. The beautifully composed *Boating*, with its Degas-like cropping, is even more effective in capturing the pleasure of 'messing about in boats'.

Inevitably, Manet sent *Argenteuil* to the Salon. It was accepted for exhibition, but met with a hostile reception. Critics pounced on absurd details – one complained that the Seine was never such a 'Mediterranean blue' – but the informality of style and subject may well have been what set their teeth on edge.

The Argenteuil paintings were as close as Manet came (not very close) to being a landscapist. He remained essentially a city man, whose idea of attractive scenery is a park or a garden. He did paint out of doors again, but typical subjects were *The Grand Canal, Venice* (1875) and several paintings done in 1878 of the road seen from his studio, including *The Rue Mosnier Decked with Flags*, Manet's version of a subject (France's national day) also tackled by Monet (pages 22-3).

The rejection of *Argenteuil*, followed by the rejection of his submissions for 1876, seems to have discouraged Manet, although he did defiantly hold an exhibition of his works at his own studio on the Rue de Saint-Petersbourg. He produced little during 1876, but that little included a masterpiece, the *Portrait of Mallarmé* (pages 176-7). Stephane Mallarmé (1842–98) was the greatest French poet of the period, writing in an evocative if 'difficult' style; the first edition of his best-known poem, *L'Après-Midi d'un Faun*, was illustrated by Manet. Although he made his living laboriously, by teaching English, his apartment was the centre of a literary and artistic circle and in the 1870s he emerged as a defender of the Impressionists in the French and British press. He and Manet became close friends despite the difference in their ages, seeing each other almost daily. Manet's affectionate portrait shows the poet in appropriately pensive mood, but also as a man of the world, with a cigar in one hand and the other tucked into his jacket pocket.

Upsurge

Manet's spirits seem to have improved quite suddenly in 1877, and 1877–9 proved to be the most prolific and creative period of his later life. There were still setbacks. His attempt to conciliate Albert Wolff by painting his portrait was a failure. The venomous *Le Figaro* critic seems not to have bothered to finish the sittings, perhaps appalled by Manet's candid revelation of his ugliness. Nor were Manet's efforts to interest him in the younger painters of any avail: Wolff was always to be an enemy of the entire group, unsparing even when writing Manet's obituary.

However, at this time Manet was rarely downcast for long. Even the rejection of *Nana* (right) by the Salon seems to have left him undaunted. Although he would not think of joining the Impressionists in their show, he was quite prepared to put *Nana* on display, rather cheekily, in the window of a fashionable milliner's in the Boulevard des Italiens! This was quite appropriate in view of the pastel tones and light-hearted treatment of the subject. Nana was a character in Zola's just-published novel *L'Assommoir*, where she begins her career on the streets, but it is highly likely that Manet knew Zola was already engaged on a new novel, actually called *Nana* (serialized in 1879), in which the girl would have a spectacular career on the stage and as a courtesan. In any event, Nana's profession is perfectly clear from the way in which she stands in her underwear, making up her face, in the presence of her elderly protector. The light-hearted mood is emphasized by the complicit way in which she looks out at us, as if mocking him, and the cropping which cuts him in two does – literally – marginalize his role.

In similarly light mood, *The Plum* (1877) showed a young woman seated at a marble-topped café table, with a cigarette between her fingers, dreaming over her plum soaked in brandy. Manet had now returned to the sophisticated world which was his natural element, painting beautiful women, Parisian streets and the interiors of the cafés and restaurants he knew so well. At about this time, change of mood or change of fashion led him to shift his 'headquarters' from the Guerbois to the Nouvelle-Athènes, a well-known café a little further east on the Place Pigalle. If Monet and the younger painters appeared there less often, having retreated to the country outside Paris, Degas was still a regular and still as uncomfortable a presence as ever, carrying into the café a sense of the distrust and resentment that were starting to show up

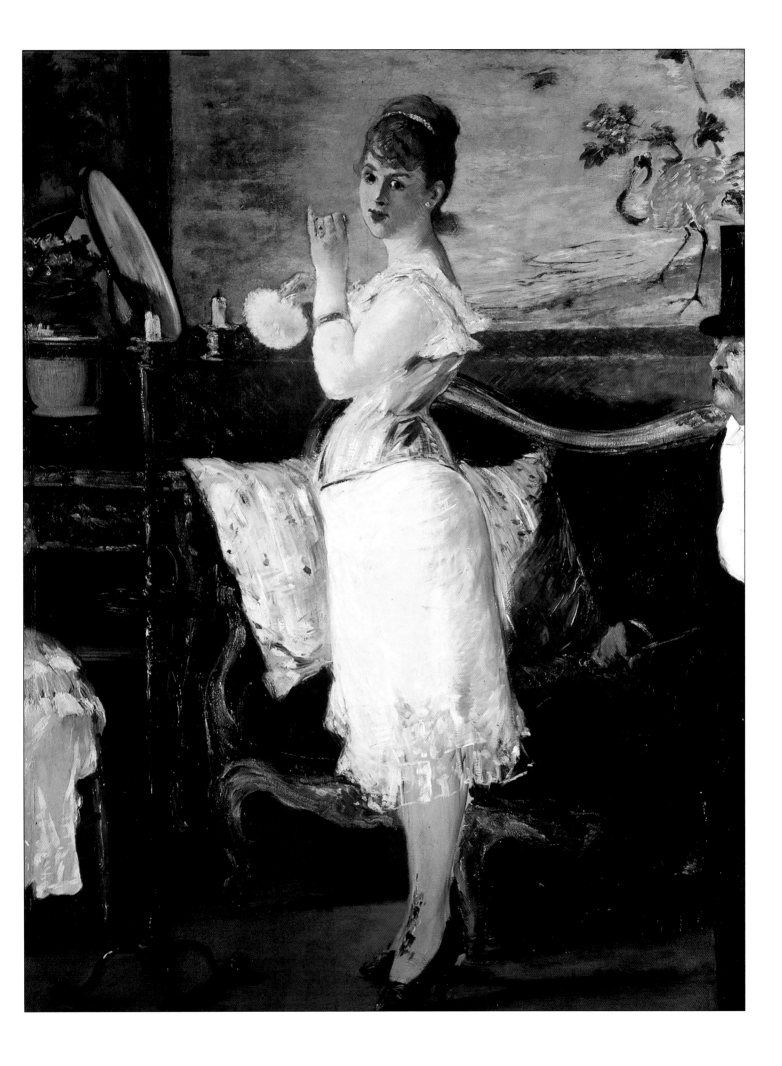

among the exhibitors at the Impressionist shows. Among the old faces were a number of new ones, including the young Irish writer George Moore, who would later become known for his novel *Esther Waters* (1894). Delighted by everything French and artistic (Manet's pastel portrait of 1879 makes him look like an astonished terrier), Moore has left lively accounts of Manet, Degas, Victorine Meurent and others in several volumes of memoirs. 'Paris has made me,' he declared, and 'I went to the Nouvelle-Athènes ... the academy of fine arts. Not the official stupidity you read about in the daily papers, but the real French academy, the café.'

The Plum was only one of a number of café scenes painted by Manet in 1877–9. *At the Café* (1877) gives us a glimpse of the audience at a café-concert, where people could drink while watching a stage show. *Inside the Café* (1878, right) concentrates on the warmth and closeness of such an establishment, the crowded tables and chairs forcing the clientele into pseudo-intimacy. There are two closely related versions of *The Beer Waitress* (also known as *The Café-Concert*, 1878–9), in the larger of which (National Gallery, London) the waitress is shown hard at work among a crowd of men who are oblivious of her as they watch the tulle-clad dancers on stage.

Manet continued to produce masterpieces, although his reception at the Salon was never very gratifying. In 1879 he showed two superb paintings, the 1874 *Boating* and *In the Conservatory*, a conversation piece whose memorable setting, a mass of brilliant, almost psychedelic plants, was suggested by the presence of lush, lavish greenery in a temporary studio that he was using. In the foreground, a woman sits on a bench, while a man leans on its back. If there is a 'story' behind the scene, the viewer is left to supply it.

Some kind of intimate drama is unmistakably implied in *Chez le Père Lathuille* (pages 182-3), an enchanting picture painted in 1879 that was, nevertheless, widely disliked when it was shown at the 1880 Salon. It was paired with the forthright if conventional *Portrait of Antonin Proust*, Manet's friend since their schooldays and a politician to be reckoned with. We can hardly doubt that *Chez le Père Lathuille* pictures a young man-older woman encounter of the kind that – in fiction – has potentially disastrous consequences for the older woman. Yet this aspect of the scene appears to have developed by chance. Père Lathuille's was a well-known restaurant, not far from Manet's old haunt, the Café Guerbois. The young man in the painting was Louis Gauthier-Lathuille, the proprietor's

son, and according to his account Manet was initially attracted by his dashing air in his dragoon's uniform. He paired the dragoon with a young actress, Ellen Andrée, who appeared in a number of Impressionist paintings. In this instance the actress was so unpunctual that Manet lost patience and substituted another model, but the new pairing failed to work until he told Louis to take off his uniform and put on the painter's own light jacket. Work started again and the scene was painted in its present form.

In April 1879 Manet moved into a new studio and, still

ABOVE: **Inside the Café** 1878 Edouard Manet OSKAR REINHART COLLECTION, WINTERTHUR

contending for official favour, wrote to the Prefect of Paris putting himself forward to decorate the council chamber of the new town hall (Hôtel de Ville). As so often, he was inspired by a Zola novel, suggesting *Le Ventre de Paris* (The Belly of Paris) as the title for a panorama of life in the capital. If his letter was ever answered, it was in the negative. Zola's public loss of faith in him, only a few months later, must have been a harder blow to bear. In an article originally written for a Russian magazine, but translated and published in *Le Figaro*, Zola had not only summed up Impressionism as a failure, but regretfully dismissed Manet as 'exhausted by hasty production', 'satisfied with approximations' and unwilling to study nature with passionate attention.

Fatal Affliction

The exhaustion, at least, was real. Manet had begun to experience rheumatic pains in the foot which became agonizing and forced him to walk with a limp. Eventually it became clear that his ailment was not rheumatism at all, but something far more serious: locomotor ataxia, a form of syphilis which, after a long period of latency, attacks the nervous system. Nineteenth-century medical science had no cure, but Manet was forced to undergo hydropathic and other treatments that were doubly painful, in their physical effects and also in exiling him from Paris at Bellevue and other rustic retreats where he was excruciatingly bored.

He was still intermittently able to work and in 1882 he at last won an accolade from the Salon jury for his *Portrait of Henri Rochefort*. He was awarded a medal – second class – which meant that his work would henceforth be admitted without previous scrutiny. Paradoxically, the subject of the painting honoured in this way was a veteran Communard, famous for his escape from confinement in France's distant New Hebridean colony. Rochefort had only just returned to France following the announcement of a general amnesty, so Manet's painting was certainly topical, but it remains hard to explain why the jury, having withheld its approval for so many years, should have honoured such an aggressively political, anti-establishment painting. One possible answer lies in a change that was made to the system in 1881, by which the state relinquished its control over the Salon in favour of a Society of French Artists. The new body proved to be hardly more enlightened than the old authorities, but perhaps felt obliged to make a liberal gesture towards an artist who was no

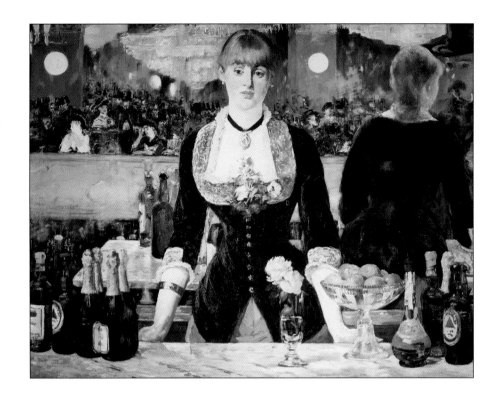

longer young and had never seriously challenged the right of the Salon to be considered 'the real field of battle'. Manet's craving for conventional recognition was further assuaged in December 1881, when his old friend Antonin Proust, now Minister of Fine Arts, saw to it that the painter was made a Chevalier of the Legion of Honour.

By this time Manet was finding it hard to work for long stretches and some of his canvases of the 1880s are painted in a notably cursory fashion. He turned increasingly to pastels, which could be used more swiftly and with less labour. He had long before mastered the medium, creating a brilliantly luminescent pastel of his wife lying on a sofa (1874, page 174). The soft, warm effects given by pastels also suited his mood in these final years of his life, when he portrayed pretty women as prettily as possible, and painted flowers and still-lifes as though determined to relish uncritically, even sentimentally, the sweet things of life.

All the more astonishing, then, that he mastered his pain sufficiently to make one large, final modern-life statement: *The Bar at the Folies-Bergère* (1882, above). Although based on sketches made at the Folies, it was painted in Manet's studio, where a bar was set up with bottles and fruit and a barmaid was brought in from the Folies to pose behind it. Manet was by now only able to work sitting down. The fascination of this canvas lies in the fact that it is a picture within a picture. The viewer is confronted with a section

of the bar and the girl behind it; the people crowded into the Folies are seen only as reflections in the mirror at the back, while the performance they are watching is confined to a pair of booted legs and a trapeze bar in the top left-hand corner of the canvas. The relationship between the barmaid and the reflection of her back is distinctly implausible and there is no sign of the customer whose reflected image she appears to be serving; but although critics have tried to explain, or explain away, such incongruities, they hardly matter to the ordinary viewer for whom the interplay between the near and the far in the picture gives it an enduring fascination.

Manet went to the 1882 Salon and seems to have behaved so normally that friends and acquaintances failed to realize quite how desperately ill he was. During the summer, spent at Rueil, outside Paris, he was able to paint a little in the garden of his rented house. But then his condition began to deteriorate rapidly. His last finished works were small, simple flower paintings, done from the blossoms in a glass in front of him. On 20 April, 1883, his gangrenous left leg was amputated, but the operation failed to save him. He died on 30 April and was buried at Passy, with old friends such as Monet, Zola, Duret and Proust in attendance.

DEGAS

By the 1870s Degas' art had achieved maturity. Until the end of his days he deepened and refined it, but its essential nature did not change. Much the same was true of his life, whatever its secret corners. He remained the bachelor dedicated to his work and although he was closely associated with the American artist Mary Cassatt, there is no serious evidence to support the idea of a romance between them. Degas is said to have remarked that he might have married Cassatt but could never have made love to her. If this is true, it indicates that he suffered from a common nineteenth-century male conflict that created many old bachelors, between the impulses of the senses and an idealized, desire-freezing conception of a 'lady'. Something of the sort can be discerned in Degas' paintings, between the way in which he treats dancers, laundresses and nudes as animals in action, and the refined social observation that characterizes his treatment of genteel creatures such as Mary Cassatt and his female friends and relations.

During the 1870s and 1880s the organization of the Impressionist exhibitions and the in-fighting that developed added spice to Degas' life. At moments he was almost a party leader, determined to maintain the anti-Salon rigour of the shows and wrangling over issues such as the content of the posters that would be put up to advertise them. It has generally been assumed that Degas was a disruptive influence (Caillebotte's letters are eloquent on the subject) and this is probably true, although it should be remarked that Pissarro seldom felt it necessary to take sides and remained on excellent terms with Degas.

One event that did have an impact on Degas' life was the collapse of the family firm after the death of his father. In 1876 Degas' strong sense of family honour led him to assume responsibility for much of the debt, after which he was 'obliged to do something to earn money every day'. A year later, in a rare admission of despondency, he complained to a correspondent of being destitute and alone. Either he was exaggerating, or earning money presented no great problems; for although he undoubtedly made large sacrifices to pay off the Degas creditors, he never seems to have been as desperate for money as fellow artists such as Monet and Sisley; among other things, he never felt compelled to take part in the disastrous auctions of the 1870s at the Hôtel Drouot. Despite its daring innovations, his art seems always to have been more acceptable to the critics and the public than most Impressionist work, although the implacable Albert Wolff bracketed Degas with Renoir as an unteachable who could not draw. Since Wolff was grotesquely ugly, Degas was able to revenge himself with one of his killing remarks: 'How should he understand? He came to Paris by way of the trees.'

Drink and Drudgery

Few of Degas' works created any prolonged controversy, but the celebrated *Absinthe* (page 158) did manage to outrage British opinion when it was shown at the Grafton Gallery in London, 17 years after Degas had painted it. The barrage of criticism was moral rather than aesthetic, but the objection was not really to picturing 'depraved' and 'boozy' people, but to the neutral stance that Degas appeared to take. Even a more emphatic title, such as 'The Evils of Drink', would probably have satisfied everybody. The evils were in a sense implied by the reference to the notoriously brain-destroying absinthe, which is undoubtedly represented by

the green liquid in the glass in front of the woman. Moreover, the cool colours and lifeless atmosphere are unmistakable comments on the situation; without the strong slabs of marble to bear it up, the picture itself would be dreary. The element of moral or social comment is unusual enough in Degas to have prompted the suggestion that the painting was inspired by Zola's recently published novel *L'Assommoir,* in which hard-pressed working-class people are shown as finding consolation and ruin in the dram-shop. The models for the apparently hopeless couple were in fact the bohemian but not particularly debauched Marcellin Desboutin

ABOVE: **On the Beach** 1876 Edgar Degas NATIONAL GALLERY, LONDON

and the actress Ellen Andrée, the woman whose unpunctuality helped to shape Manet's *Chez le Père Lathuille* (pages 182-3).

Degas continued to paint scenes with dancers to the end of his working life. He was briefly interested in the circus, but also took up the apparently unrelated study of women working in the steam and heat of a laundry. It is tempting to interpret his series of oils and pastels on the subject in terms of social comment, but this is almost certainly wrong. In *Women Ironing* (page 190) Degas has captured the tiredness and the toil of these poorly paid workers, but what interests him are their characteristic gestures and the challenge of translating them into a formally satisfying work of art. Nothing we know about him suggests that he saw the women's labours as anything but a part of the inevitable order of things. In Degas' Olympian view of the world, the exploited laundresses, like the milliners and their customers, like jockeys and their horses, are valued above all as the raw materials of art.

The strongest hints of personal sympathy in Degas' works are found in portraits of people of his own class, and particularly of fellow artists. These are often shown in their studios, as though Degas wished to insist that their work was the thing that mattered about them and, perhaps, cut them off from non-artists. In his *Portrait of Edmond Duranty* (page 155), painted the year before the writer's death, the enclosing wall of books and the chest-high desk covered with books and manuscripts, suggest that Duranty has been trapped rather than liberated by literature.

The mixed media employed on the portrait (watercolour, gouache and pastel) provide one among many examples of Degas' persistently experimental attitude and his concern with contrasting and varied textures. From the late 1870s he made increasing use of pastels, partly because they were a swifter, less eye-straining medium, but also because they offered scope for experiment. By diluting the material or steaming, rubbing or scoring the surface of the work, he could create an extraordinary variety of effects, visible in, for example, *Café-Concert at Les Ambassadeurs* (page 189), *Le Tub* (pages 168-9) and the late *Woman Drying Herself* (page 191). On occasion Degas created two versions of the same scene, using pastels for one and oils for the other; the results (for example, in *Miss La La*) are classic demonstrations of the differences between the two media.

In the 1880s Degas ventured into a different realm by writing a number of sonnets, which were circulated among friends but never published in his lifetime. On one occasion he is said to have

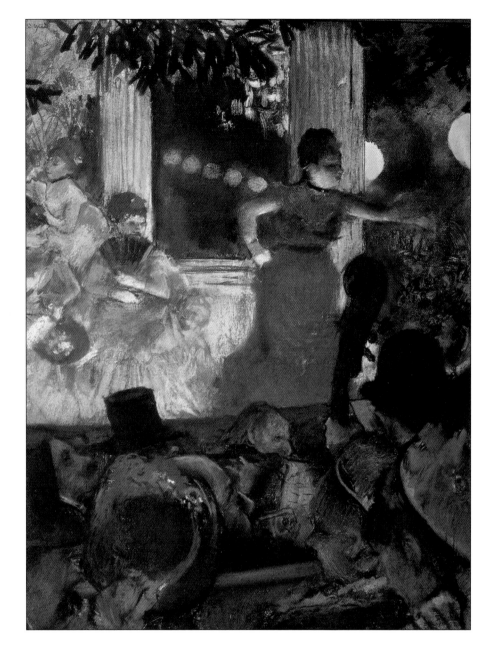

complained to the poet Mallarmé that he found composition very difficult in spite of having an abundance of ideas. 'But Degas,' said Mallarmé, 'poems are written with words, not ideas'. The story shows how difficult it is to grasp an art one has never practised: Degas would not have needed to be reminded that 'pictures are painted with pigments, not ideas'.

The Secret Degas

Degas' interests also extended to printmaking. He employed lithograph, etching, aquatint and other techniques to render the subjects normally associated with his work. He even produced a

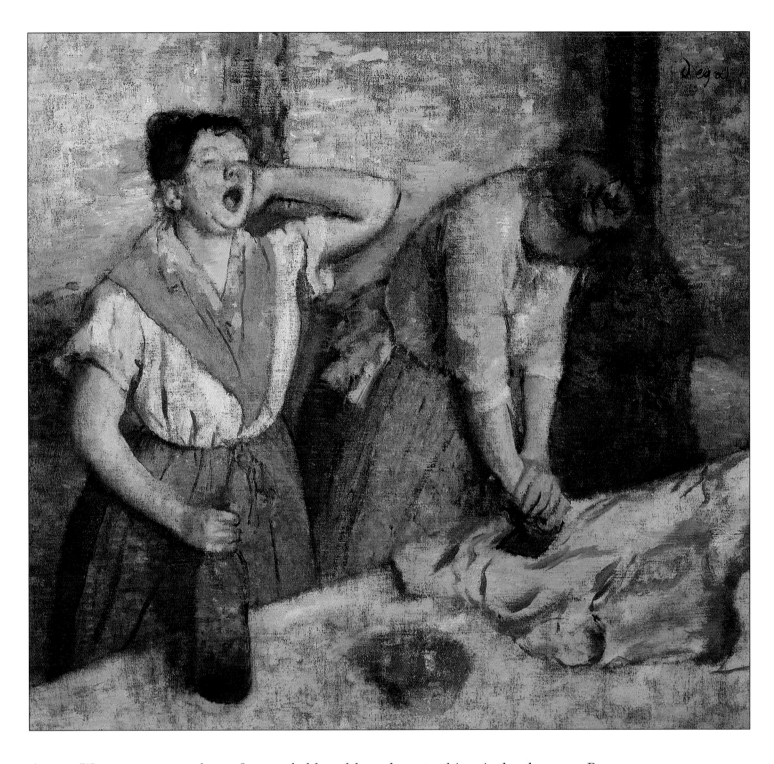

number of remarkable, although not *plein air*, landscapes. But interest has inevitably focused on the brothel scenes that he chose for black and white monotypes (one-off prints) in the 1880s. These were never shown in public and no doubt have a personal significance, although they can also be related to the prevalence of prostitution as a theme in contemporary writing by Zola, Guy de Maupassant, the Goncourt brothers and others. Degas' treatment of the subject, although sometimes touched with humour, is always grotesque, and the women are shown as graceless and lumpy, drawn with no sign of the pleasure in flesh textures that permeates

his pastels of nudes. A reference in one of his letters suggests that Degas did, at least occasionally, frequent brothels, so the monotypes presumably represent his responses to the experience.

In his sixties Degas was as curmudgeonly as ever, although he was still able to relax, take part in charades or indulge his new hobby, photography, among a few welcoming families whom he had known for years, such as the Valpinçons, the Rouarts and the Halévys. Sooner or later he fell out with everybody else, and when the Dreyfus case began to stir up animosities, even his extended domestic circle was disturbed. A passionate anti-Dreyfusard, Degas

ABOVE: **Woman Drying Herself** 1890-5 Edgar Degas NATIONAL GALLERY OF SCOTLAND, EDINBURGH

broke with Jewish friends such as the Halévys and Pissarro, and became so obsessed with the notion of an anti-French conspiracy that he even refused to employ a model because she was a Protestant and therefore on the 'other side'.

Early in the 1890s he still had enough of the schoolboy romantic in him to watch dozens of performances featuring the opera singer Rose Caron, although he made no attempt to approach her. At home the reality of his existence was his dragon of a housekeeper, Zoé Closier.

As his eyesight became worse, Degas continued to create, painting pastels of dancers and nudes whose indefinite, blot-like textures are wonderfully evocative. Later still, nearly blind, he relied on touch rather than sight, modelling in wax. He had become interested in sculpture as early as the 1860s, but had never exhibited anything except *The Little Dancer, Aged Fourteen Years*, a large wax figure that was seen at the 1881 Impressionist show; with characteristic audacity Degas had dressed her in a real dancer's costume. The figures he modelled in his old age bore witness to the purity of his artistic impulse, since they were never intended to be seen by outsiders. When he died, wax models were found in various states of preservation scattered around his studio. Skilled workmen were employed to cast those that could be salvaged in bronze, creating a posthumous body of work – mainly dancers and other female figures in motion – that led to the recognition of Degas as one of the greatest sculptors of the nineteenth century.

In the last few years of his life he was virtually blind and very deaf. Deprived of his vocation, he often wandered the no longer familiar streets of Paris, miraculously surviving the motor traffic. He lived to see France enter World War I, but not to be sure that his country would emerge victorious. He died in Paris on 27 September, 1917.

MONET

During the 1870s Monet seemed to find endless inspiration in Argenteuil and its surroundings. He painted the picturesque little town, the riverside promenade, the surrounding countryside and the boats that appeared during the weekend regattas for which Argenteuil was nationally known. He also painted the garden of his house, with or without Camille and

Jean in it. Always a lover of flowers, at Argenteuil Monet had become a passionate gardener, encouraged and instructed by a new painter friend, Gustave Caillebotte, who was equally enthusiastic about horticulture and sailing. Monet's conversion was striking enough for his visiting friends Manet and Renoir to paint him at

work while Camille and Jean relaxed. Eventually, in old age, Monet's art and his garden were to become one and the same.

Tranquil or zestful, sometimes energized by the passage of a train across a bridge, Monet's canvases remained as seemingly carefree as ever. In reality, his position was as precarious as it had always been. In good times he seems to have spent lavishly, without a thought for the morrow. When the bad times came, there were no reserves and he felt no shame in writing desperate begging letters to friends, just as he had done to Bazille before the war. Yet even at this point in his career, the good times were remarkably

good: in 1873 his income was about 24,000 francs, enough to keep at least three ordinary families. Evidently none of it stayed in his pocket, for when the recession reduced the amount to about 10,000 francs a year in 1874 and 1875, he was in desperate straits, living on credit and reduced to writing a note to Manet asking for an immediate loan of 20 francs. Complaining about his poverty seems to have become a habit, for he continued to do it well into the 1880s, when he had at last become a financial success.

The first Impressionist exhibition was a disappointment from a sales point of view, even though Monet had some superb, and shrewdly chosen, entries. *The Poppy Field at Argenteuil* (page 137) is among the best-known of all Impressionist evocations of summer ripeness. The role of *Impression: Sunrise* (pages 134-5) in naming the exhibiting group has already been touched on. True, the notion that a work of art might represent an 'impression' was already in the air, but Monet's painting gave Louis Leroy the word he needed for his satirical squib and fixed it once and for all on Monet and his friends. Some of Leroy's barbs were also aimed at *Boulevard des Capucines* (pages 138-9), which can be seen as an attempt by Monet to steal the show. A few months before the opening he had come to Paris and painted two views of the boulevard from the windows of Nadar's studios. One of them was included in the 1874 show, positioned so that visitors could simultaneously take in the real and the painted view. But this pleasant flourish passed without comment by spectators who were busy being astounded and irritated by the host of black blurs with which Monet represented the crowds on the street.

Enter the Hoschedés

His fortunes improved in 1876. At the second Impressionist exhibition he sold *The Japanese Girl* (page 151) for 2,000 francs. He also became friendly with the wealthy Ernest Hoschedé, who invited him to spend the summer and autumn at his country house, the Château de Rottembourg, at Montgeron, not far from Paris. Monet was lavishly entertained, commissioned to paint four very large canvases for the Hoschedés' dining room and given his own studio in the grounds of the château. Both Ernest Hoschedé and his wife Alice became close friends of Monet and Camille, with interesting consequences for all four.

Between January and April 1877 Monet was back in Paris, working obsessively to finish a new project in time for the third

Impressionist exhibition. He had obtained permission to set up his easel inside one of the capital's railway termini, the Gare Saint-Lazare, and proceeded to paint an unprecedented series of views of the station, the sheds, the locomotives, and above all the steam and smoke (page 157). Although trains had featured in paintings, including some of Monet's, before this, no one had tackled the grimy environment of the big-city station, let alone revealed its pictorial possibilities. Eight of the Gare Saint-Lazare canvases were shown at the 1877 Impressionist exhibition, along with 22 other paintings by Monet.

Monet's excursions to Montgeron and Paris may have indicated that Argenteuil was losing its appeal, for shortly afterwards he decided to leave. To judge from the tales in his letters of barely avoided evictions and mounting debts at the butcher's and baker's, the town can no longer have been a very comfortable place for the family to live in. With help from Manet and Georges de Bellio, a local doctor and loyal patron, Monet managed to pay his creditors enough to be allowed to move away. Even so, he still had to leave behind the 1865 *Déjeuner sur l'Herbe*, with the dire consequences described earlier.

While looking for a new home, the Monets returned to Paris, where Camille gave birth to a second child, Michel, in March 1878; although still a young woman, she was never really well afterwards. Monet spent his time in Paris painting gardens and views of the Seine, but on 30 June he celebrated France's national day with two brilliantly colourful canvases of the crowds and flag-decorated streets, *The Rue Montorgeuil* (page 193) and *The Rue Saint-Denis*.

Vétheuil

These can be seen as an appropriately flamboyant farewell to the capital; he never lived there again. By September 1878 he and his family were living at Vétheuil. Like the lively little town of Argenteuil, Vétheuil lay beside the Seine, but there the resemblance ended. Monet's new home was no more than a village and too far from Paris to attract weekenders. The implication was that he intended to turn his back on modernity and find a place in a more traditional community – a curious change of direction after his labours at the Gare Saint-Lazare.

One advantage of living at Vétheuil was its cheapness – all the more important since Monet's 'family' was abruptly enlarged. When his friend Ernest Hoschedé, a compulsive speculator, went

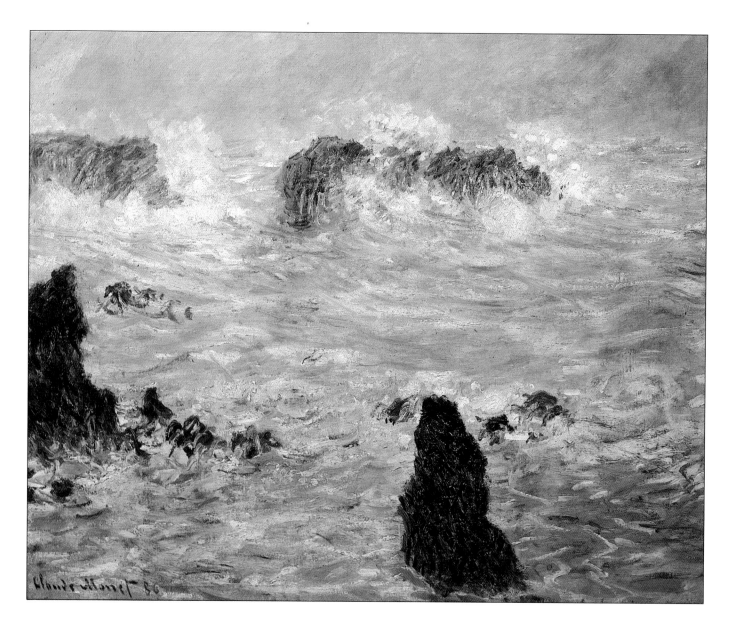

bankrupt, Monet lost more than a patron: Hoschedé's art collection was auctioned and works by Monet and other Impressionists went at knockdown prices, confirming their low commercial standing. An even more dramatic consequence was that the Hoschedés and their six children took refuge with their former protégé at Vétheuil, making Monet the head of a household of ten people.

His response was a furious burst of creativity in which he painted Vétheuil, the river and his garden in all their moods. Meanwhile Camille sank rapidly and died on 5 September, 1879; Monet painted her on her deathbed and to his friend Georges Clemenceau is said to have confessed that he had been taken aback to find himself behaving like an artist rather than a husband, keenly studying the colour changes that death was bringing about on her features.

ABOVE: **Storm: Rocks at Belle-Ile** 1886 Claude Monet © DACS 1996 MUSÉE D'ORSAY, PARIS

With Camille dead and Hoschedé often absent in Paris, Alice Hoschedé remained to look after the children. Or at least that was the reason given at first. At some point since their meeting in 1876 – we have no idea when – their relations had become intimate. As if reflecting the dramatic nature of these events, the winter of 1879–80 was savage. The Seine froze over and when it thawed there was a tremendous tearing noise that echoed through the streets of Vétheuil. Monet painted a series of spectacular canvases depicting every phase of the thaw, including *Ice Breaking Up at Vétheuil* (pages 194-5).

Disillusioned with the Impressionist shows, Monet had taken part grudgingly in 1879, but in 1880 he followed the example of Renoir and Sisley by trying his luck once more at the Salon. At first he wrote to Duret saying frankly that he was acting in self-interest, convinced that breaking into the Salon would help him to sell, but he was soon trying to justify himself by complaining to a journalist that 'Our little church has become a banal academy whose doors are open to any tyro', conveniently forgetting that the Impressionists had always accepted a mixed bag of exhibitors in order to help pay the bills. In the event, only one of Monet's submissions, a relatively bland, purpose-painted landscape, was accepted. From this time onwards he simply ignored the Salon.

He was able to do so because better times were at last on their way. In 1880 the dealer Durand-Ruel was ready to start buying again after a long period of financial difficulty, and in 1881 Monet signed a contract that ensured him a regular income. Even more important, the public began to respond to his work, partly because tastes were beginning to change, but also because Monet had found a subject which continued the dramatic vein of his Vétheuil thaw canvases and had a strong popular appeal: the sea. In 1881 he was painting the wave-pounded Norman coast at Fécamp and after that he went away, year after year, to Pourville, to Varengeville, to Etretat, whose great eroded rock-arches brought him back three years running, and in 1886 to Belle-Ile.

This remote little island lay off the south coast of Brittany, facing the full fury of the Atlantic. In paintings such as *Storm: Rocks at Belle-Ile* (page 197) Monet sought to capture the elemental struggle between rock and water. His letters show how emotionally involved he became with the 'sinister' and 'fearful' scenes he witnessed. A young journalist, Gustave Geffroy, happened to be staying on Belle-Ile at the same time and described the tenacity with which Monet carried on painting in all weathers, if necessary lashing

RIGHT: **Rouen Cathedral: Harmony in Blue and Gold** 1894 Claude Monet © DACS 1996 MUSÉE D'ORSAY, PARIS

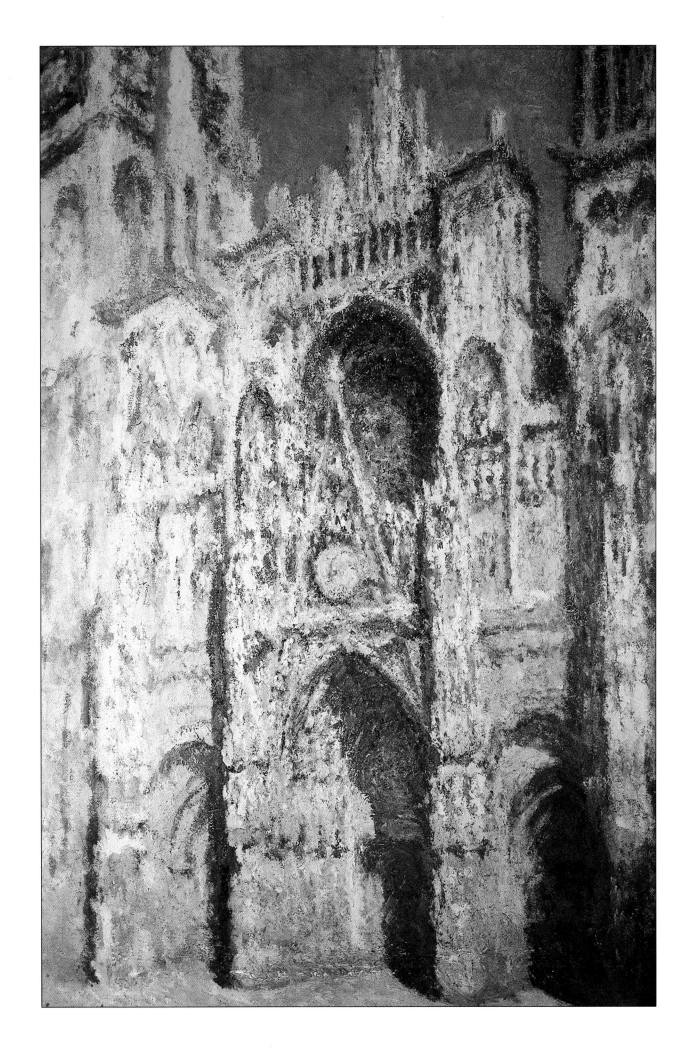

his easel into place. He also confirmed that Monet started several pictures in an afternoon, working on first one and then another, depending on the state of the light. Although Monet often exaggerated the extent to which his canvases were painted in the open air without any extra work in the studio, testimony of this kind leaves no doubt that direct contact with nature was the true source of his inspiration.

Giverny: Paradise Found

Meanwhile Ernest Hoschedé had effectively disappeared from the scene and the ambiguous situation in the Monet-Hoschedé household had made Vétheuil an uncomfortable place to live. (The ambiguity was only removed in 1892, after Ernest Hoschedé's death, when Monet and Alice were able to marry.) Monet and his extended family moved in 1881 to Poissy and then, two years later, found their final, ideal home at Giverny, another village on the Seine, some 80 kilometres from Paris. They moved into Le Pressoir (the Cider Press), a large house with pink walls and green shutters, and Monet soon reported to Théodore Duret that 'I am delirious with joy: this Giverny is a splendid place for me'. Over the years he would paint every aspect of the place – his own garden, the village, the surrounding meadows and, above all, the river. Just as he had done at Argenteuil, he adapted a boat to serve as a floating studio, plodding out every morning to paint at crack of dawn.

However, his travels were far from over. He sought new challenges and, incidentally, new subjects that prevented the public from becoming tired of his work. Returning from trips to the Mediterranean coast, he brought back canvases filled with the blues and pinks of the South; he painted in Holland and in the valley of the Creuse and at Rouen in France; and later trips would take him to Norway, London and Venice. As his popularity grew, he played off dealers against one another, maintaining his independence and steadily driving up his prices. In 1889 a joint exhibition held with Auguste Rodin, who was already recognized as the leading sculptor of his time, confirmed Monet's status as a great French painter. He was now a wealthy man, able to buy Le Pressoir and embark on a programme of alterations and extensions that would turn it into his private kingdom.

He was also able to take time out from his work in 1890 to mount a successful campaign to buy Manet's *Olympia* and present

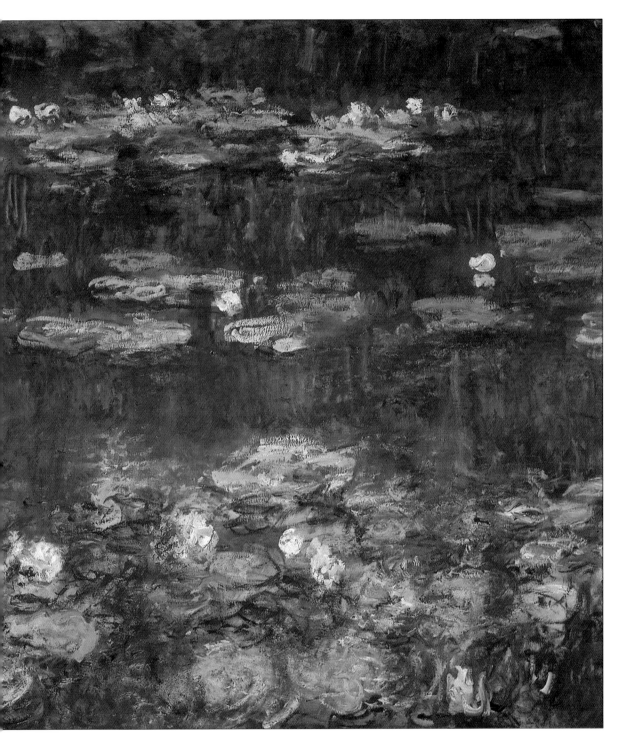

it to the Luxembourg Museum; from the Luxembourg it was certain, in time, to be transferred to the Louvre and recognized as a national treasure. Monet's generous gesture helped Manet's widow and paid off some of Monet's debt to the dead artist, who had often come to his assistance. And, naturally, if Manet was admitted among the immortals, his peers – with Monet at their head – were bound to follow in due course.

Monet had long been in the habit of working on several canvases in the course of a day, turning from one to another as the light and atmosphere changed. From this the idea of a series of paintings, all on the same subject, developed. The Gare Saint-Lazare series (page 157) was merely thematic, since it included interiors and exteriors, recording various aspects of the station. But during the 1890s Monet increasingly concentrated on a single subject, so that the series canvases became distinguished by their painterly treatment, inspired by varying conditions, rather than any important differences between their subjects.

In 1889–91 Monet pursued the idea through series paintings of the Creuse valley, haystacks and poplars. Then in 1892, and again in 1893, he spent three months in Rouen, painting the cathedral from a room looking across a square on to it. The result was an extraordinary series of 30 canvases (page 199). In these the cathedral is seen from only three slightly different viewpoints, corresponding to Monet's moves from one room to another. Like a great musician, he had created a series of variations in which mastery of the medium, rather than the ostensible subject, was what mattered. In the *Cathedrals*, the Impressionist concern with light reaches a grand climax, as the solid stone appears to melt under its impact. Paradoxically this also represents a turning away from the here-and-nowness of Impressionism, as Monet's painting was clearly becoming a matter of intensely expressive, subjective responses to the motifs he worked on.

From the 1890s his career is a story of continuous artistic and public triumphs. There were more series, culminating in visits three years running to London (1899–1901), whose notorious fogs delighted Monet. He painted over 100 canvases, comprising three series of Thames-side pictures, featuring the Houses of Parliament, Waterloo Bridge and Charing Cross Bridge.

This was the last of his painting excursions, with the exception of a short stay in Venice in 1908. The final quarter-century of Monet's life was spent in a glorious celebration of Giverny. Through land purchases and extensive engineering work that included a diversion of water from the river Epte, he created an opulent, paradisial water garden which never failed to inspire him.

Of the hundreds of Giverny garden paintings, the most celebrated are those of the lilies that covered the surface of his pool. Monet's last great project, long meditated, was a round room

in which the viewer would be surrounded by these flowers, floating on an unbroken, tranquil expanse of water. Taking shape in 1914, the scheme took a new turn when Monet's friend Clemenceau, who had become prime minister, pledged the state to provide a suitable setting for the work if Monet would present it to France. Many difficulties remained, including harrowing cataract operations to save Monet's sight, but the *Grandes Decorations* were completed by the time of his death on 6 December 1926. A few months later, installed in the Orangerie, in the corner of the Tuileries gardens in Paris, they sealed Monet's fame and made manifest the triumph of Impressionism.

RENOIR

During the 1870s Renoir created some of his most enchanting works – the sun-dappled scenes and portraits of beautiful women that have always been his most popular paintings. Although hard up for a few years, he managed better than his friend Monet, but he was sometimes irritated by the assumption that, as a bachelor, he was less in need of assistance than his friends. After the end of his relationship with Lise Tréhot, many beautiful models passed through Renoir's studio – the actresses Jeanne Samary and Henriette Henriot, the rumbustious Margot Legrand, who looks so charmingly young and innocent in the *Café-Concert* of 1876, and the young Anna Lebeuf who modelled *Nude in Sunlight* (page 148) and was dead less than three years later. If Renoir's relations with any of them were more than professional, he was too discreet to say and his pictures give us no clues. His paintings of women are probably his greatest glory and yet, for all their freshness and glow, they are curiously innocent and unsensual. Renoir himself made an interesting and significant distinction when he deprecated talk of 'flesh' in connection with his nudes, insisting that what fascinated him was a lovely *skin*.

A model named Nini took the part of the first-night sophisticate in Renoir's famous *La Loge* (The Box, page 145), shown at the Impressionist exhibition of 1874. Even at the time, its quality kept it clear of the criticism directed at most of the Impressionists' works, although Renoir was only able to sell the painting for a badly needed 425 francs that paid his back rent. A miraculous combination of clarity and loose, free brushwork distinguishes this

evocation of a high life that the impecunious Renoir probably knew nothing about; the canvas was painted in his studio and the evening-dressed swell with the binoculars was actually his brother Edmond. The rich interplay of blacks and pearly whites, heightened with touches of colour, shows Renoir as an apparently effortless master of a manner that he never chose to follow up.

Sunlit Scenes

More typical of his non-portrait works were a group of wonderful outdoor scenes. In the early 1870s, influenced by Monet, he painted land- and riverscapes. But back in Paris, his deeper-rooted impulse towards figure painting soon broke out again. In 1876 he rented part of a tumbledown house in the Rue Cortot in Montmartre and painted some of his most celebrated pictures in the wild garden of the house or, just round the corner, at the Moulin de la Galette. The hill of Montmartre had once been thick with windmills (*moulins*), but by this time the area had become citified and the Moulin de la Galette survived by becoming a place of entertainment (a *galette* is a kind of pancake). According to Edmond Renoir, his brother practically lived there for six months in order to paint the *Moulin de la Galette* (plate 159), absorbing the atmosphere and working in the open air. Most of the people in the foreground were bohemian or artistic friends of Renoir's who willingly trooped up to the Galette and danced and drank in the garden while the painter worked. With superb skill, he rendered the irregular, semi-amorous movements of the couples and the restless gaiety of the crowd, spangling the entire scene with patches of sunlight.

Shown at the 1876 Impressionist exhibition, *Moulin de la Galette* was fairly well received, perhaps only because critics were more outraged by the green reflections on the body of the *Nude in Sunlight* (page 148), modelled by the unlucky Anna Lebeuf in the garden at the Rue Cortot. This was also the setting for *The Swing*, another enchanting, well-known painting in which a young woman is shown standing on a swing, with two male admirers in attendance. The large areas of sun-dappled purple shadow were too much for some commentators, who could see nothing in them except wilful eccentricity.

None of these sunshine works suggest the struggle for recognition and the hard times that Renoir and his colleagues were going through. Renoir took an active part in organizing the early Impressionist shows, and the disastrous 1875 auction at the

Hôtel Drouot was held on his direct initiative. With poetic injustice he was the greatest sufferer, some of his canvases selling for less than 100 francs. Apparently undeterred, he took part in the equally unsuccessful sale of 1877 before concluding that the Impressionists' independent stand was a lost cause.

With a certain ruthlessness that he concealed under his air of bluff common sense, Renoir promptly decided to start sending canvases to the Salon again. A typically charming work, *The Cup of Chocolate*, was accepted in 1878 and praised by critics eager to welcome Renoir back into the fold of orthodoxy. Three years later, still evidently stung by reproaches from some of his old comrades, Renoir wrote defensively to Durand-Ruel, 'There are scarcely fifteen collectors who can appreciate a painter not approved by the Salon. There are eighty thousand of them who wouldn't buy a single thing if the painter hadn't shown it at the Salon. That's why

BELOW: **Portrait of Madame Charpentier and her Children**
1878
Auguste Renoir
METROPOLITAN MUSEUM OF ART, NEW YORK

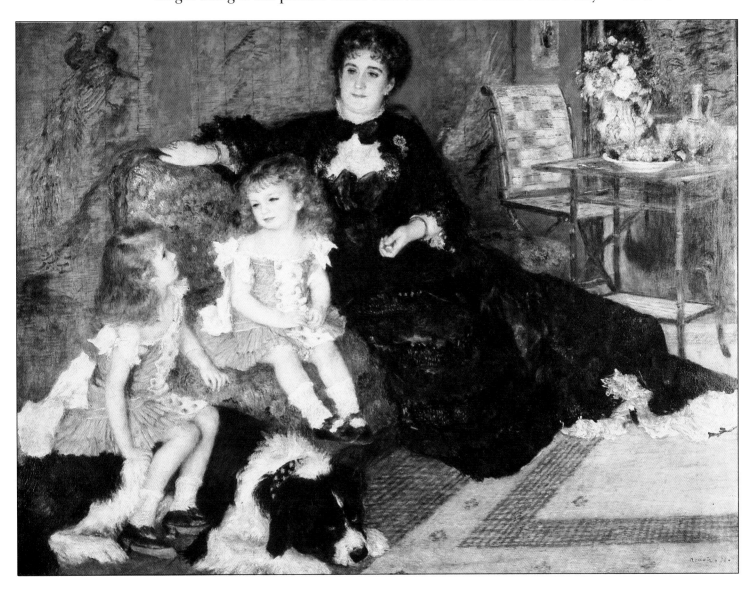

I send in two portraits every year ... My submission to the Salon is purely a matter of business.' Which was another way of saying that the Impressionist exhibitions had never been more than a convenience for him, and that he had never had any intention of trying to change the system of juries and prizes that artists such as Degas and Pissarro found so objectionable.

One good reason for this conservatism was that Renoir was already starting to make a reputation as a portraitist and to acquire patrons. Among these was the ex-customs officer Victor Chocquet, who became a Renoir partisan until he was overcome by an even greater enthusiasm for the work of Cézanne. Even more important for Renoir was his connection with the publisher Georges Charpentier, who bought three of his canvases at the 1875 Hôtel Drouot sale. Charpentier's avant-garde magazine, *La Vie Moderne*, took up the cause of the new painters, and its offices were used to mount one-man shows which played their part in eroding the power of the Salon.

Success

Taken under Charpentier's wing, Renoir was the first artist to benefit. No doubt the fact that his brother Edmond edited the magazine was helpful, but it was above all his skill as a portraitist that made him such a valuable acquisition for Charpentier and, in particular, for his ambitious society hostess wife. Renoir became their court painter, enjoying their luxurious surroundings and genuinely enjoying painting the two Charpentier children. In 1878, looking for a way of ensuring that his work would be hung in a more prominent place at the Salon, he painted a large portrait of *Madame Charpentier and her Children* (page 205). The style was a skilful compromise between Impressionist free brushwork and academic detail. Similarly, the muted informality of the group was made acceptable by the presence of children and a dog. The 'advanced' tastes of the Charpentiers were apparent in the bamboo furniture and other elements of 'Japanese' decor, opulent enough to our eyes but very sparse by Victorian standards.

Thanks to the Charpentiers' influence, the canvas was hung at the 1879 Salon as Renoir wished, and enjoyed a great success. His circle of patrons expanded to include the diplomat Paul Bérard, who commissioned many paintings of family and friends, often in the setting of their home at Wargemont. At the same time

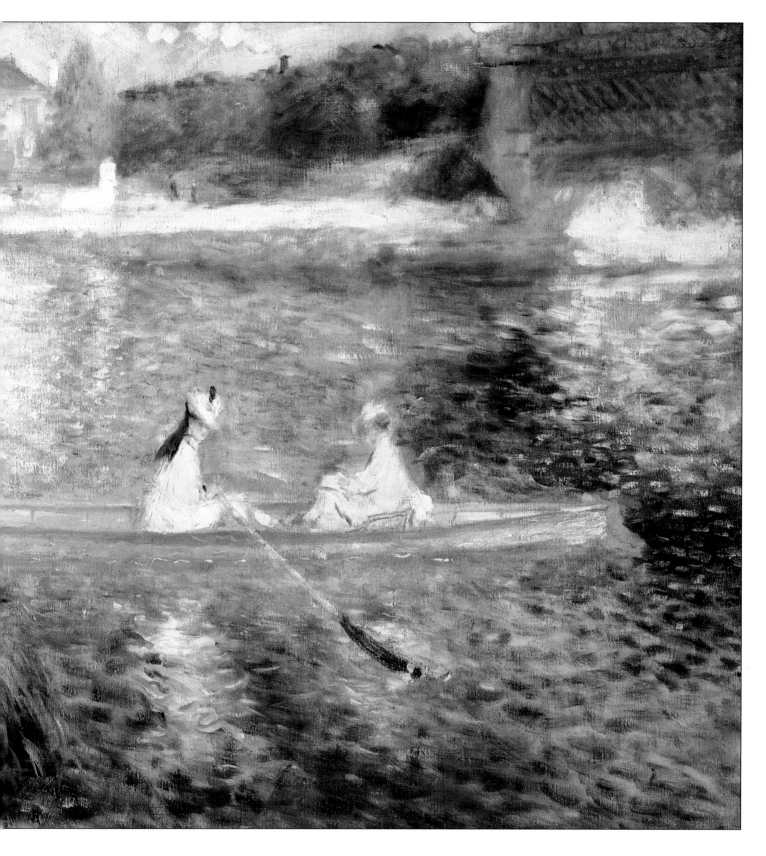

he continued to paint nudes, café interiors, the circus and boating scenes such as *The Skiff* (above, and also known as *The Seine at Asnières*) and *The Luncheon of the Boating Party* (page 19). *The Boating Party*, ambitiously large by Renoir's (although not by academic) standards, was begun in 1880 and finished in 1881,

ABOVE: **The Skiff**
1879
Auguste Renoir
NATIONAL
GALLERY, LONDON

after Renoir had returned from a trip to Algeria. It has become one of those pictures that are felt to encapsulate the carefree spirit of Impressionist art, although Renoir's modification of the strict *plein-air* treatment is fairly obvious. Like the *Moulin de la Galette*, it is peopled with the artist's friends and set in a familiar location, the first-floor balcony of a well-known riverside restaurant. Fournaise, the proprietor, as informally dressed as his customers, stands on the left, gripping the railings, while the young man straddling the chair is the painter-patron Gustave Caillebotte. Even more than the Moulin de la Galette, the painting suggests the free and easy atmosphere and lowering of class barriers that characterized the boating fraternity in an otherwise stiff and buttoned-up society.

The appealing young woman with the tip-tilted nose, playing with the dog, is Aline Charigot, who had become Renoir's mistress in 1879. Her country simplicity suited Renoir, although he did not make up his mind to marry her until 1890, five years after the birth of their first son, Pierre.

Meanwhile he continued to send canvases to the Salon, ignoring the Impressionist exhibitions. His only reappearance, in 1882, was a formality; all the Renoirs in the show belonged to its organizer, Durand-Ruel, and the artist himself never deigned to turn up. His remarks in a letter to Durand, expressing his disapproval of being seen with 'revolutionaries' such as Gauguin and 'the Israelite Pissarro', show Renoir in his least attractive light.

Changes of Style

His intemperance may well have been prompted by his own sense of crisis. In the 1880s he became increasingly unsatisfied with his work, feeling that the Impressionist way of painting lacked the solidity and permanence that he found in the Old Masters. A visit to Italy late in 1881 confirmed his fears, making him conscious of an inferiority by comparison with the great Renaissance artists and, in particular, with Raphael. Over the next few years he moved towards a new *manière aigre* ('sour manner' or severe or dry style). Even *Luncheon of the Boating Party* showed a slight hardening of outlines and smoothing of surfaces, and this became more obvious in the well-known *Umbrellas* (1883), so 'transitional' that some areas of the picture are painted more freely than others, as though Renoir had changed styles in the course of working on it. Similar differences occur between three panel paintings of dancing couples,

also dating from 1883; and although these are now regarded as very successful works, Renoir was still far from content.

For three years he struggled with a large *Bathers* (below), which he finally completed in 1887. Its almost sculptural modelling is lightened by the colouring and the playful mood, but there is a certain artificiality about the scene, caused by the lack of integration between figures and background, that stops it from being entirely successful. In the event, the severe style was not popular and evidently failed to hold Renoir himself. By the end of the 1880s he was modifying it by going back to a looser brushwork, creating

BELOW: **The Bathers** 1884-7 Auguste Renoir TYSON COLLECTION, MUSEUM OF ART, PHILADELPHIA

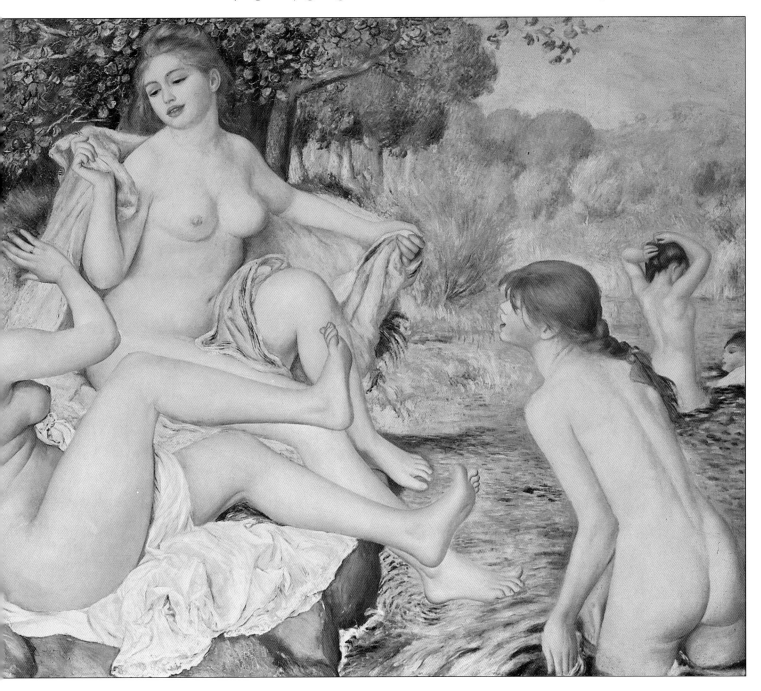

silkier textures and employing pearly highlights that romanticized his subjects. In fact, the term 'pearly style' is often used to describe Renoir's work from the 1890s onwards. During this last, long phase he abandoned many of his earlier subjects, concentrating on opulent nudes, fresh young girls and charming children. Apart from a few portraits and landscapes, these became the staples of an art that abandoned any contact with contemporary reality, retreating into a timeless dreamland of soft femininity.

Renoir's 'retreat' was encouraged by attacks of rheumatism and arthritis, which led him to leave the damp north and settle at Cagnes in the South of France. He eventually acquired Les Collettes, a large property filled with olive trees, and proceeded to build himself a house. His increasing disablement may also have encouraged him to concentrate on painting nudes. Among his favourite models was his own children's nurse, Gabrielle Renard, who appears in one of Renoir's more characterful, but typically rubicund, late paintings, *Gabrielle with a Rose* (left).

Eventually Renoir was confined to a wheelchair and his fingers were turned into his palms, immovable; but although he was unable to change his brush, he could still wield it. In 1916–18 he even practised sculpture, using a trained carver as his 'hands'. Even in the last year of his life, his paintings showed no falling off in skill. He lived to see the end of World War I, dying at Les Collettes on 3 December, 1919.

PISSARRO

In 1879, after Renoir had abandoned the Impressionists and showed the *Portrait of Madame Charpentier and her Children* (page 205), Pissarro wrote to his son with characteristic generosity, 'Renoir has had a great success at the Salon. He seems to be launched – I am pleased, poverty is so hard.' More than ten years older than Renoir, Pissarro had known poverty for far longer and his troubles were nowhere near over. Nevertheless, having committed himself to break with the Salon, he never went back and was the only major Impressionist who exhibited at every one of the shows between 1874 and 1886. He also took a leading role in organizing them. Pissarro's mild, kindly personality calmed disputes and diverted artistic egos set on collision course, holding together, for a surprisingly long time, such uncongenial

spirits as Caillebotte and Degas.

Yet Pissarro himself was prone to self-doubt, and the apparent failure of each exhibition threw him into deep depressions. Well into his forties, he began to wonder whether he would ever achieve a reasonable degree of security through painting. He had a large family to support and the well-meant nagging of his wife – who could not understand why he carried on instead of taking a steady job – hardly helped. Nevertheless, Pissarro always insisted that 'painting's the only thing that counts'.

During the 1870s he produced work of outstanding quality,

RIGHT: **The Pork Butcher** 1883
Camille Pissarro
TATE GALLERY,
LONDON

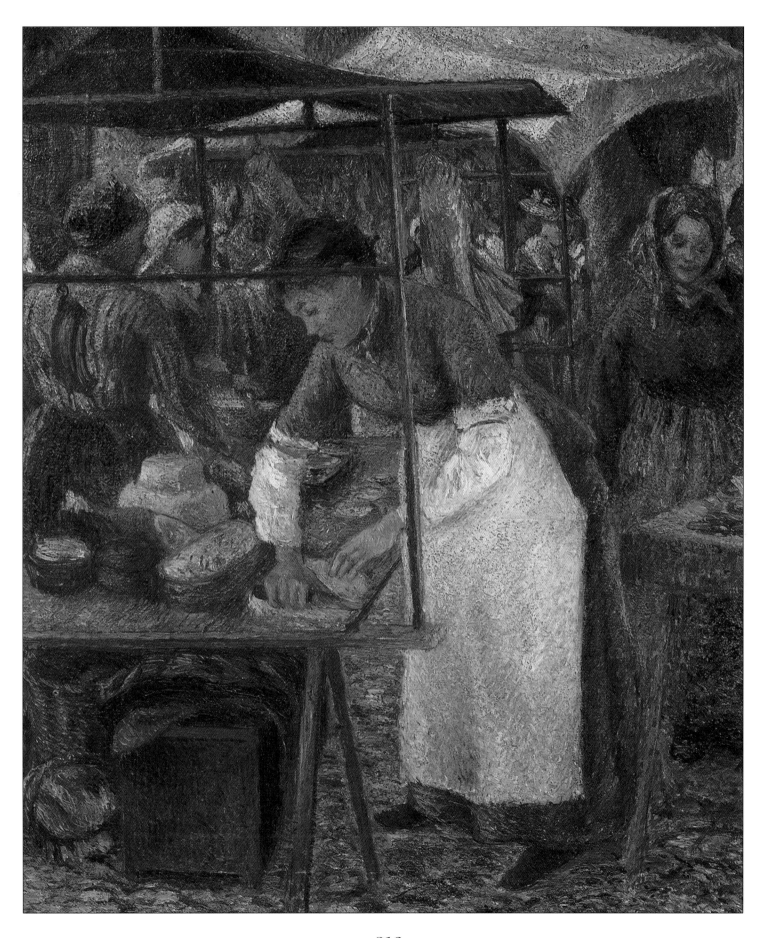

perhaps benefiting as much from his contacts with Cézanne as Cézanne more obviously did from working beside him. Pissarro had now abandoned the simple views of earlier years, with a road or stream leading into the picture, and seemingly painted from inside the scene, achieving much greater immediacy. His use of trees as a kind of screen or irregular frame can be traced from *Chestnut Trees at Louveciennes* (page 21) to *Red Roofs* and *Côte des Bœufs* (page 212). With their rigorous organization and rich textures, these are the culminating works of Pissarro's middle age.

At the end of the 1870s he experienced a loss of confidence that seems to have had its roots in continued ill success and a feeling that Pontoise was worked-out as a subject. He was also oppressed by the sudden death of his closest friend, Ludovic Piette, whom he had met at the Académie Suisse in the 1860s. Piette had exhibited with the Impressionists and his farm had often served as a refuge for Pissarro when times were hard. Now, when times were still hard, Pissarro again turned to painting fans and blinds to make ends meet, as well as producing a variety of prints.

New Directions

In 1880, like the other Impressionists, he found himself much better off when Durand-Ruel began buying paintings again. This encouraged him to strike out in a new direction. Able to afford models, at least among the local farm girls, he took up figure painting. People and animals always played a more important part in his landscapes than in equivalent works by Monet or Sisley, but only now did they become the actual subjects of his paintings – a rather curious state of affairs for an artist so passionately committed to 'progressive' politics.

In Pissarro's paintings of the 1880s this commitment is unmistakable. Almost all of them are populated by rural working people and there is a lively interest in workplaces and working practices. On the other hand, Pissarro's canvases seem to be set 'after the revolution' among happy and contented people, and this gives even such a beautiful work as *The Pork Butcher* (page 213) a touch of sentimentality. He tackled the same kind of subjects after his conversion to Neo-Impressionism, the regular 'dotting' technique that he took up after meeting Signac and Seurat in 1885. It says a good deal for Pissarro's modesty and open-mindedness, but also for his uncertainties, that he was prepared to follow the example of two much younger men and abandon Impressionism.

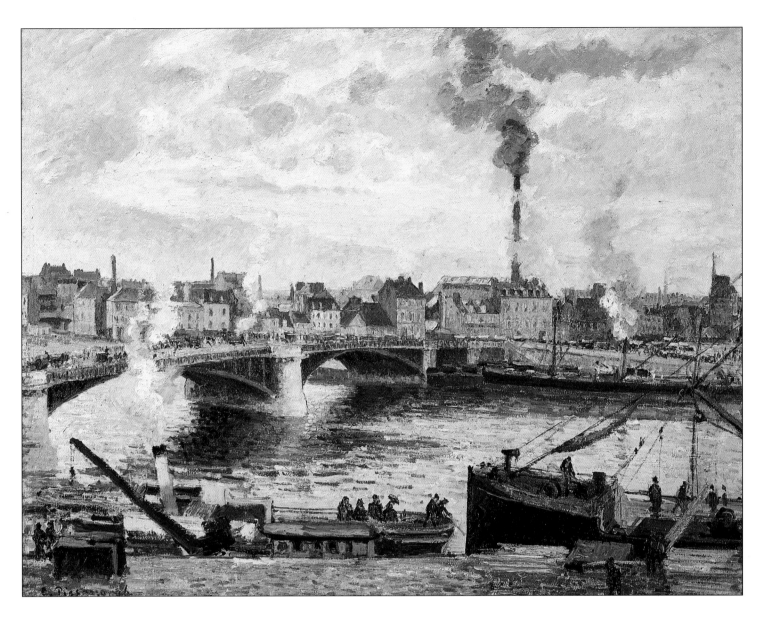

It was also ironic that the conciliatory Pissarro, by insisting on a strong Neo-Impressionist presence at the 1886 exhibition, ensured the final break-up of Impressionism as a cohesive movement.

A true intellectual of his epoch, Pissarro was delighted with the idea of making painting into a science; but within a couple of years his enthusiasm was flagging. A canvas such as *Women Haymaking* (page 214-15) suggests why. The pointillist technique has proved highly effective in giving a sense of great sunlit expanses, idealizing the women's heavy work, yet there is something not quite convincing – not quite in keeping with the kind of things they are doing – in the statuesque stillness so characteristic of Neo-Impressionism. For Pissarro, at least, the lack of spontaneity in the act of painting, as well as the character of the work itself, made pointillism unsatisfactory in the long run. His final verdict ,

ABOVE: **The Great Bridge, Rouen** 1896 Camille Pissarro CARNEGIE MUSEUM OF ART, PITTSBURGH

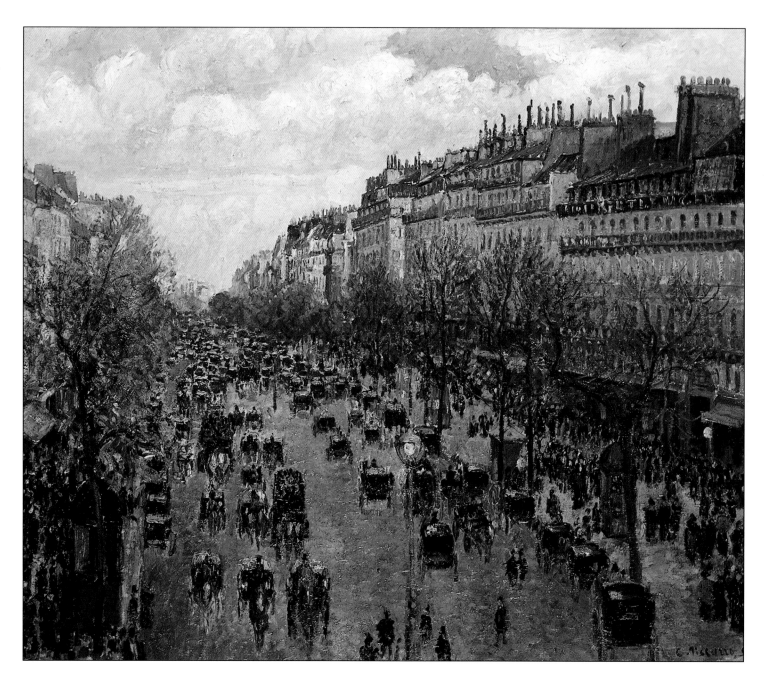

ABOVE:

Boulevard Montmartre: Afternoon, Sunshine 1897 Camille Pissarro HERMITAGE MUSEUM, ST. PETERSBURG

therefore, was that to paint in Neo-Impressionist style was 'to abandon movement and life'.

Meanwhile he and his family had left Pontoise at the end of 1882. After a brief stay at nearby Osny while they house-hunted, they settled in 1884 at Eragny-sur-Epte. Pissarro was delighted at first, noting that the countryside was lovely and Eragny itself only two hours from Paris on the Dieppe railway line. Perhaps his reference to Paris was significant, for he soon tired of Eragny, a fact that may have a bearing on his later practice as a travelling artist. His wife Julie was determined to put down roots, and when an opportunity arose to buy the house, she approached the

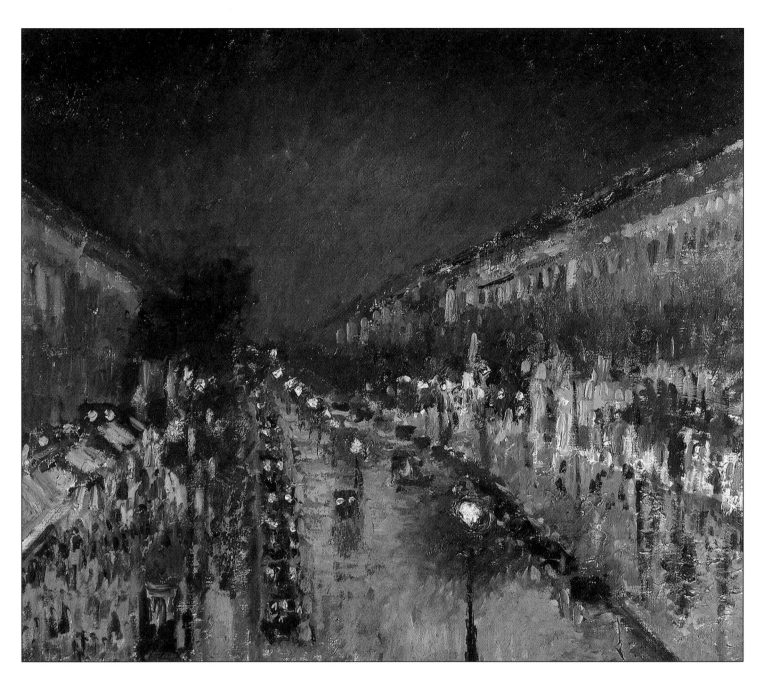

now-wealthy Monet for a loan. Pissarro, absent in London on family business, was evidently dismayed but loyally backed up her request. Monet obliged and Pissarro was never able to free himself from Eragny for good. Ironically, the place has become as completely associated with him as Giverny has with Monet.

The Dangers of Politics

During the early 1890s Pissarro's work at last began to command reasonable prices, and by 1896 he had repaid Monet and was enjoying a modestly prosperous lifestyle. However, there were other alarms.

ABOVE:
Boulevard Montmartre: Night 1897
Camille Pissarro
NATIONAL GALLERY, LONDON

In the mid-1880s his left-wing political convictions had crystallized into a commitment to anarchism. Unlike other forms of socialism, anarchism advocated the abolition of the state and a society run by groups of freely associated individuals and co-operatives. More immediately important was the fact that anarchists were divided between peaceful and violent wings, and that from about 1892 violent anarchists had embarked on a campaign of bombings and assassinations. Pissarro was against violence, but anti-terrorist laws and waves of arrests inevitably threatened anyone regarded as suspicious. In 1894, as an anarchist and a foreigner, he found it prudent to spend several months in Brussels until the worst was over. However, as on all his trips abroad during this period, he thoroughly enjoyed himself.

An even more disturbing development was the anti-Semitism that was becoming endemic in France even before the Dreyfus affair. When that became a major issue in 1897, the deep divisions in French society were reflected by divisions between the Impressionists. Degas became a fanatical anti-Dreyfusard and anti-Semite, an outlook shared to a greater or lesser degree by Renoir and Pissarro's old friends Cézanne and Guillaumin. By contrast, Monet and Pissarro were convinced of Dreyfus's innocence and were reconciled with Zola when the writer emerged as his champion, denouncing the cover-up in his famous article *J'Accuse*. Although he had long broken with orthodox Judaism and was opposed to all forms of religion, Pissarro felt that the anti-Semitic furore compelled him to acknowledge his Jewish origins. His fears of being assaulted on the street proved groundless, probably because white-bearded patriarchs (see his self-portrait, page 222) were a fairly common sight in the late nineteenth century; Monet and Degas looked almost equally Mosaic. Curiously enough, one ambiguity of Pissarro's position was removed at the end of his life, when it became clear that, although born on foreign soil, he was, as the son of a Frenchman, himself French.

Painting the Town

Despite these perplexities, in the 1890s Pissarro experienced a second great surge of creativity. He executed some fine canvases at Eragny, but he was most inspired and most prolific in an unexpected role – as a painter of townscapes. Considering that Pissarro's work had always ignored cities, bourgeois life and even (except in backgrounds) the factories that were producing an industrial

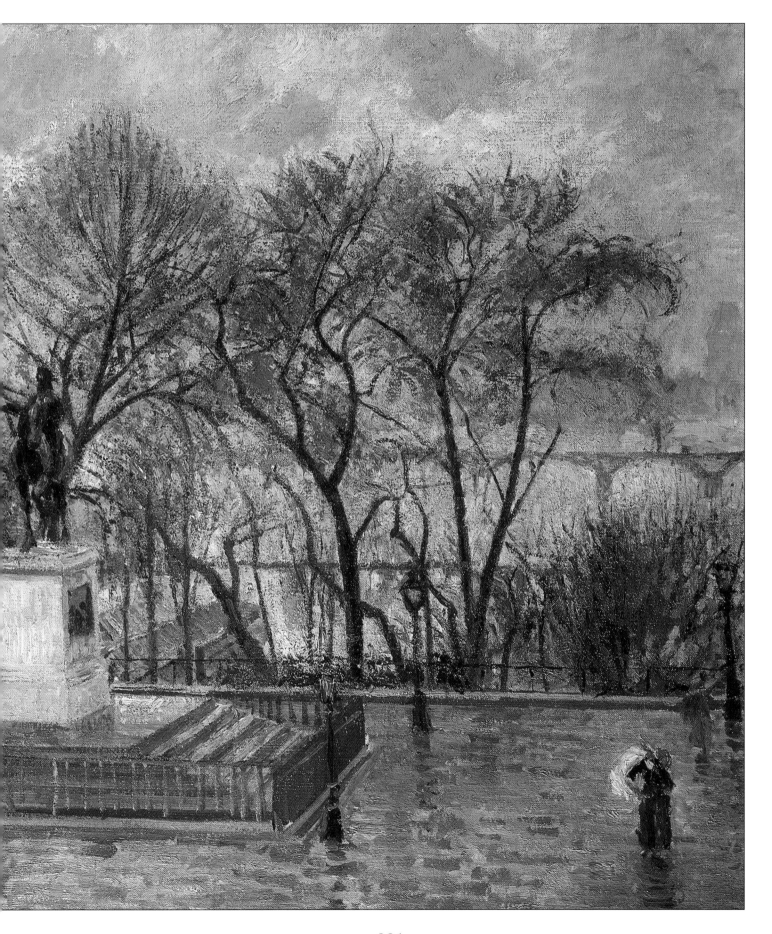

PREVIOUS PAGES
220-1: **Terrace
of the Pont-Neuf**
1902
Camille Pissarro
PRIVATE
COLLECTION

RIGHT: **Self-
Portrait** 1903
Camille Pissarro
TATE GALLERY,
LONDON

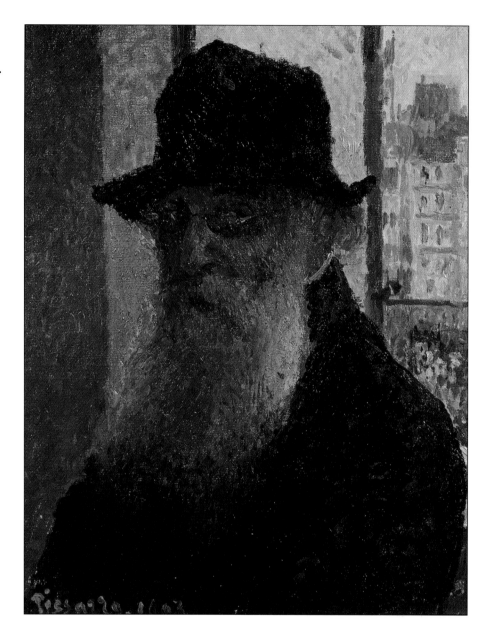

working class, this was an extraordinary development. If there is any explanation, it is perhaps no more than the relaxation of ideological preoccupations that sometimes accompanies old age, combined with a strong desire to escape from Eragny.

The condition of Pissarro's eyes was probably another factor. He had suffered an eye infection in 1888 and by the early 1890s could not paint out of doors. Painting at the windows of his Eragny house offered limited possibilities, whereas he could travel from one hotel or lodging to another, and from one town to another, in a search for new motifs. Like Monet, Pissarro painted series, striving to capture the changes effected by the light, the weather and the season, but in most of his canvases there is more human bustle, either in the form of crowds or boats coming and going. In

1892–3 he was in Paris, painting a small-scale series whose subject was the streets leading to the Gare Saint-Lazare. Gathering confidence, he worked at Rouen from 1895, creating vigorous views of the Pont Boïeldieu and the busy port (page 217). Unlike Monet, Pissarro saw the town as a 'beehive'.

Returning to Paris in 1897, Pissarro embarked on an even more ambitious series. From his room in the Hôtel de Russie he painted 14 views of the Boulevard Montmartre. Apart from two immensely crowded scenes of Shrove Tuesday processions down the boulevard, *Afternoon, Sunshine* (page 218) is representative in its exhilarating high view and sense that, whatever the situation on the pavements, the road is, as yet, broad enough to cope with the traffic, which is proceeding in quite a decorous fashion. Even more striking is *Boulevard Montmartre: Night* (page 219), a virtuoso effort which captures the masked effect of artificial light surrounded by darkness, and artfully uses the reflections in the wet streets to brighten the scene further.

One Parisian series followed another, as Pissarro tackled the Avenue de l'Opéra, the Tuileries Gardens, and various views of the Louvre and the Pont-Neuf (page 220-1), with excursions to Dieppe for series paintings of the Church of Saint-Jacques and the harbours and, in 1903, to Le Havre. Seemingly indestructible, he was taken ill quite suddenly with an abscess on his prostate gland and, probably as a result of inadequate treatment, died on 13 November, 1903.

SISLEY

Sisley was the most single-minded of the Impressionists. Despite his poverty, he remained faithful to *plein-air* landscape painting, never trying to raise money by doing portraits, scenes with a hint of drama or even the watercolours and fans that Pissarro turned to in hard times. (He did, just once, think of approaching Pissarro about the possibility of painting fans, but seems not to have followed through.) Until almost the end of his working life, when he produced some seascapes, he avoided wild nature and was content to paint tranquil views of the villages and riversides of northern France.

The superficial sameness of his work may be one of the reasons why Sisley, alone among the Impressionists, failed to make his

mark during his lifetime. Comparison with the most spectacularly successful of his friends, Claude Monet, suggests that a life's work that included storms, rocky islands and coasts, luscious southern views and cathedral façades may have contained an element of commercial calculation as well as artistic choice. Although Sisley's reserve and pride may account for his failure to market his work aggressively, it is difficult to imagine why, when he was so often desperate, he never attempted to vary it. Like his decision to live at a distance that diminished his contact with his old comrades, this leaves one with an impression that, for some unknown reason, Sisley actively sought obscurity and half-embraced failure.

However, for most of the 1870s Sisley was living at Louveciennes and saw Monet, Renoir and Pissarro quite often. Like them, he found his hopes dashed by the economic downturn and the unsatisfactory outcome of the 1874 exhibition, although it looks as though Sisley must have sold something for 1,000 francs, since the co-operative, which took a ten per cent commission on sales, received 100 francs from him. His canvases of 1874 showed no signs of discouragement and were, in fact, painted in exceptionally favourable conditions. An ardent collector, the opera singer Jean-Baptiste Faure, generously took Sisley with him on a four-month trip to England. Temporarily free from worry, the artist produced some of his finest work, generally choosing quiet Thames-side scenes around Hampton Court; but in *Regatta at Molesey* (pages 224-5) he tackled a more obviously exciting river subject, reminiscent of events that he must have seen with Monet and Renoir at Argenteuil. Although the figures are small, their role in this picture is unusually important. The bent backs of the oarsmen and the gestures of the enthusiasts urging them on are brilliantly captured with a few brushstrokes that help to energize the entire scene. The big flags in the foreground add notes of stronger colour and gaiety, making this a quintessential Impressionist celebration of outdoor pleasures.

The Flood Paintings

A few months after his return from England, Sisley moved from Louveciennes to nearby Port-Marly. The river banks at this point were weak and liable to flooding, and Sisley had painted the resulting deluge as long before as 1872. When it happened again, he produced a series of six paintings which are among his most

famous works. The human drama of the inundation had no appeal to him as an artist, and his versions of the scene (page 163) are as tranquil as most of his pictures. *Floods at Port-Marly* might be a rendition of an age-old landscape, in which the trees rise directly out of the water and the house (the Auberge Nicolas) rests directly on it, in the style of a Venetian palace, while punts substitute for gondolas.

Meanwhile, what little is known of Sisley's life is a monotonous tale of failure. The Hôtel Drouot sales of 1875 and 1877 netted him a few thousand francs, but only in return for large numbers of pictures. Results at the Impressionist exhibitions were no better and by the late 1870s he was often in such straits that he accepted 25 or 30 francs for one of his paintings. In 1878 he even asked Théodore Duret to look for a backer who would pay him 500 francs a month for six months, in return for which Sisley promised to hand over 30 canvases; that is, he would do them for 100 francs apiece. Duret was unable to find such a person, although he did manage to persuade a friend to buy seven of Sisley's paintings.

Without a few loyal collector-friends such as Duret, Sisley and his family would probably have starved. Among the others were Faure, the Argenteuil doctor Georges De Bellio, who often came to the rescue of Monet as well, and a patissier named Eugène Murer. Like several patrons of the Impressionists, including the dealer Durand-Ruel, Murer can be characterized in two very different ways, either as a generous soul or as a shrewd operator. In 1877 he opened a restaurant on the Boulevard Voltaire in Paris, where he gave dinners for his painter friends every Wednesday; but although he bought their works and built up a superb collection, he paid rock-bottom prices. He also showed a distinct preference for the canvases of Pissarro and Sisley, the least successful (and therefore the cheapest) of the Impressionists.

Georges Charpentier of *La Vie Moderne* was more directly helpful. Although Renoir was his main protégé, he came to Sisley's assistance at a critical moment in 1879 when the painter and his family had been evicted from their home at Sèvres, sending them the money to find a new place to live. Sisley's letter of appeal suggests that he had been cold-shouldered by some of his fellow Impressionists because he had decided to follow Renoir's example and send in paintings to the Salon. He told Duret that he was tired of vegetating and that although the Impressionists' shows had been useful in making them known, the prestige of the official

exhibitions could not be ignored. If his work was accepted, he 'might be able to sell something'. Unlucky as always, Sisley was rejected while Renoir triumphed with *Madame Charpentier and her Children*.

The Stones of Moret

In 1880 Sisley moved to Veneux-Nadon, some 70 kilometres south of Paris, on the river Loing. The area was to be his home for the rest of his life. The choice was a curious one, since most of his friends lived in Paris or, like Monet and Pissarro, had settled down river in already familiar places in the Seine valley. Although he wrote urging Monet to come and stay with him, Sisley must have known that his decision would increase his isolation. In the 1880s and 1890s he was highly productive, but opinions are sharply divided as to the merits of his late work. To most eyes it seems more uneven than the pictures of the 1870s and sometimes too shrill in colouring. However, the little town of Moret, in particular, inspired a good many paintings in which Sisley achieved a new firmness of structure and sense of weight. Among them are scenes such as *The Bridge at Moret* (page 225) and a series of 15 paintings of the church (visible in the background of *The Bridge at Moret*) whose immense solidity forms a fascinating contrast to Monet's apparently melting cathedrals.

Towards the end of Sisley's life its ironies multiplied. In 1894 Gustave Caillebotte died and left his Impressionist paintings to the state. The following year, a group of them were accepted by the Musée du Luxembourg and implicitly destined for the Louvre. They included *Regatta at Molesey* and another canvas by Sisley, who thus joined the immortals while continuing to live and suffer: a retrospective exhibition of his work, held in 1896, was a complete failure.

By this time Sisley was often ill with facial neuralgia and rheumatism (penalties of open-air working) and a worsening throat condition. However, he had found a staunch supporter in an industrialist, François Depeau, who financed a trip to Normandy and later, in 1897, to England and Wales. On the coast of South Wales, at Penarth and Langland Bay, he painted his only seascapes, including the delightful *Morning, Lady's Cove* (pages 230-1).

Despite his English origins and his cross-Channel excursions, Sisley was a thorough Frenchman and in 1898 belatedly attempted to take out citizenship. He was unsuccessful even in this, since the

necessary documents had been mislaid or destroyed. He was soon distracted by his companion Eugénie's illness, a cancer of the tongue that killed her in October 1898. Sisley, who had nursed Eugénie devotedly, outlived her by only three months, dying of cancer of the throat on 29 January, 1899. Monet organized a sale for the benefit of Sisley's children and within a year the prices of his works were rising steeply.

MORISOT

One of the canvases sent in to the 1874 exhibition by Berthe Morisot was *The Cradle* (page 127), which is quite certainly her most famous work. Painted in 1873, it shows Morisot's sister Edma gazing with solemn tenderness at her baby daughter. Here Morisot expressed, without having herself experienced, the fulfilment of motherhood. It was something that, for a long time, she seemed likely to sacrifice in return for her independence. She knew from Edma's letters, and from her sister's falling away as an artist, that marriage was a doubtful venture for a woman with talent; but as the years passed, the impulse to become a wife and mother evidently grew stronger. Luckily for Morisot, at 33 she was able to accept a man who was highly suitable, both socially and personally, and who proved in fact to be an excellent choice.

Eugène Manet was the 41-year-old brother of the great Edouard. He was wealthy, a gentleman of leisure, at once reserved and highly strung, like Berthe herself, and ready to support her in her career. They married in December 1874. In the church register Berthe described herself as 'of no profession' and in a letter to her brother she announced that she had at last 'entered into the positive side of life'.

It was her good fortune that 'the positive side of life' did not damage her career as an artist. Eugène was a sufficiently skilful amateur to enjoy painting side by side with her when they visited England in 1875, and Morisot's commitment to the Impressionists remained unshaken. She exhibited – keeping her maiden name – at all but one of the shows, missing that of 1879 in the aftermath of pregnancy, and in 1875 put her pictures up for sale at the Hôtel Drouot as a gesture of solidarity with her more financially pressed colleagues.

Her work was now mainly confined to feminine and domestic or garden subjects, and perhaps for this reason (or perhaps from chivalry) was treated relatively kindly by the critics. But there were exceptions, notably the implacable Albert Wolff of *Le Figaro*, who made Morisot's participation in the 1876 exhibition sound like a moral lapse: 'Five or six lunatics, including one woman – a group of wretches touched by the madness of ambition – have joined to show their work … As in most gangs, there's a woman in with them. Called Berthe Morisot, she retains a certain femininity amid her ravings.' Not surprisingly, Eugène Manet had to be talked out of challenging the critic to a duel.

The Manets' comfortable life-style, at home in Passy or enjoying the summer at Bougival, made it easier to ignore such attacks. In 1878 Morisot gave birth to a daughter, Julie, who became the centre of her interests. Now part of the Manet clan, Berthe was also affected by the deaths of Edouard in 1883 and, a year later, of his brother Gustave. At the final Impressionist show in 1886, part-financed by Eugène and Berthe, Eugène was again a tower of strength, despite a violent argument with Pissarro over the virtues of Neo-Impressionism. Then Eugène's health, too, began to deteriorate and he remained a semi-invalid until his death in 1892.

Achievement and Recognition

In view of all these distractions – much less avoidable for a woman than for her male counterparts – Morisot's productivity was remarkable. Well over 800 of her paintings survive. Victorian convention made it inevitable that large areas of experience were closed to her because she was a woman, but in compensation she was able to record a world of feminine interest that male artists could never approach with the same intimate knowledge. Her very distinctive style, with its feathery or even slashing brushstrokes, is seen in such paintings as *Woman at her Toilet* (1875), *In the Dining Room* (page 233) and a number of self-portraits and portraits of Julie. From the mid-1880s she was strongly influenced by Renoir, arguably to the detriment of this distinctiveness; her most ambitious work, the large *Cherry Pickers* (1891), is uncomfortably reminiscent of his late style.

Morisot's position as a woman and her natural reserve meant that she never pushed her work, which was slow to gain the conventional marks of success. After his initial enthusiasm, Durand-Ruel grew cool and it was only in the late 1880s that

Morisot's paintings were seen outside the context of the Impressionist 'gang'. Her first one-woman show was not held until 1892, when another firm of dealers, Boussod and Valadon, persuaded her to put her grief for Eugène behind her and gather together a representative group of works for a big retrospective. Only two years later her *Woman in a Ball Gown* followed Manet's *Olympia* into the Musée du Luxembourg, having been purchased by the state (as a result of some wire-pulling) at a sale of Théodore Duret's collection.

From the mid-1880s Morisot was an influential hostess, holding Thursday dinners attended by old friends, whether Impressionists such as Degas, Renoir, Caillebotte and Monet, or the more conventional Puvis de Chavannes and Fantin-Latour. The poet Mallarmé was also a devoted admirer. Glimpses of Morisot's last years are given in the diary of her daughter, Julie Manet, which is even more notable for an interesting, if dutiful, account of a visit to Monet at Giverny.

Early in 1895 Julie fell seriously ill with influenza. Morisot nursed her, caught the infection, and was carried off with shocking swiftness on 1 March, still only 54 years old.

═══ CAILLEBOTTE, CASSATT AND ═══ GUILLAUMIN

Gustave Caillebotte 1848 – 1894

In any account of the Impressionists, the name of Gustave Caillebotte comes up frequently, but in a variety of roles that has blurred his posthumous image. Reading of his activities as an organizer, backer and patron, it comes as a mild surprise to find that he was the youngest of the Impressionists (only 26 when the first exhibition was held). His early death also distorted the shape of his career, depriving it of the narrative weight that attaches to long lives such as those of Degas, Monet, Renoir and Pissarro. For these reasons Caillebotte has been mainly remembered for the magnificent collection of Impressionist paintings that he left to the French nation. Recently, however, his own work has been re-evaluated and seen to possess considerable distinction.

Gustave Caillebotte was born in Paris on 19 August, 1848. His father had made money as a manufacturer of beds and blankets; he was evidently a gifted businessman for he rapidly accumulated

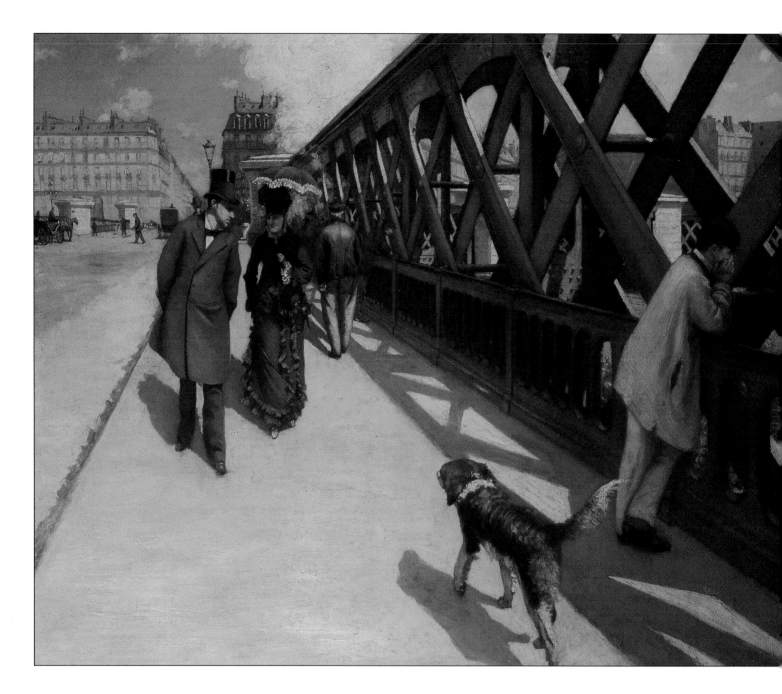

family properties in Paris and on its outskirts. Gustave went to school at the prestigious Lycée Louis le Grand and eventually qualified as a lawyer in 1870. During the war with Prussia which broke out that year, he served in the National Guard. How he came to take up painting is not clear, but by 1872 he was working in the studio of Léon Bonnat, and the following year he passed the examination to enter the Ecole des Beaux-Arts.

In 1874 Caillebotte's father died, leaving him a wealthy man and his own master. From this time, if not before, he led the life of the gentleman enthusiast, able to devote himself to a variety of passions – stamp collecting, gardening, boating and painting.

These were not fleeting fancies: Caillebotte took all of them seriously throughout his life and put a great deal of effort into them, for example designing his own boats. As an artist he must have made rapid strides, since Degas considered asking him to take part in the 1874 exhibition. He and Degas seem to have known each other well by this time, perhaps through Bonnat, who was one of Degas' friends. At some point he also became friendly with Monet, who was living at France's boating capital, Argenteuil, which Caillebotte often visited in the summer; eventually he bought a property on the other side of the river at Gennevilliers. He infected Monet with his own passion for gardening on the grand scale and, along with Manet, became the provider of a series of urgently requested loans that kept the Monet household going.

The Urban Realist

In 1875 Caillebotte's submissions to the Salon were rejected and when he received an invitation from Renoir to join the Impressionists in 1876, he accepted. His exhibits, especially *Floor Strippers* (page 152), created a stir. Caillebotte's personal brand of urban realism had a clear-cut photographic quality, high viewpoint and deep perspective that made it distinctive and unusual. The working-class subject of *Floor Strippers* was paralleled at the 1877 show by *House Painters*, but this was clearly part of a wider interest in the modern city; his other two exhibits were *Rainy Day, Paris* and *Pont de l'Europe* (left). In *Pont de l'Europe* both a bourgeois couple and working men are seen on the great iron bridge over the tracks leading to the Gare Saint-Lazare. By accident or design, Monet's Gare Saint-Lazare series was also shown at the 1877 exhibition and visitors to the show might have been forgiven for supposing that they were witnessing the birth of a new school; whereas in fact Monet's station paintings were effectively his farewell to the 'modern life' genre.

Caillebotte himself seems to have followed no set programme. He painted a number of apartment interiors with figures who convey a very modern sense of tensions or ennui, but over the years he also painted still lifes, nudes, landscapes, portraits and self-portraits. His enthusiasm for strenuous outdoor pursuits gave a special vitality to his paintings of oarsmen and divers. By contrast with Monet and Manet, whose viewpoint is usually that of the spectator, Caillebotte involves us in the action, accurately noting attitudes, gestures and muscular strains. However, when he ventured

into classic Impressionist territory, as in *Sailing Boats at Argenteuil* (right), he gave a good account of himself, combining a breezy sense of movement with his own liking for the 'close-up' and a firmly structured composition.

Caillebotte's role as an exhibition organizer dated from 1877, when he found the premises in the Rue Le Peletier and put up the money for the show. He was deeply involved again in 1879 and 1880, but his rows with Degas led to his dropping out altogether in 1881. He returned for the 'unity' show of 1882, but took no part in the final event in 1886, dominated by Degas and the Neo-Impressionists. Degas' cantankerousness was criticized even by loyal friends such as Berthe Morisot, but Caillebotte was not faultless, with a taste for laying down the law that could be irritating. A few years later, at the 'Impressionist dinners' held at the Café Riche, Renoir would make a point of researching a few contentious subjects from an encyclopaedia in order to hold his own in arguments with Caillebotte, whose face is described as turning progressively deeper shades of red and purple as the debate continued.

Most of the Impressionists nevertheless had cause to be grateful to Caillebotte, whose wealth enabled him to pay good prices for works that were unsaleable elsewhere. France should also be grateful, since he planned from the very beginning to give his collection to the nation, drawing up a will to that effect as early as 1876. The terms of his final will, made in 1883, were substantially unchanged: his pictures were to go to the nation, but had to be accepted on the understanding that they would not be consigned to an attic or a provincial museum. Caillebotte patently feared that the authorities would take the easy way out – accept the offer of these still-controversial works, and then put them somewhere out of sight and forget all about them.

RIGHT: **Sailing Boats at Argenteuil** *c.* 1889 Gustave Caillebotte MUSÉE D'ORSAY, PARIS

The Caillebotte Bequest

Caillebotte died on 21 February, 1894. As his executor, Renoir offered 67 pictures, plus Caillebotte's own *Floor Strippers*, to the Museums Consultative Committee. By this time Manet's *Olympia* had gone into the Luxembourg and the state had actually commissioned and bought a painting, *Girls at the Piano*, from Renoir. However, there were still powerful forces ranged against the Impressionists. After an initial acceptance, the authorities changed tack, and long and difficult negotiations ensued. Finally,

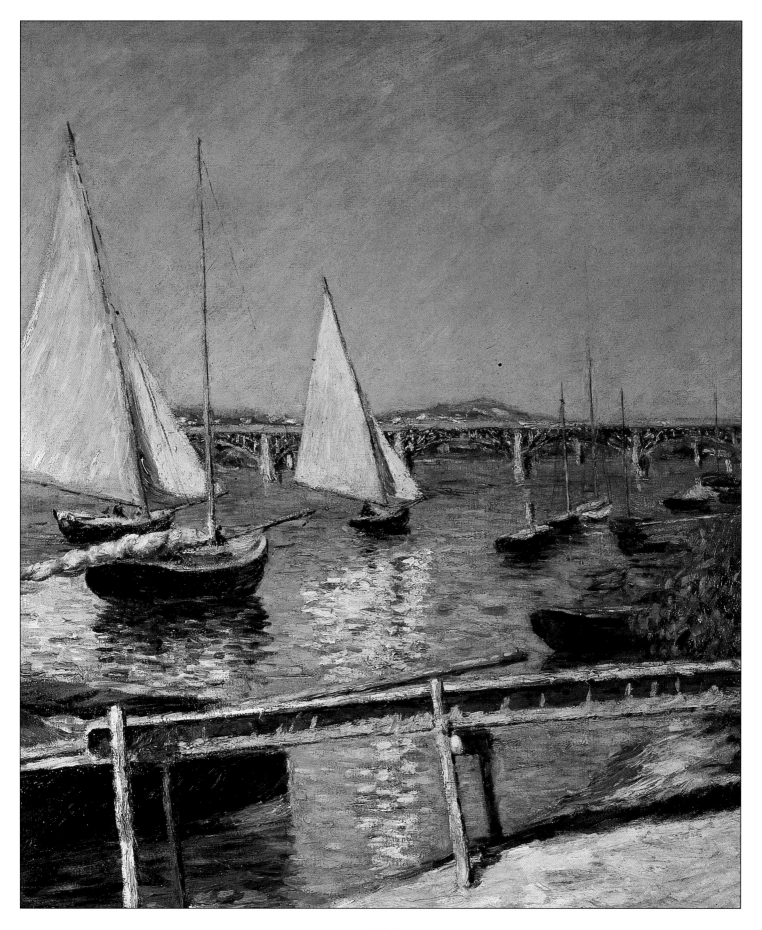

a year later, the state accepted 38 of the proffered 67 paintings for exhibition in the Musée du Luxembourg.

Although this now seems a wilfully blind decision, it should be said that the Luxembourg was, in effect, a museum devoted to living artists, and acceptance of such a large bequest would have meant swamping it with Impressionist paintings to the detriment of the approved academic artists of the day. No bad thing, of course, but even the display of the truncated collection caused an uproar, with protests from the Academy of Fine Arts and questions asked in the French Senate.

The paintings that went into the Luxembourg included many of the very finest Impressionist works. Among them were Manet's *The Balcony*, Monet's *Regatta at Argenteuil* and *Gare Saint-Lazare*, Renoir's *Moulin de la Galette* and *Nude in Sunlight*, and Pissarro's *Red Roofs*. Curiously, there was no painting by Morisot, an omission that was corrected by the state purchase of *Woman in a Ball Gown* at the Duret sale of 1894. As the haggling over the Caillebotte Bequest was still going on, Morisot actually went into the Luxembourg ahead of all her peers except Manet and Renoir.

By the early years of the twentieth century the atmosphere had changed radically. In 1908 a new bequest by Count Isaac Camondo was accepted and in 1929 Caillebotte's collection was moved to the Louvre. Nowadays, the main state collection of Impressionist paintings is housed in a special museum devoted to nineteenth-century French art, the Musée d'Orsay in Paris.

Mary Cassatt 1844–1926

A number of American artists moved in and out of the Impressionist milieu, notably James McNeill Whistler and John Singer Sargent. The only one who took part in the exhibitions was a remarkable woman named Mary Cassatt, a strong character who, unlike Berthe Morisot, remained a spinster and made an entirely independent career for herself.

Mary Stevenson Cassatt was born on 22 May, 1844, at Pittsburgh, Pennsylvania, known at that time as Alleghany City. Her stockbroker father had become wealthy by making shrewd investments and the family spent two years in France and Germany in 1853–5. After this she was brought up conventionally at home until she chose to enter the Pennsylvania Academy of Fine Arts in Philadelphia, where she studied from 1861 to 1865.

Since there were as yet almost no Old Master works in

LEFT: **Young Woman Sewing**
c. 1886
Mary Cassatt
© DACS 1996
MUSÉE D'ORSAY,
PARIS

American museums, Cassatt persuaded her father to allow her to pursue her artistic career in Europe. Escorted across the Atlantic by her mother, she settled in Paris and worked for a time under an established master named Charles Joshua Chaplin, but she always declared that her study of great painters in the Louvre and other museums had been her true educators. In 1868, as 'Mary Stevenson', she had her first Salon acceptance with *The Mandolin.*

During the Franco-Prussian War, Cassatt returned briefly to America. On her return she visited Italy and Spain before settling permanently in France. Her work remained conventionally accomplished, although she seems to have become aware of

Impressionism at some point in the 1870s, brightening her palette and probably doing some *plein-air* painting.

The turning point in Cassatt's career occurred when Degas invited her to exhibit with the Impressionists. She later said that seeing Degas' pastels 'changed my life', and that, with Manet, Courbet and Degas as her masters, 'I rejected conventional art. I began to live.' As the quotation indicates, she was not simply a disciple of Degas, absorbing a variety of 'modern' influences. However, her relationship with Degas was particularly close, although there was probably no substance to contemporary rumours that they were lovers. Degas admired her work (but only intermittently, as was his way) and used her as the model for a number of pictures, notably his *Milliners* series. Cassatt exhibited with the Impressionists from 1879, abstaining only in 1882, out of loyalty to Degas.

Like Degas, Cassatt was essentially a figure painter, taking women, girls, children and occasionally male relatives as her subjects; from the 1880s mothers and their infants became a favourite subject. The settings are usually gardens or domestic interiors, although a few of her more Degas-like compositions have theatre backgrounds. Occasional ventures into other areas include *In the Omnibus* (1891) and *The Boating Party* (1893, page 243). She often employed the free brushwork of the Impressionists and, tackling similar subjects to Berthe Morisot, sometimes adopted Morisot's long, slashing brushstrokes and light palette. The resemblance is visible in *Young Woman Sewing* (page 241), but so is Cassatt's preference for more emphatic draughtmanship and more solid modelling. In a good many of her paintings of the late 1880s and early 1890s the subjects have a fresh-faced, large-limbed appearance that has come to seem distinctively American.

Contact with Degas encouraged Cassatt to experiment with pastels and printmaking. Like so many of her contemporaries, she was influenced by the smooth, clean lines, flat colour areas and unusual compositions of Japanese prints. After seeing a large exhibition in Paris, she produced a set of western counterparts which many regard as the crown of her work. They were shown at her first one-woman exhibition, held at Durand-Ruel's gallery in 1893. Not dissimilar in spirit is the large oil painting *The Boating Party* (page 243), in which the near-flat colour areas do not militate against a marked three-dimensional effect that makes the boat seem about to heave towards us.

Despite her determined independence, Cassatt could not entirely avoid the fate of the nineteenth-century woman. In 1877

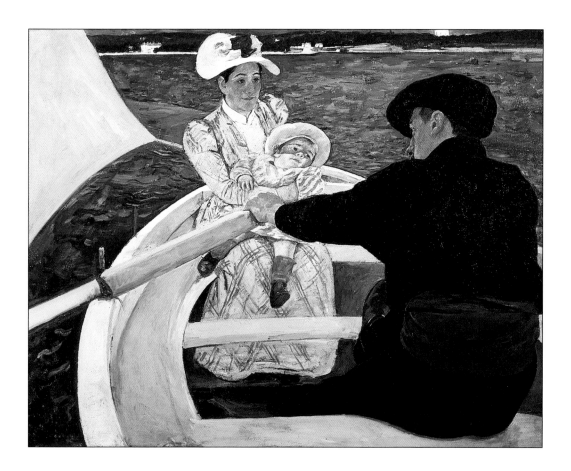

her parents settled in France and she had to combine her work as a painter with managing their household. Like a well-brought-up lady – Berthe Morisot was exactly the same – she did not push her paintings and prints, so that recognition was slow in coming. It did come, however – at least in France, where Durand-Ruel staged a retrospective exhibition of her works in 1893 and the state awarded her the Legion of Honour in 1904.

Americans were less forthcoming, ignoring her 1895 show in New York and mishandling and managing to lose a mural she was commissioned to paint for the Chicago World's Fair of 1893. Cassatt's revenge on her fellow countrymen was to educate them, encouraging her brother to buy Impressionist paintings and helping her friend Louisine Havermeyer and her husband to accumulate a collection of European masterpieces which eventually found their way into American museums.

Cassatt herself made return visits to the United States in 1898 and 1908, but France remained her home. From the 1890s her relations with Degas were cool, although she attended his funeral in 1917. She spent an increasing amount of time at her country house, the Château Beaufresne, outside Paris. Her sight deteriorated and after 1914 she was unable to work. Although financially secure, she was increasingly sad and isolated in her last years, dying at her home on 14 June, 1926.

ABOVE: **The Boating Party** 1893 Mary Cassatt © DACS 1996 NATIONAL GALLERY OF ART, WASHINGTON, DC

Armand Guillaumin 1841–1927

Armand Guillaumin is seen as a minor figure because his life and work are almost always discussed in association with those of the Impressionists. However, although he cannot command much space in the company of Pissarro, Cézanne and Monet, his paintings are, by less elevated standards, always interesting and often forceful. It is worth remembering that the great Cézanne was not above learning by copying one of Guillaumin's characteristic views of the Seine.

Guillaumin was born on 16 February, 1841, in Paris, but his family origins were humble and provincial. He went out to work at 15 and was employed by a railway company for most of his twenties. Studying at the Académie Suisse, he met and became friendly with Pissarro and Cézanne. For a brief period (1868–72) he tried to make his way as an artist; a portrait by Guillaumin shows Pissarro painting blinds, an occupation both artists took up in order to survive.

After this, Guillaumin painted only in his spare time. Thanks to Pissarro's insistence, he was accepted as an exhibitor in 1874; among the works he showed was the spectacular *Sunset at Ivry* (1873). He also took part in five of the later exhibitions, missing those of 1876 and 1879. Some of his best-known pictures date from the 1870s, notably *The Bridge of Louis-Philippe* (1875) and *Port at Charenton* (1878).

In 1891 Guillaumin had an extraordinary stroke of luck, winning 100,000 francs in a lottery. At 50 he was able to devote himself to painting at last, developing an intense colouristic style that was often condemned for its un-Impressionist violence, but is now seen as interesting for its links with later artists such as his friend Vincent van Gogh and the Fauves whose works created a sensation in the early years of the twentieth century. Guillaumin outlived even Monet, dying on 26 June, 1927.

Cézanne and the Post-Impressionists

During the 1880s, long before Impressionism had been accepted by the art establishment, new trends were appearing. Impressionism had 'broken the mould' and from this time onwards innovations and new styles proliferated, often appearing before the sensation created by the previous one had had time to die away. Such movements included Neo-Impressionism, Symbolism and Art Nouveau. The major painters of this generation are known as Post-Impressionists, a catch-all term that rightly suggests that they are different from one another as well as from the Impressionists. They are properly the subjects of a separate book, but their relationship with Impressionism makes it appropriate to look briefly at their careers.

Paul Cézanne 1839–1906

In any neat scheme of nineteenth-century artistic developments, Cézanne is an anomaly. He was a little older than most of the Impressionists, came to *plein-air* working relatively late under the tutelage of Pissarro, and yet developed a style in the 1880s that took him beyond Impressionism and made him a key figure in the development of modern art. The belated Romantic of the 1860s and Impressionist of the 1870s eventually became the greatest of the Post-Impressionist 'generation'.

Pissarro recognized that, even at his most Impressionist, Cézanne preferred to emphasize the underlying structure of a scene rather than concentrate on fleeting effects; and this would prove to be his way forward from Impressionism. Although he remained close to Pissarro, painting in his company as late as

ABOVE: **Château
Noir** c.1904
Paul Cézanne
PRIVATE
COLLECTION

1881, he took part in only one Impressionist exhibition after 1874 (that of 1877). Almost as though he relished rejection, he sent his canvases to the Salon year after year. One was finally accepted in 1882, thanks to a painter friend on the jury, but after that the rejections simply went on as they had before.

Outside the Salon, Cézanne made little effort to publicize or sell his works, although he was usually short of money – shorter than ever once his father began to suspect that he had a mistress and a child somewhere, despite Cézanne's resolute denials. He was reduced to begging his boyhood friend Zola to send Hortense a regular sum to live on. Dr Gachet and Victor Chocquet bought his work, but otherwise there was only Père Tanguy, the little ex-Communard paint merchant, whose shop filled up with unsold Cézannes; his generosity in giving Cézanne art materials on credit almost bankrupted him.

Cézanne's life took a new turn in 1886, when his ailing father allowed him to marry Hortense and then died, leaving Cézanne independently wealthy. Less happily, the year also witnessed the publication of Zola's novel of artistic life, *L'Œuvre*, in whose failed hero Cézanne recognized many of his own traits. He thanked Zola with dignity for sending him a copy of the book and never communicated with him again.

From 1886 Cézanne spent most of his time at Aix while the art world forgot all about him. Later, when his work began to attract attention, many people were surprised to hear that he was still alive. Meanwhile, he was creating masterpieces in pursuit of his ambition 'to make of Impressionism something solid and durable, like the art of the museums'. He continued to paint landscapes in the open air, but the 'sensation' he experienced was rigorously disciplined by his constructive instinct. The brushwork became an

ABOVE: **Still Life with Basket**
1888-90
Paul Cézanne
MUSÉE D'ORSAY, PARIS

essential element in the picture, with patterned strokes assembled into building blocks or directed so that they seemed to be on the march. Cézanne also used a number of devices to make every area of his canvas 'strong', if necessary ignoring rules of perspective and proportion. By such means he transformed landscape, portraiture and the nude. Still life, a lowly art by academic standards and only occasionally practised by the Impressionists, became in Cézanne's hands a major genre. More than any other artist of his time, Cézanne liberated painting from 'reality', creating canvases that existed for their own sake, solid, durable and autonomous.

Cézanne remained a strange and eccentric personality, although there was never any doubt about his sanity. In the 1890s he cut himself off from old friends like Monet and Pissarro, avoiding them even on the street. On the other hand, he was pleased to play the sage with younger men, writing a number of letters to the painter Emile Bernard that give us some insight into his ideas; his advice 'to treat nature by the cylinder, the sphere and the cone' has often been interpreted as an anticipation of the early twentieth-century Cubist movement. In 1895 Pissarro persuaded a rising young dealer, Ambroise Vollard, to visit Cézanne, and the outcome was the painter's first Paris show. In 1896 two of his paintings were

hung at the Musée du Luxembourg as part of the Caillebotte bequest. His reputation grew steadily greater, but he was still far from the zenith of his fame when he died at his home on 22 October, 1906.

Paul Gauguin 1848–1903

Born on 7 June, 1848, Gauguin was the same age as Caillebotte, but he made a much later start as a painter. He showed his work in the last five Impressionist exhibitions, but remained something of an outsider, tolerated as a protégé of Pissarro. It was only some years afterwards that his assertive personality and self-chosen exile on Tahiti laid the foundations of a legend; but without his experience of Impressionism and Impressionists that could never have happened.

Gauguin was born in Paris but lived in Peru until he was

BELOW: **Mahana No Atua** 1894 Paul Gauguin ART INSTITUTE OF CHICAGO

seven. At 17 he joined the merchant navy, transferring to the fighting service and serving through the Franco-Prussian war. In 1871 he returned to Paris and was taken on by Bertin's, a stockbroking firm. As an outside man whose job was to find new clients, he was very successful and became very prosperous. In 1873 he married a Danish girl, by whom he had five children.

Gauguin's interest in art seems to have begun in the 1870s, when he and a colleague became enthusiastic 'Sunday painters' and also spent some of their time at the Académie Colarossi, a 'free' institution run on similar lines to the Académie Suisse. Gauguin is said to have seen and admired the 1874 Impressionist show, but his own work remained more conventionally dark-toned until he met Camille Pissarro; in 1876 he even had a painting accepted by the Salon. In the late 1870s he spent as much time as he could at Pontoise and Osny, painting with Pissarro and learning from him; and thanks to Pissarro he was able to exhibit with the Impressionists. In 1879 he sent in a piece of sculpture at the last moment, and he was more fully represented at all of the last four shows. He also took a prominent role as an organizer and intriguer, evidently anxious to establish his insider status.

One good reason why the Impressionists tolerated Gauguin during these years was that he was a patron as well as an amateur artist, buying the other exhibitors' pictures and building up a fine collection. He certainly longed to give himself up to painting, but his resignation from his job was deferred until after the financial collapse of 1883, which ended the speculative boom on which his success had been based. 'From now on I paint every day!'

The price of liberation proved to be high. An attempt to establish himself in Rouen failed miserably, and Gauguin and his family took refuge with his wife's relations in Copenhagen. After a few months of ill-success Gauguin returned to France, leaving his wife behind. Although there was no official separation, they never lived together again.

Free of family ties, he developed rapidly as an artist and a personality. Down to the mid-1880s much of his painting remained Impressionist in style, although the huddled figures in *Beach at Dieppe* (page 248) make the picture rather un-Impressionist in mood. However, Gauguin's taste for figure painting, for creating a sense of mystery, and for primitive and exotic places soon became pronounced. They were fed by his contact with Symbolism in Paris, by a brief, disastrous trip to Martinique in the Caribbean, and by his stays at Pont-Aven and Le Pouldu in Brittany,

which still kept traces of its non-French (hence 'primitive') culture.

In 1888 Gauguin made a complete break with Impressionism in paintings such as the well-known *Vision after the Sermon*. The abandonment of Impressionist everydayness of subject-matter was even more striking than the new 'Synthetist' style he adopted, with strong outlines and flat colours ultimately derived from Japanese prints. After various tribulations, including a traumatic few months at Arles with Vincent van Gogh, he decide to set out for the exotic paradise that he dreamed of. Tahiti turned out to be not quite as he imagined, but the pictures he painted there and in the Marquesas supplied the mystery and magic that seem to have been absent from the European-dominated reality of island life. Although he reintroduced an element of modelling into his Synthetist style, paintings such as *Mahana No Atua* (page 249) are a world away from Impressionism, stylistically as well as geographically. Quarrelling with the colonial authorities, weakened by a syphilitic infection, at home neither in France nor in paradise, Gauguin died of a heart attack on 8 May, 1903.

Vincent van Gogh 1853–1890

Three other great Post-Impressionist masters had vital contacts with the Impressionists. Georges Seurat (1859–91) has already been mentioned as the head of the Neo-Impressionist school which claimed to put Impressionism on a scientific basis. Astonishingly precocious and sadly short-lived, he was painting Neo-Impressionist masterpieces in his early twenties (*Bathers at Asnières*, 1884) and finished the famous *Sunday Afternoon on the Grande Jatte* in time to hang it at the 1886 exhibition. The younger Henri de Toulouse-Lautrec (1864–1901) began to make his mark in the late 1880s with paintings and posters of modern-life subjects, the most celebrated being scenes from nightspots such as the Moulin Rouge and the music halls. He owed much to Degas, but his work had a distinctively acid, gamey flavour. A childhood accident stunted his legs and probably determined his choice of milieu and alcoholic, destructive way of life.

Vincent van Gogh was older than Seurat and Lautrec, but like Gauguin he took a tortuous path to a career in art. Born at Groot Zundert in Holland on 30 June, 1853, he was the son of a minister of the Dutch Reformed Church. He worked for an art dealer at The Hague and later in London and Paris, apparently too preoccupied with social and religious problems to sense his own vocation. A

combination of headlong impetuosity, burning sincerity and instability doomed his personal life, which passed from crisis to crisis, and assured the failure of his missionary work in the Borinage mining district in southern Belgium.

In 1880 Van Gogh at last resolved to become an artist. His entire output was the work of the next ten years. By 1886, virtually self-taught, he had produced powerful drawings of peasant life and paintings that included *The Potato Eaters* (1885). Dutch academic art was even darker-toned than its French counterpart and Van Gogh's experience of Paris and Impressionism (and Neo-Impressionism) was a tremendous liberation into colour. Paintings such as *The Restaurant de la Sirène at Asnières* (above) were not only brighter than anything he had done in Holland or Belgium, but more freely brushed and more vibrant.

However, Van Gogh soon began to use colour more expressively, although he continued to paint out of doors in Impressionist style. When he moved to Arles in 1888 the strong southern colours reinforced this tendency. The few weeks during

which he shared his house at Arles with Gauguin ended with an attempted attack on Gauguin and a mental collapse during which he cut off a piece of his own ear. He entered a mental hospital as a voluntary patient and, on his release, took a room at Auvers, where Dr Gachet agreed to watch over him. His extraordinary, turbulent landscapes and his *Portrait of Dr Gachet* (below) with 'the sad expression of our times', exemplify the new expressive language he had developed. His mental condition remained precarious and, while painting in a field, he shot himself in the chest, dying two days later on 29 July, 1890.

Impressionism continued to influence French artists for years to come. Elsewhere in Europe and in America its main impact was only felt in the early years of the twentieth century. But by then the heroic age was over.

LEFT: **Portrait of Dr Gachet** 1890 Vincent van Gogh PRIVATE COLLECTION

Index to Illustrations *(Artists are listed in alphabetical order)*

Acknowledgements

The Publisher would like to thank the following for their kind permission to reproduce the paintings in this book:

Bridgeman Art Library, London/Giraudon, Paris/© DACS 1996 – Musée d'Orsay, Paris – 63, 65, 73, 75, 137, 157, 193, 197, 199, 241: /**Musée d'Orangerie, Paris** – 200-1: /**Art Institute of Chicago** – 66-7: /**National Gallery of Art, Washington** DC – 6, 243: / **Museum of Fine Arts, Boston, Mass.** – 151: /**Private Collection** –194-5

Bridgeman Art Library, London/Giraudon, Paris – **Städtische Kunsthalle, Mannheim** – 36-7: /**Musée des Beaux-Arts, Tournai** – 182-3: /**Musée Fabre, Montpelier** – 107: /**Musée d'Orsay, Paris** – 9, 17, 18, 20, 46-7, 49, 50-1, 59, 96-7, 112-3, 115, 119, 127, 141 [also used on front cover], 146-7, 158, 159, 163, 190, 224-5, 226-7, 247, 252, 253

Bridgeman Art Library, London/©DACS 1996 – Private Collection – 58: /**National Gallery, London** – 70-1, 74: /**Musée Marmotton, Paris** – 134-5: /**Pushkin Museum, Moscow** – 138-9: /**Musée des Beaux-Arts, Rouen** – 244

Bridgeman Art Library, London – **Musée d'Orsay, Paris** –12-13, 24, 28-9, 34-5, 39, 41, 103, 104-5,110, 114, 117, 130, 133, 152-3, 161, 170-1, 174, 176-7, 210, 239: /**Musée Municipal, Pau** – 52: /**Musée des Beaux-Arts, Tournai** – 173: /**Musée des Beaux-Arts, Lyon** – 189: /**Musée du Petit Palais, Geneva** – 236-7: /**Musée de Grenoble** – 109: /**Phillips Collection, National Gallery of Art, Washington** DC – 19, 121, 129: /**Chester Dale Collection, National Gallery of Art, Washington, DC** – 233: /**Metropolitan Museum of Art, New York** – 54-5, 205: /**Art Institute of Chicago** – 98-9, 166-7, 249: /**Tyson Collection, Philadelphia Museum of Art, Pennsylvania** – 208-9: /**Carnegie Museum of Art, Pittsburgh, Pennsylvania** – 217: /**Oscar Reinhart Collection, Winterthur** – 181: /**National Gallery, London** – 22-3, 42-3, 165, 186-7, 206-7, 212, 219: /**Tate Gallery, London** – 213, 222: /**Courtauld Institute Galleries, University of London** – 145, 184: /**Burrell Collection, Glasgow Art Gallery and Museum** – 155: /**National Gallery of Scotland, Edinburgh** – 90-1, 191: /**Städelsches Kunstinstitut, Frankfurt** – 69: /**Museum Folkwang, Essen** – 77: /**Wallraf-Richartz Museum, Cologne** – 78: /**Kunsthalle, Hamburg** – 89, 179: /**Städtische Kunsthalle, Mannheim** – 92-3, 100: /**Dreyfus Foundation, Kunstmuseum, Basle** – 214-5: /**Ny Carlsberg Glyptotek, Copenhagen** – 248: /**Hermitage Museum, St. Petersburg** – 218: /**Pushkin Museum, Moscow** – 84-5: /**Private Collection** – 21, 81, 220-1, 230-1, 246

National Gallery of Art, Washington DC – 87, 122-3

AKG Photos, London – **Musée d'Orsay, Paris** (Photo: Eric Lessing) 33, 148, 168-9

Every effort has been made to attribute the copyright holders of the paintings used in this publication and we apologise for any unintentional ommissions or errors. On notification we will be happy to insert an ammended credit in any subsequent edition.